DRAWING IN THE
ITALIAN RENAISSANCE
WORKSHOP

Victoria and Albert Museum

DRAWING IN THE ITALIAN RENAISSANCE WORKSHOP

FRANCIS AMES-LEWIS AND JOANNE WRIGHT

An Exhibition of Early Renaissance Drawings
from Collections in Great Britain
held at the
University Art Gallery, Nottingham
12 February to 12 March 1983
in association with the
Arts Council of Great Britain
with the financial assistance of Sotheby Parke Bernet & Co.,
Marks and Spencer, and the Boots Company plc.
and at the
Victoria and Albert Museum, London
30 March to 15 May 1983

The catalogue is sponsored by
Pirelli

Published by the Victoria and Albert Museum, London
Casebound trade edition published by
Hurtwood Publications Limited, London Road,
Westerham, Kent.

First published 1983
Copyright © Francis Ames-Lewis and Joanne Wright
Copyright © photographs as listed in acknowledgments

ISBN 0 905209 31 1 (paper)
ISBN 0 903696 22 3 (cased)

Designed by Patrick Yapp
Printed in Great Britain by Westerham Press Limited

FRONT COVER/JACKET: Detail from *Studies of Standing and
Kneeling Figures; Sketch of Hands and an Ear* (Catalogue no 21 recto)
by Benozzo Gozzoli; courtesy of the Earl of Harewood.
BACK COVER/JACKET: *Peacock*, North Italian; reproduced by permission of
the Trustees of the Chatsworth Settlement.

Contents

List of Lenders 6

Foreword 7

Acknowledgments 8

Photographic Acknowledgments 10

Notes on the Catalogue 12

Introduction 13

The Colour Plates 17

The Catalogue 41

I Introduction to Techniques 43

II Modelbooks and Sketchbooks 95

III The Draped Figure 145

IV The Nude Figure 177

V Compositional Drawings 219

VI Studies of Heads 283

Glossary 322

Biographies of Artists 324

Select Bibliography 327

List of Lenders

Birmingham, Barber Institute of Fine Arts 63
Chatsworth, Devonshire Collection 5, 17, 30, 45, 48, 49, 50, 52, 53, 57, 58,
 65, 66, 71
Edinburgh, National Gallery of Scotland 1, 2, 6, 28
Harewood, Earl of Harewood Collection 21
Liverpool, Walker Art Gallery 13
London, British Museum 3, 15, 22, 23, 24, 25, 26, 27, 32, 37, 39, 41, 54, 56, 60
London, Victoria and Albert Museum 20, 46
Oxford, Ashmolean Museum 9, 12, 18, 29, 33, 34, 47, 55, 61
Oxford, Christ Church 7, 10, 14, 16, 31, 35, 36, 38, 40, 44, 59, 68, 69, 70, 72, 74
Private Collection 8, 19
Rugby, Rugby School 11
Truro, Royal Institution of Cornwall 4
Windsor, Royal Library 42, 43, 51, 62, 64, 67, 73

This exhibition of Quattrocento drawings, held at the Victoria and Albert Museum and Nottingham University Art Gallery, and organised by Francis Ames-Lewis and Joanne Wright, is the first attempt to show the role of such drawings in the Renaissance workshop, to put them in a technical perspective – how they were made and why – and to consider how their usage relates to studio practice at the time. The catalogue of the exhibition is published by the V & A with generous support from Pirelli Limited.

Both the V & A and the Nottingham Gallery share an ideal of discussing art within its social and historical context. This exhibition and catalogue pursue that aim, seeking to bring the workshop to life, and to examine the role of drawings over and above their visual impact on today's observer; for in the Renaissance drawing was not seen in isolation, but rather as a means to an artistic end.

But beyond its didactic purpose, this exhibition offers the first opportunity since 1953 for the visitor to appreciate the wealth of early Renaissance drawings in this country, and to wonder at the delicate beauty of the works of such great draughtsmen as Pisanello, Verrocchio, Carpaccio and Leonardo da Vinci, before their gentle mood was overwhelmed by the grandeur of the High Renaissance.

ROY STRONG
Director
Victoria and Albert Museum

RICHARD SCHOFIELD
Director
Nottingham University Art Gallery

Acknowledgments

This exhibition was conceived in 1978, and has been in preparation during the course of five years. Over these years the organisers have received nothing but encouragement, helpfulness, and goodwill from all who have generously lent their precious possessions; and the staffs of the museums, printrooms, and other institutions from which we have borrowed drawings have shown constant kindness and enthusiasm. We would like especially to thank Her Majesty the Queen, His Grace the Duke of Devonshire, the Earl of Harewood, and a private collector who wishes to remain anonymous; Hamish Miles of the Barber Institute of Fine Arts, Birmingham; Peter Day and Michael Pearman at Chatsworth; Colin Thompson and Keith Andrews of the National Gallery of Scotland; Neville Ussher and George McTague at Harewood; Timothy Stevens, Mark Evans and Maria Villaincour Baker at the Walker Art Gallery, Liverpool; John Gere, John Rowlands, Nicholas Turner, Martyn Tillier and Sheila O'Connell at the British Museum (Department of Prints and Drawings); Michael Kauffmann and Susan Lambert at the Victoria and Albert Museum (Department of Prints and Drawings); Kenneth Garlick and Christopher Lloyd at the Ashmolean Museum, Oxford; David Alston and Joanna Woodall at Christ Church, Oxford; Paul Martin of Rugby School; H.L. Douch and Roger Penhallurick of the Royal Institution of Cornwall, Truro; and Jane Roberts and Henrietta McBurney of the Royal Library, Windsor Castle. To the Royal Library we are further indebted for their generous loan of screens for the display of double-sided drawings.

We are also very grateful to many others like James Byam Shaw, Julien Spock of Sotheby's, Francis Russell of Christie's and Clovis Whitfield of Colnaghi's whose advice on a variety of questions has been most valuable. To the photographic departments of the museums from which we have borrowed, to the commercial photographers who have often stepped in at short notice to provide us with transparencies and prints, and to the staff of the museums and printrooms, and the photographers, on the Continent and in the USA with whom we have corresponded, we extend our gratitude for their patience and dispatchfulness.

This exhibition could not have been mounted, nor this catalogue produced, without the help of our sponsors. The Arts Council of Great Britain have guaranteed to underwrite to a substantial level the costs of showing the drawings at the University Art Gallery, Nottingham, which has also been greatly helped by financial assistance from The Boots Company plc, Marks and Spencer, and Sotheby Parke Bernet & Co. The production of the catalogue, and the financing of other aspects of the exhibition, have been sponsored by a generously large sum donated by Pirelli Ltd.

We have been encouraged and supported throughout by the keen interest taken by Richard Schofield and his staff at the University Art Gallery, Nottingham; and invaluably helped by Michael Darby and Garth Hall in the Exhibitions Department of the Victoria and Albert Museum, Brian Griggs of the Design Section, Nicky Bird, the Publications Officer, Simon Tait, the Public Relations Officer, and not least by the Museum's Director, Sir Roy Strong. For the design of this catalogue, and for the thankless task of editing our typescript, we are deeply indebted to the patient and tireless efforts of Patrick Yapp; and we are very grateful to Peter Grundy and Tilly Northedge for their assistance with the graphic design of the exhibition.

Amongst numerous others who have helped us in a wide variety of ways, we would like to acknowledge in particular the kindness and help of Tom Northey, Mike Sixsmith, Edward Blacksell and Ruth Henderson Deeves, Tom Morris, Pamela Courtney, Peter Murray, John Steer, Jenny McCleery, Anthony Hamber, Tony Holmes, Sheila Riley, Isobel Sayer, Jane Moseley and Dorothy Farquhar; and in general all our friends, colleagues and students who have offered stimulating ideas and advice, or have expressed their pleasure and enthusiasm at the prospect of this exhibition coming to eventual fruition. Last but not least, we thank Christabel Ames-Lewis and Peter Wright for their loving support and encouragement through the ups and downs of these years of our work on the exhibition.

Photographic Acknowledgments

(colour plate numbers are in italics)

Nottingham, Tony Holmes (Devonshire Collection, Chatsworth; reproduced by permission of the Trustees of the Chatsworth Settlement) 5, *17*, *30(A)*, 30(B), *45*, 48 recto, 48 verso, 49 recto, 49 verso, *52*, 53, *57*, 58 recto, 58 verso, 65, 66, 71 *recto*, 71 verso

(Harewood, Earl of Harewood Collection) *21 recto*, 21 verso

Oxford, Ashmolean Museum 9, 12 recto, 12 verso, 18 recto, 18 verso, *29*, 33, 34 recto, 34 verso, 47, 55, 61

The Governing Body, Christ Church 7, 10, 14, 16, 31, III A, 35 recto, 36, 38 recto, *38 verso*, *40*, 44, 59, 68, 69, 70, *72*, 74

Paris, Musée du Louvre, Cabinet des Dessins (Service de Documentation Photographique) 10a, II D, 17a, 17b, III B, III G, IV E, 37a, 44a, 45b, V F, 55c, VI A, VI B, VI D

Rotterdam, Museum Boymans-van Beuningen (Fréquin-Photos) 45a, 64a

Rugby, Rugby School 11, 11c

Strasbourg, Musée des Beaux-Arts 22a

Syracuse, Palazzo Bellomo, Museo Nazionale di Sicilia 23b

Truro, Royal Institution of Cornwall 4

Venice, Accademia (Osvaldo Böhm) 34a, 58a, 59a

Vienna, Lichtbildwerkstätte 'Alpenland' 23a, 34b, V B, VI E

Windsor, Royal Library (reproduced by gracious permission of Her Majesty the Queen) I E, 29b, 42, 43, 51, 62, VI G, 64 recto, 64 verso, 67 recto, 67 verso, 71c, *73*, 74b

Notes on the Catalogue

The exhibits are grouped into six sections, numbered in Roman numerals, I–VI. Illustrations in the section introductions are captioned with the appropriate Roman numeral followed by an upper-case letter, e.g. III A, IV B.

The exhibits themselves are numbered in Arabic numerals, 1–74. Documentary illustrations to each exhibit are captioned with the Arabic numeral followed by a lower-case letter, e.g. 22a, 35b.

This system is used for all cross-references in the text of the catalogue.

Measurements of all drawings, both those exhibited and those illustrated in the documentation, are given in millimetres, height first, followed by width. For some of the paintings and sculpture illustrated for documentary purposes, the measurements are for convenience given in centimetres.

The *bibliography* for each catalogue entry has been kept to the minimum necessary. The first reference in each case is to the museum or exhibition catalogue in which the drawing is most fully discussed. Other references follow in alphabetical order of the authors of books, catalogues or articles. Abbreviated bibliographical references are expanded in full in the first sections of the select Bibliography, on page 327 of the catalogue.

Problems of attribution are not discussed in detail in this catalogue, since the thrust of the exhibition is towards consideration of the technique and purpose of the drawings included.

Introduction

The Early Renaissance was the first great age of the art of drawing in Western Europe. For a variety of reasons, which are explored in this exhibition, there was an enormous increase in the practice of drawing between the late fourteenth and the early sixteenth centuries. Whereas around 1400 the functions of drawing and drawings were (as far as we can tell) but few, by the High Renaissance drawing was put to a large range of different uses. During the fifteenth century, furthermore, both graphic styles and handling became less restricted, moving away from the controlled, precise modes generally current in the late Gothic period towards a wider range of free, individual styles which reflected the more personal and experimental ways of thought of Renaissance artists. Similarly, the versatility with which the Renaissance draughtsman exploited the techniques available to him developed rapidly during the quattrocento. These points, fundamental to an understanding of fifteenth-century drawing practice, are examined in detail in the introductory section of the exhibition.

Drawing played many varied roles, both practical and theoretical, in the work of the Italian Renaissance artist's studio. From the day of his arrival in the workshop, the new young apprentice found that drawing formed the basis of his training. Studying from a model (whether another drawing, a sculptural work, or a posed workshop assistant) was a practice increasingly encouraged by Renaissance masters. It served the double function of training the apprentice's eye and hand by prompting him to observe carefully, and reproduce faithfully, the forms of nature, and of channelling his graphic style towards the general workshop manner, so as to ensure that collaborative works emerging from the workshop would not be too heterogeneous in execution and quality. Secondly, drawing became gradually more and more important as the natural medium for experimenting with pictorial ideas: thus, many Renaissance drawings had a basically practical function in the preparation for a specific commissioned work, which was usually a painting, but sometimes an engraving or a piece of embroidery or sculpture. Such drawings range between brief, early sketches of whole designs and detailed studies of particular forms within the composition to be depicted. When working on a commission, the artist also often took up motifs drawn either in the theoretical training of his apprenticeship, or in the broadening of his professional experience and skill, and preserved in his workshop sketchbooks or portfolios. Finally, and most significantly, drawing was the means by which the fifteenth-century artist came to grips with the new demands and expectations generated by the cultural and intellectual changes of the Italian Renaissance. No longer could he rely on the time-honoured representational conventions and formulas of earlier centuries.

He had to observe and explore afresh the whole of the natural world, and in particular the structure, movements and emotions of Man; for the ideal to which Renaissance artists and their patrons aspired was the realistic and convincing representation of the forms and interactions of human beings. This exhibition seeks to examine the early Renaissance artist's pursuit through drawing of those goals, and to trace some of the changes which in consequence occurred in workshop drawing practice.

Our knowledge and understanding of the techniques and procedures of drawing in the early Renaissance is greatly illuminated by a number of written sources, of which three are so important as to deserve some mention at this point. The earliest is Cennino Cennini's *Il Libro dell'Arte*, translated into English as *The Craftsman's Handbook*, which was written in Padua in about 1400 as a manifesto of Florentine fourteenth-century artistic practice. It is essentially a technical manual, from which we (like the fifteenth-century painter) can learn such practical lessons as how to prepare paper for silver-point drawing, how good charcoal for drawing is made, and so on. Occasionally, however, Cennini offers valuable insights into the attitudes of the late Gothic artist and the organisation of his workshop. These attitudes sometimes coincide, but more often contrast, with those encouraged by Leon Battista Alberti, whose *Della Pittura* of 1436 is a theoretical treatise, with very few of the practical hints and recipes which make up the bulk of Cennini's text. The Renaissance principles of Alberti's theoretical stance are developed in greater detail, with extensive advice on how they can be put into practice, by Leonardo da Vinci in his notes, written in the decades around 1500, towards an uncompleted *Trattato della Pittura*. Leonardo's writings are perhaps the most useful for understanding the drawing practice of the Renaissance workshop, for he discussed many of the later fifteenth-century artist's concerns and makes more detailed recommendations than earlier writers had on how drawing can, and should, be exploited in the pursuit both of solutions to artistic problems and of perfection in pictorial representation.

If these written sources increase our knowledge of the processes of fifteenth-century drawing, contrastingly severe limitations are placed on it by the loss of innumerable drawings themselves. It was, for example, standard practice to draw with the silverpoint on prepared wooden tablets which could, for economy's sake, be used over and over again. The vast majority of working drawings have thus disappeared; and since most surviving drawings from the early part of the century were made specifically to be preserved, as contractual drawings perhaps, or in workshop model-books, they tend to be fully, if not laboriously, finished rather than free and experimental. When, towards the end of the century, the pre-eminence of the stylus gave way to the near-universal use of pen and ink, or black and red chalks (both being more versatile techniques which answered better the developing needs of the Renaissance draughtsman), more drawings survive, because they had to be made on paper, and not on the disposable prepared surface. At this stage of the Renaissance, therefore, a somewhat clearer picture begins to emerge of the uses of drawing in the artist's workshop routine.

The growth in the use of paper therefore means that the number of drawings which survive (albeit often fortuitously) increases during the course of the century, and represents a progressively higher percentage

(albeit still small) of the total originally made. But it did not fundamentally alter the status of drawing or of drawings. The expansion of drawing activity was principally due to the development of artistic preoccupations which could best, and perhaps only, be examined and explored through drawing. This growth therefore indicates both that the artist encountered an increasing number of problems, and that he sought solutions to them with new determination and thoroughness. Drawing was thus the medium generally used for exercise and training, and for exploring artistic problems which, when worked through, could be applied in the preparation of compositions for the more formal medium of painting. Only very occasionally, during the early Renaissance, can drawings be said to have been, or to have been intended as, works of art in their own right. The production of portrait drawings, in lieu of the more costly painted portrait, arose in North Italy late in the fifteenth century; and both Mantegna and Signorelli produced highly finished drawings in the decade before 1500, apparently as manifestos of their preoccupations and skills aimed at an educated élite. But these are exceptions. Generally speaking, drawings had no artistic value beyond their immediate practical function, and no commercial value, since they did not depict images or narrative scenes to the high degree of finish which was expected by the open market.

It is as much good luck that so many drawings have survived from the early Renaissance, as ill luck that many, many more must have been destroyed: thrown away, burned, or perhaps more often returned to the papermills for repulping. Not until around 1520 did the activity of collecting drawings begin to become usual enough to increase significantly the chance of survival of fifteenth-century drawings. From the middle of the sixteenth century, drawings were assembled in large numbers in private collections, sometimes for their historical value (vital to Giorgio Vasari whose *Libro de'Disegni*, the visual complement to his monumental *Lives of the Artists*, was the first and perhaps the greatest collection of old master drawings), but more often for the quality of spontaneous creativity which was so admired in drawings by the connoisseurs of later centuries.

This is, indeed, the quality which still affects the viewer of early Renaissance drawings more strongly perhaps than any other. The conclusions we have reached, concerning the status of drawing and drawings in the early Renaissance, emphasise the essentially practical and experimental roles of the activity of draughtsmanship. It is the graphic freedom born of experimentation which makes some of the drawings exhibited here frankly mediocre, and makes many others virtuoso displays of the draughtsman's art. These latter have immediate and powerful appeal to the twentieth-century eye, accustomed as it is to admiring just that spontaneity and unfinished bravura which was beneath the notice of the patrons and the public of Renaissance Italy. But this exhibition seeks to provide today's public not only with a range of aesthetic delights, but also with an opportunity to explore how and why the early Renaissance draughtsman made and used his drawings.

The Colour Plates

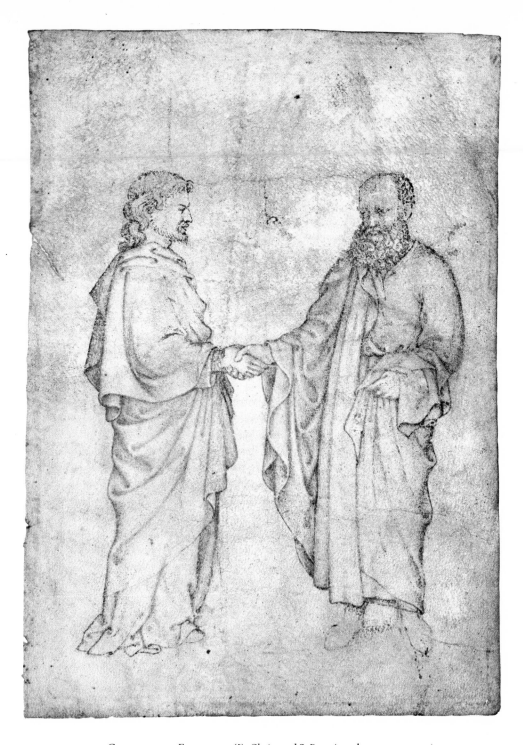

1 GENTILE DA FABRIANO(?) *Christ and St Peter* (catalogue no. 1 recto)

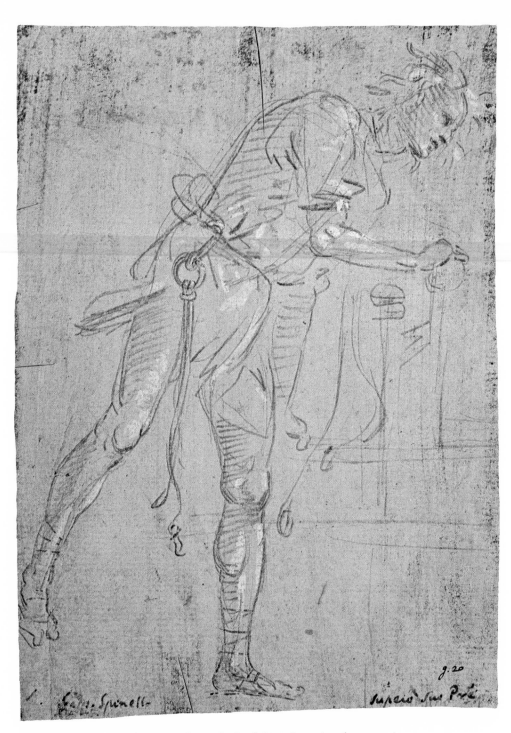

2 FILIPPINO LIPPI *Study of a Litter-bearer* (catalogue no.7)

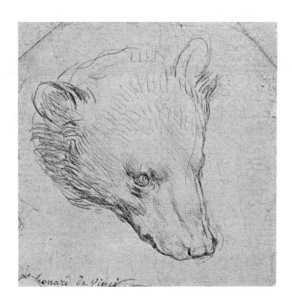

3 LEONARDO DA VINCI *Study of a Bear's Head*
(catalogue no.8)

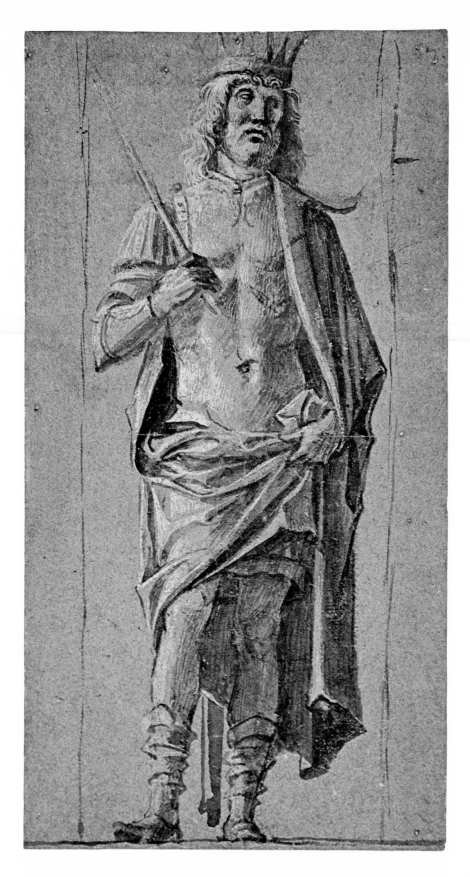

4 BARTOLOMMEO MONTAGNA *Figure of a Standing Crowned Man* (catalogue no.9)

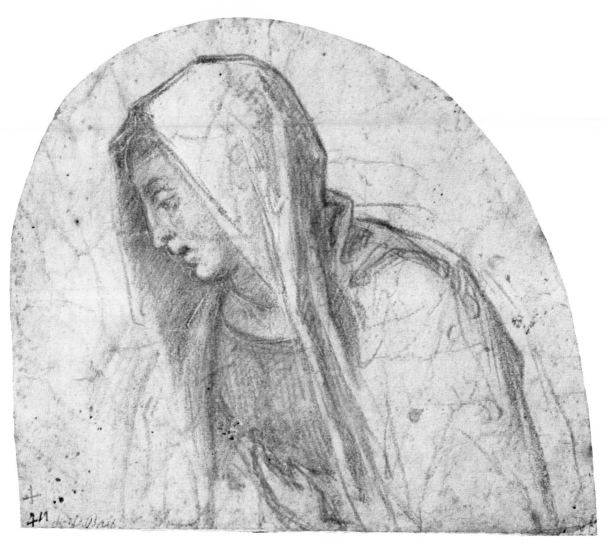

5 FRA BARTOLOMMEO DELLA PORTA *Study of the Mourning Virgin* (catalogue no.14)

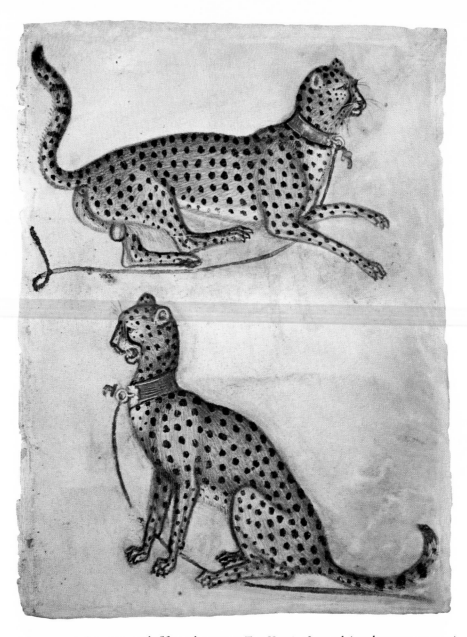

6 LOMBARD SCHOOL, early fifteenth century *Two Hunting Leopards* (catalogue no.15 recto)

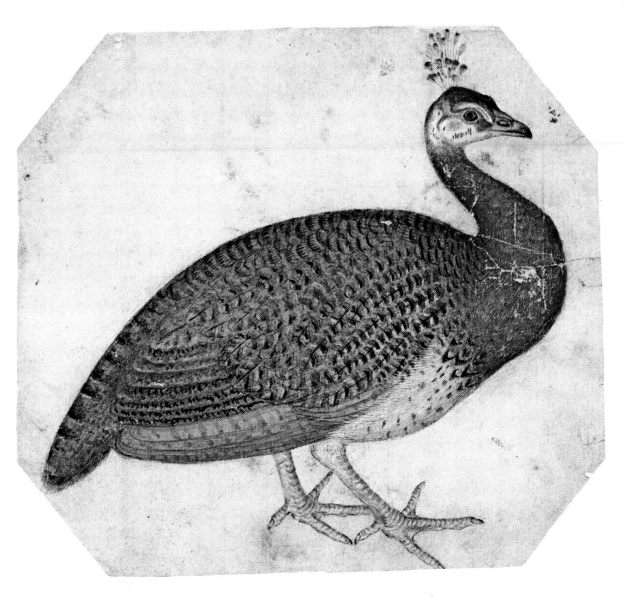

7 NORTH ITALIAN, first half of fifteenth century (?) *Peacock* (catalogue no.17)

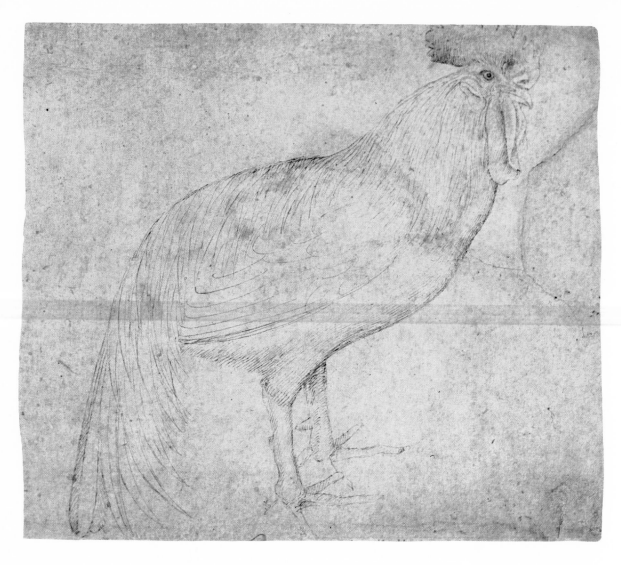

8 ANTONIO PISANELLO *Study of a Cock* (catalogue no. 19 recto)

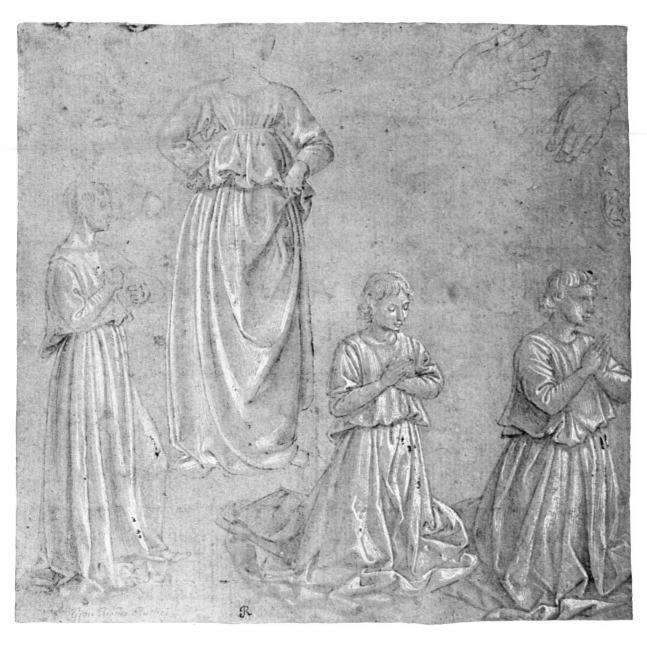

9 BENOZZO GOZZOLI *Studies of Standing and Kneeling Figures;*
Sketch of Hands and an Ear (catalogue no.21 recto)

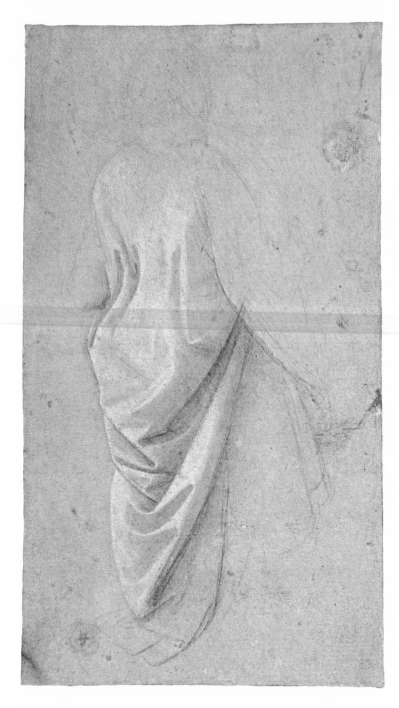

10 WORKSHOP OF FRA FILIPPO LIPPI *Study of Drapery* (catalogue no.29)

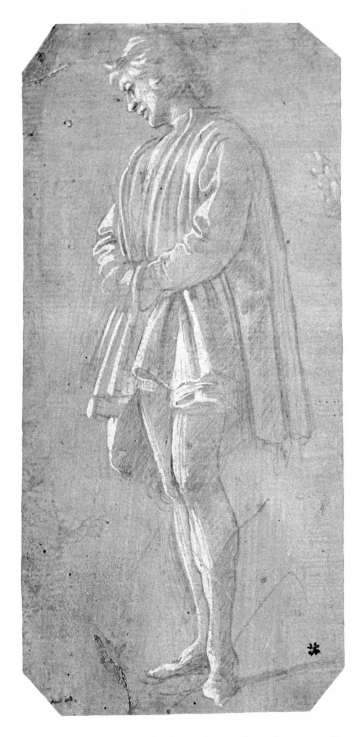

11 FILIPPINO LIPPI *Study of a Standing Youth* (catalogue no.30A)

FILIPPO LIPPI P:

12 FILIPPINO LIPPI *Studies of Nude and Draped Figures* (catalogue no.38 verso)

13 Antonio Pollaiuolo *Hercules and the Hydra* (catalogue no. 39 recto)

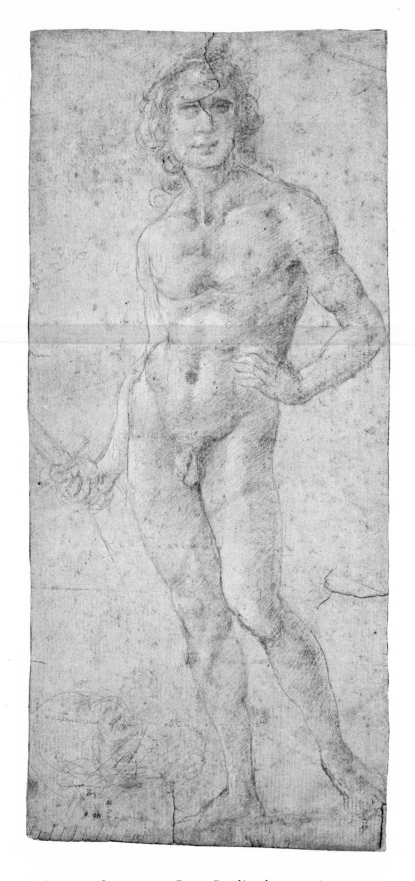

14 Lorenzo di Credi *David* (catalogue no.40)

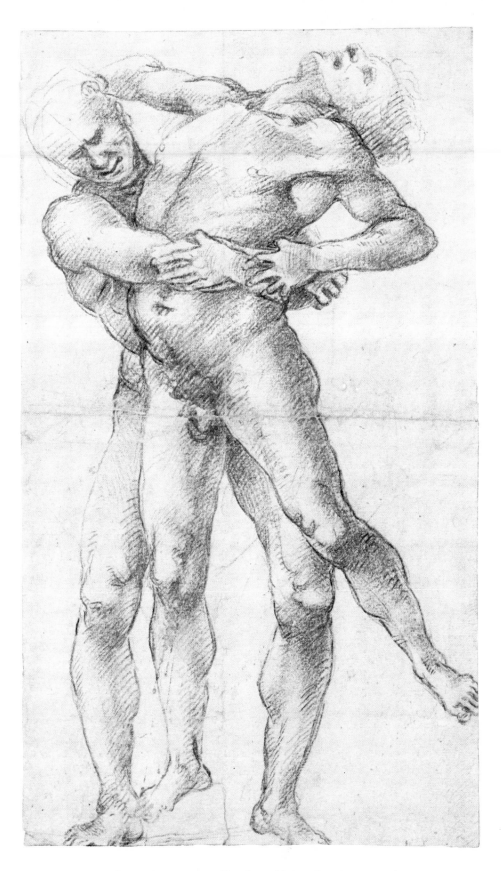

15 LUCA SIGNORELLI *Hercules and Antaeus* (catalogue no.42)

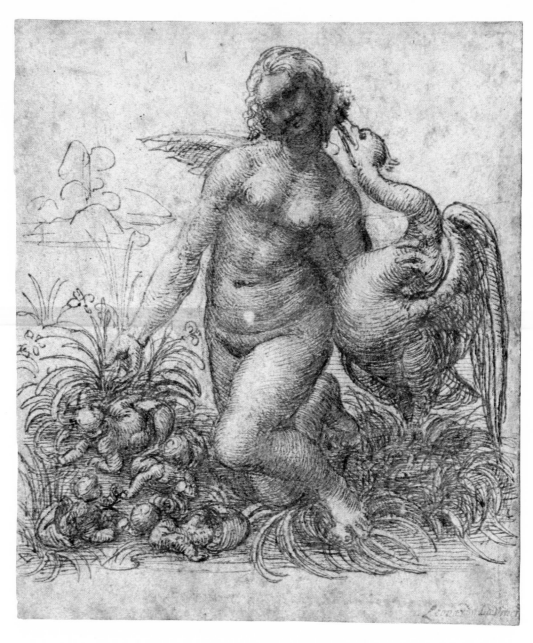

16 LEONARDO DA VINCI *Leda and the Swan* (catalogue no.45)

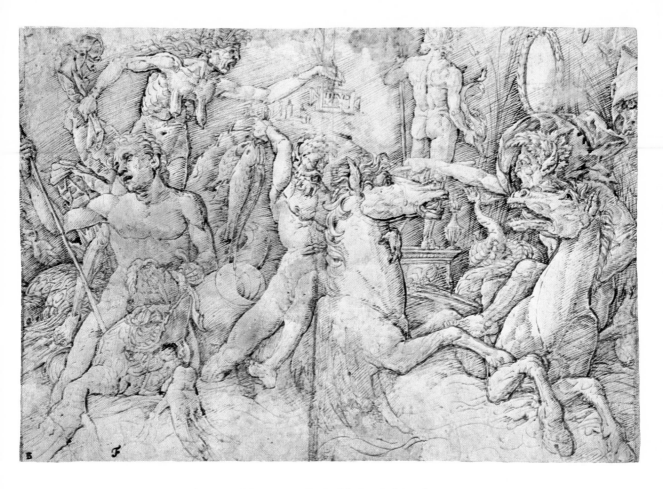

17 ANDREA MANTEGNA *Battle of the Sea-Gods* (catalogue no.52)

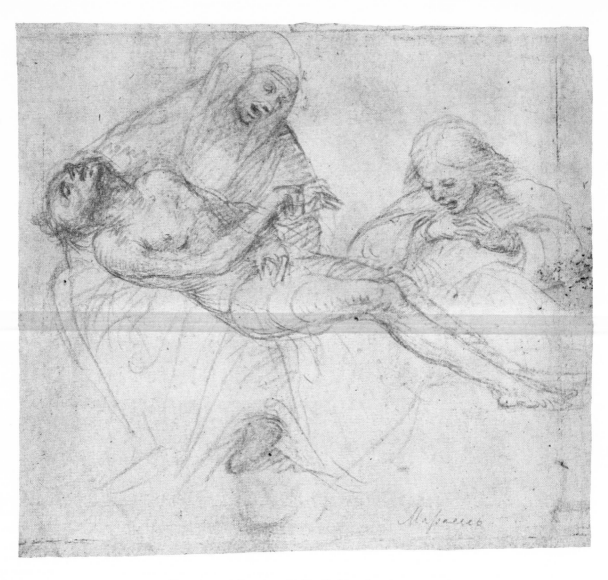

18 ERCOLE DE' ROBERTI(?) *The Pietà* (catalogue no.54 recto)

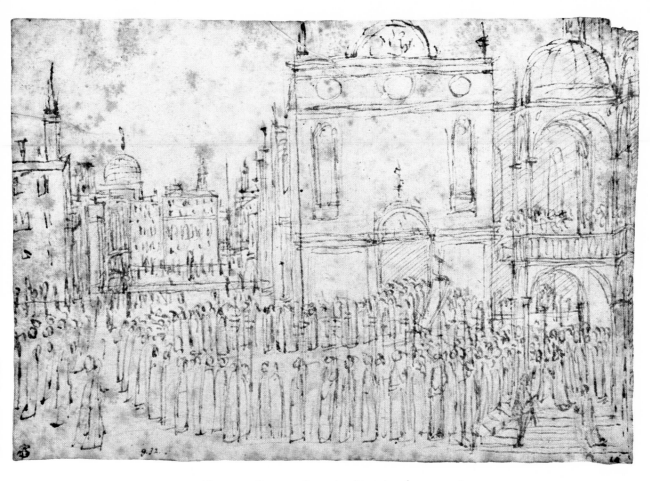

19 GENTILE BELLINI *Processional Scene* (catalogue no.57)

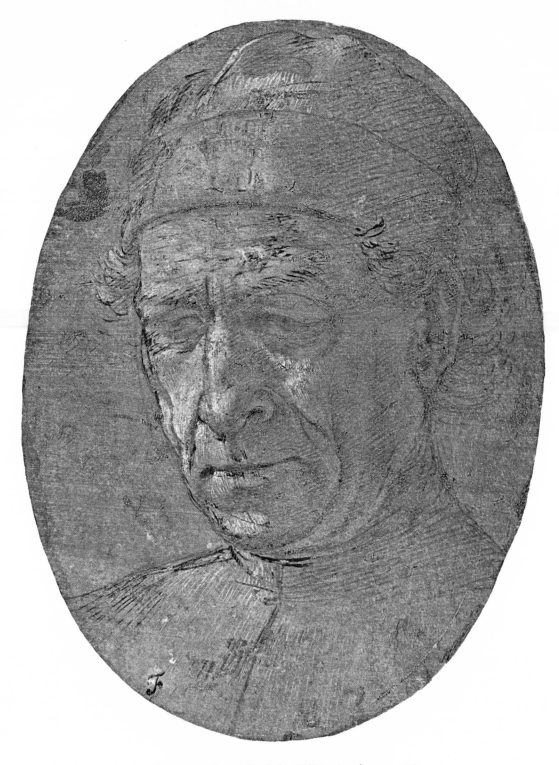

20 FILIPPINO LIPPI *Head of an Old Man* (catalogue no.66)

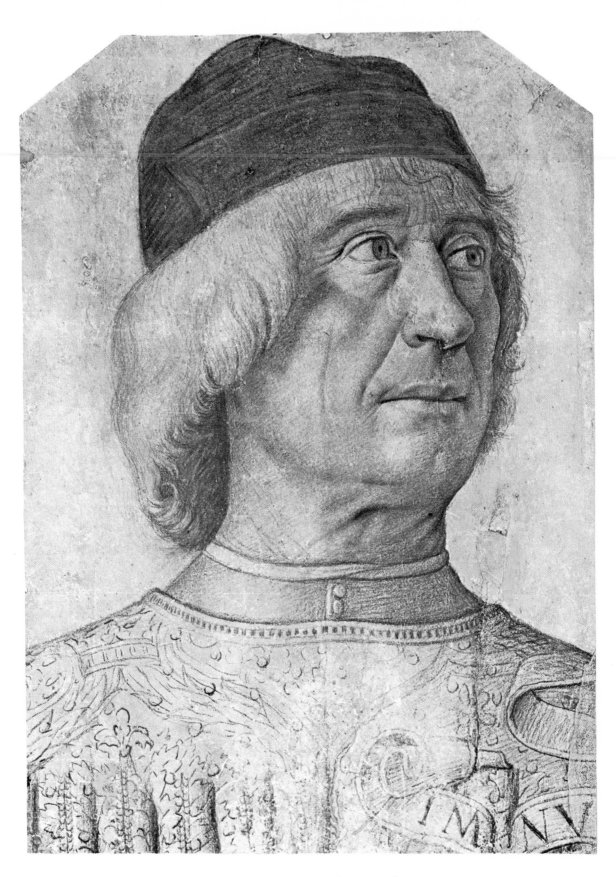

21 GIOVANNI BELLINI *Portrait of a Man* (catalogue no.69)

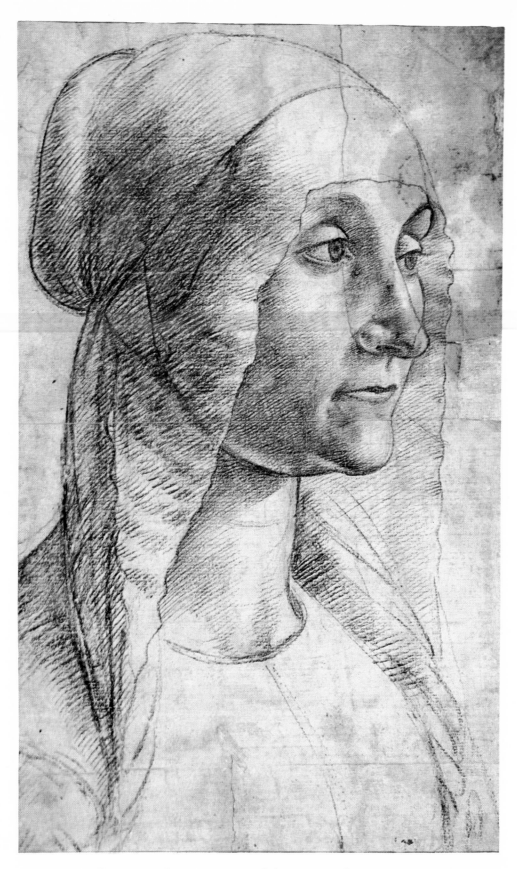

22 DOMENICO GHIRLANDAIO *Head of a Woman* (catalogue no.71 recto)

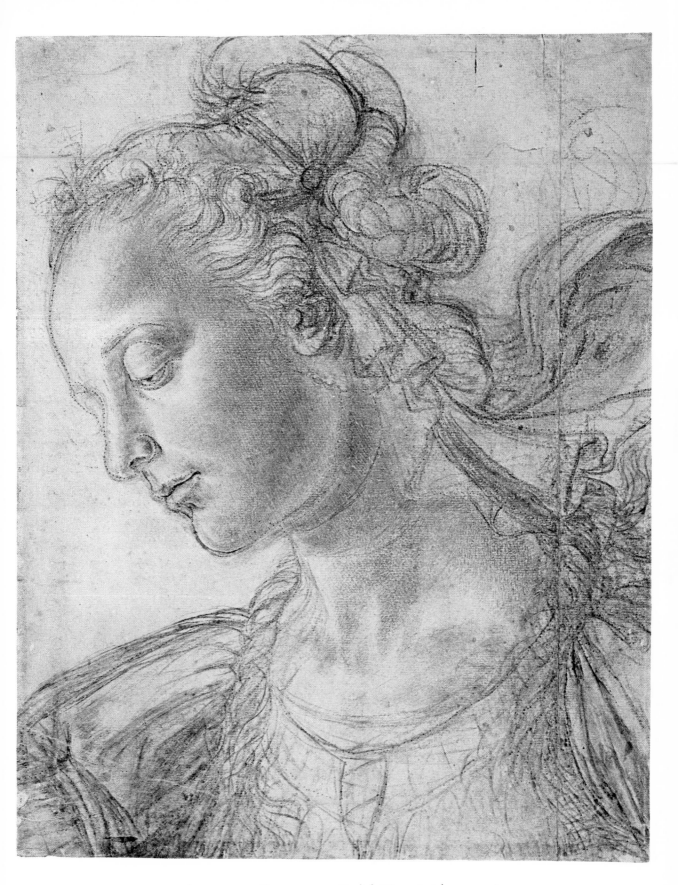

23 ANDREA DEL VERROCCHIO *Head of a Woman* (catalogue no.72)

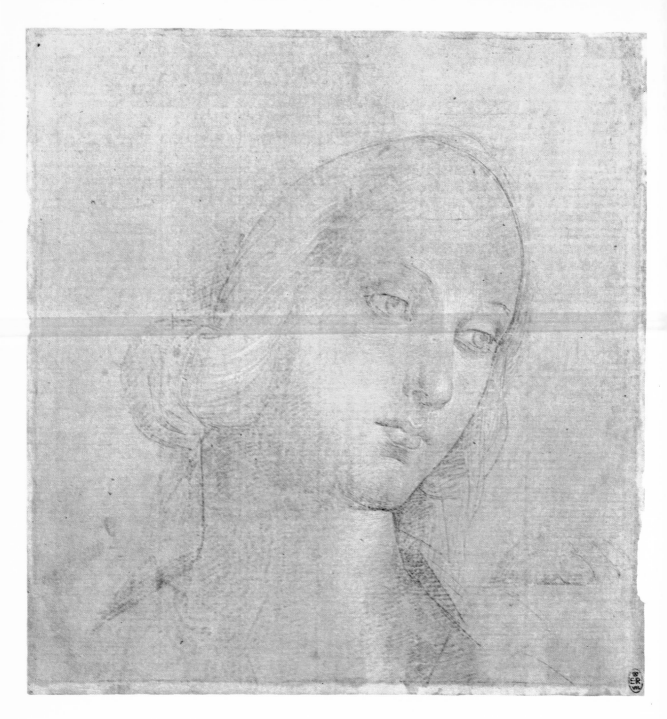

24 PIETRO PERUGINO *Head of the Virgin* (catalogue no.73)

The Catalogue

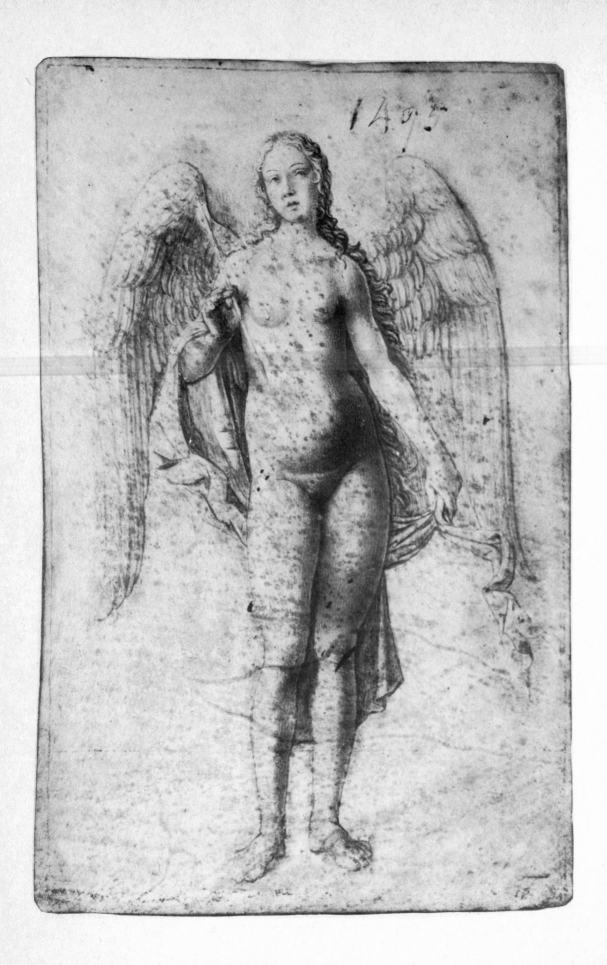

Until the middle of the fifteenth century, one of the principal drawing surfaces was vellum. This was a very fine quality parchment prepared from the skins of young calves or kids, soaked in a lime pit and scraped clean. The skins were then wetted, rubbed with pumice, chalk or ground bone, to smooth and prepare the surface, and were stretched tightly across a frame to dry. The two sides of the skin are known, rather baldly, as 'hair' and 'flesh', and the distinction can still be seen clearly on the finished, prepared surfaces (1,15,18). The 'hair' side is darker, slightly shiny and lightly mottled, whereas the 'flesh' side is paler and of a more even tone. The dependence on an animal source, with the hidden costs of rearing and feeding, the vicissitudes of breeding, and the laborious process of preparation, meant that vellum was expensive and not always readily available. But it did provide the draughtsman with a marvellously durable surface which was smooth, highly absorbent and tonally mellow; and extremely attractive to work on, especially with pen and ink.

The expansion of the paper industry in response to the evolution of the printing press heralded a decline in the use of vellum. Still costly, but much less so than any type of parchment, paper was produced with increasing abundance as the century progressed. Although at first considered less durable than vellum, it came to be regarded with less suspicion as production techniques improved and usage widened.

The increase in the availability of paper was perhaps the single most important factor in the development of quattrocento drawing practice. In the first place, since it was both less rare and less costly than vellum, the draughtsman could afford to use it more liberally, and this stimulated a significant expansion in the role of drawing in the workshop. Whereas vellum had been reserved for well thought-out, beautifully polished studies which were preserved, often in studio modelbooks, to be used by succeeding generations of artists as exemplars (Section II), paper gave the artist a new freedom to experiment, to explore natural form, and to probe his way through trial and error around both specific objects and compositional inventions. Furthermore, the wider availability of paper stimulated the development of new techniques, and it is these which are the subject of Section I of the exhibition.

Despite the obvious practical attractions of paper, vellum continued in regular use throughout the century in North Italian workshops. This can at least partially be explained by regional differences in attitude towards the function of drawing. While experimentation with the new possibilities offered by paper, and with the wide range of techniques which it encouraged, seems to have appealed to Florentine draughtsmen, the tradition of highly

1A North Italian Draughtsman, *c.*1500, *Winged Female Figure.* Cambridge, Fitzwilliam Museum, 2622. Pen and ink, with wash and bodycolour, on parchment; 314×208 mm.

finished modelbook drawings persisted in North Italy, lending a conservatism to drawing practices and techniques there. Even at the end of the century and beyond, we find examples of vellum being used by North Italian draughtsmen, resulting in the incongruity of modern Renaissance forms described on a traditional, old-fashioned surface (I A, IV G).

According to Cennino Cennini the drawing medium to be mastered first by the studio assistant was silverpoint. The instrument itself was a stylus made of silver, often sharpened at both ends, one end finer than the other, to allow for some variation in line strength. The most renowned example of the appearance of such a stylus is seen in Rogier van der Weyden's *St Luke Drawing a Portrait of the Virgin* (IB). The technique demands great control and skill. The line made by the silverpoint is light, delicate and even. The point of the stylus is drawn over the prepared surface, whose texture scrapes off a fine deposit of silver: this rapidly oxidises, to leave the characteristic fine line, varying in colour from a soft grey to a dark greyish-yellow. The strength and width of the line is constant. By increasing pressure on the silverpoint, the draughtsman would only risk damaging the surface: to produce a thicker and darker line, he had to use the blunter end of his stylus. That the silverpoint line is indelible made precision even more necessary.

Cennini's recommendation was, therefore, based on entirely practical considerations. The controlled handling demanded by the instrument made silverpoint the perfect discipline for the trainee artist. Cennini also advocated that the apprentice should be set to work on a tablet of box or figwood, prepared with a coating of ground bone mixed in spittle, as appears to be shown in 3. Drawings made on this surface could be scraped off when no longer required, the tablet retextured and made ready for reuse. This clearly helped to keep down the workshop bills for paper and vellum, without sacrificing the students' opportunity for practice.

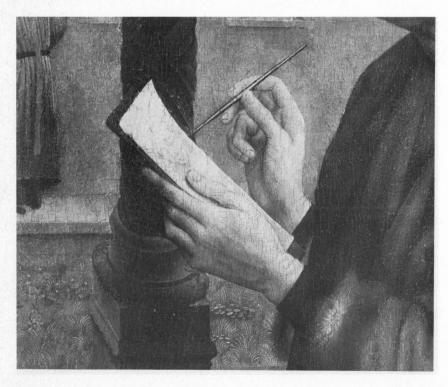

IB Rogier van der Weyden, *St Luke drawing a Portrait of the Virgin*, detail: hands of St Luke. Boston, Museum of Fine Arts, 93.153. Oil on panel; 138 × 111 cm.

Styluses were also made from other metals, such as copper, gold and lead, but silver was by far the most commonly used. Leadpoint, being an alloy of lead and tin, and therefore softer than other metal points, would mark untreated paper, but also blunted very easily and tended to be used only for very swift sketching, to be worked over in another medium. For all other styluses, however, the paper or vellum had to be specifically prepared to receive the metalpoint mark. These preparations were rather more sophisticated than the bone and spittle coating used on apprentices' tablets, comprising finely ground bone and white lead, coloured with an earth pigment and bound together with size. Several fine layers were carefully brushed on to the surface, to leave it smooth, even and delicately tinted (5,6 recto,7). Colouring the preparation provided the draughtsman with a third tone-value, midway between the silverpoint grey and the highlights which were added in a heightening of white pigment. In this way a rather more subtle description of the passage from light to shade, across an object or figure, could be made.

Because of the essentially linear nature of the medium, areas of shadow had to be indicated by hatching, and, where the shadow was deepest, cross-hatching. The most skilled metalpoint draughtsman developed the art of hatching to such a degree that, in some cases, it is difficult to believe that what we see is a series of extremely fine lines laid so closely beside each other that they have become imperceptible as individual units. It seems rather to be an area of subtly varied tone (5,29). Highlights, generally of a finely textured and pure white lead, were added with a brush in order to bring the drawing to completion. Where it has been laid on most thickly, the white lead has sometimes discoloured through oxidisation, resulting in blackish patches within the heightening, which distort the effect. When the heightening has been more thinly applied, the colour of the preparation can often be seen through the milky-whiteness of the highlight, creating an even fuller tonal range. Some silverpoint studies, such as 29, come close to tempera painting in both character and working method, and Cennini's comment that through silverpoint the artist 'discovers the entrance and gateway to painting' (Cennini/Thompson p.9), seems singularly appropriate. Heightening required deft handling, particularly when it was used for figures, and especially heads, for if applied too thickly it could disfigure rather than enhance the study.

The amount of care and labour that were necessary to produce a silverpoint drawing, from the preparation of the paper to the controlled handling of the stylus, and the delicacy of touch required for the addition of the heightening, meant that draughtsmen tended to reserve the use of silverpoint on paper for drawings that were carefully considered and immaculately executed. These were studies to be kept and treated with respect in the workshop portfolio. Later in the century, however, we do find cases of the technique being used in a more spontaneous way. An outstanding example of this is found in the work of Filippino Lippi, who, with seeming disregard for its conventional usage, employed both silverpoint and heightening with fluent ease in his studies of figures caught fleetingly in movement (7,38).

But silverpoint was obviously a far from perfect medium for sketching, or for making swift jottings of motifs or compositional ideas. As this type of study became increasingly important to the quattrocento draughtsman,

pen drawing emerged as the technique best fitted to respond to his new requirements. In the early part of the century, pen and ink had been used on vellum, and the combination of the absorbency of the surface and the ability of the quill to suggest a variety of textures, made for drawings of great character and attractiveness (1). But it was only when the pen was freed from the restraints of modelbook neatness that its full potential could be realised.

The quill pen (IC) is a much more versatile tool than the metalpoint. The nib can be cut in a great variety of ways, each affecting the nature of the marks produced. Its organic origins make it flexible, and susceptible to the character of the hand manipulating it. It responds to speed, hesitation, changes in direction and (perhaps most significantly) pressure, in a way that the silverpoint does not. But for these very reasons, as Cennini knew, pen drawing requires great skill, experience and control. The young artist would only be ready to use the pen after working exclusively in the prescribed silverpoint for the first year of his apprenticeship.

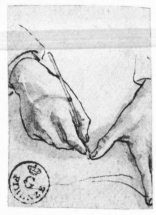

Paper did not have to be prepared to receive pen drawing, but sometimes artists would tint the surface by brushing on a coloured wash. This provided a middle tone equivalent to the preparation for silverpoint, and at the same time increased the attractiveness of the sheet. Benozzo Gozzoli favoured a reddish-pink wash (20,21), similar to that used by Pisanello (19), and one wonders whether he might have learned directly from the earlier draughtsman's example. Heightening was often added to such pen drawings, sometimes along with diluted ink, applied with a brush. This wash further extended the tonal range and indicated the strength and direction of light falling on the subject (10). The inks themselves were either made from carbon particles, which produced a strong black ink, or from a combination of the acids found in natural galls (such as oak apples) and ferrous sulphate, which gave the more usual dark brown ink.

IC Maso Finiguerra (?), *Study of a Draughtsman's Hands*. Florence, Uffizi, 86F. Pen and ink with wash on paper; 54 × 42 mm.

The quattrocento draughtsman regularly used the brush for the application of heightening and of wash in tonal pen and wash studies. But he seems to have regarded it as an auxiliary tool, to be used at a late stage in the drawing process, rather than as an important alternative instrument to extend his range of graphic techniques. Domenico Veneziano's brush drawings on blue paper (10a) are rare examples of what was, in the mid-quattrocento, a novel technique; but towards the end of the century, particularly in Domenico's native Venice, the interest in brush drawing increased (9,34,70). However, drawing with the brush generally seems to work less well in practice than it

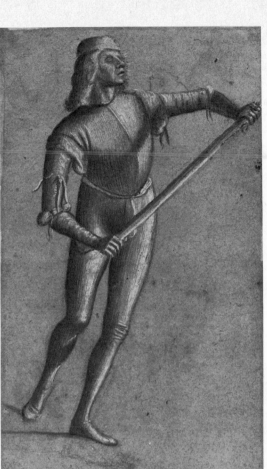

ID Vittore Carpaccio, *Study of a Gondoliere*. Boston, Isabella Stewart Gardner Museum. Brush, brown pigment and white heightening on faded blue paper; 254 × 149 mm.

promises in theory. The potential versatility of line and tone was seldom realised in drawings of this period, and even an artist of Carpaccio's standing tended to use his brush as though it were a stylus, producing outlines and minutely thin parallel brushstrokes of body colour and heightening, rather than areas of tonal modulation (ID). Many Venetian brush drawings are on the blue paper known as *carta azzurra* (9,70,ID). Originally manufactured in Arabia, this paper probably became known to Venetians through their trading connections with the East. Quite apart from the inherent attractiveness of its colour, it again provided the same mid-tone effect as did the coloured preparations for silverpoint, or the colour-tinted papers of Pisanello and Gozzoli.

At the beginning of the century, Cennini made brief mention of chalk as a drawing material, but in such a cursory way that we must suppose he had little or no personal experience of using it. The possibilities it offered in terms of tonal modulation probably did not occur to early quattrocento draughtsmen, whose preoccupations were with detail and linear precision. Not until the second half of the century, when artists started to develop an interest in the more sophisticated description of the internal modelling of form, did chalk become established as an important technique.

The two chalks most favoured were black and red, although white chalk was occasionally used for heightening. The breadth and directness of the medium enhanced the freedom and spontaneity with which it could be

used. Black chalk was extremely valuable for work on a large scale, particularly the preparation of cartoons for fresco decoration. Red chalk, being less friable, was more appropriate to smaller-scale, more detailed drawings. Black chalk had the greater tonal range but was more prone to crumble. A carbonaceous shale, its soft texture and fine consistency gave it a unique advantage over other drawing materials used at this date: the possibility of rendering changes in tone absolutely smoothly and continuously across an area of form (13). The breadth and subtlety of tonal modulation also meant that chalk could be used to create atmospheric effects, as forms seem to emerge from very soft, graduated shadows (72). It is surely not coincidental that its increased usage towards the end of the century lies parallel with the gradual decline in tempera painting, in favour of the broader, more atmospheric oil technique. Red chalk did not enjoy widespread popularity until

the sixteenth century. A clay base saturated with haematite, its warm colour is especially appropriate for use in studies of human expression, as in Fra Bartolommeo's tender study of the grieving Virgin (14). Perhaps its less extensive tonal range inhibited its full development alongside black chalk in the quattrocento, although Leonardo da Vinci, in his studies for the heads of the disciples for the *Last Supper* of the 1490s, demonstrated brilliantly the expressive capabilities of the medium (IE, VIG).

Charcoal, which also has the capability of breadth, was again well known to the fifteenth-century draughtsman. Cennini described the method of its preparation from willow-sticks, and advocated its use for preliminary compositional sketching. Its essential advantage was that it could be erased simply by using a feather to brush off the mark, so that second thoughts could be accommodated easily, an important consideration when working out a composition. But at the same time it tended to smudge, the brittleness

IE Leonardo da Vinci, *Study for the Head of St Bartholomew* (?). Windsor, Royal Library, 12548. Red chalk on reddened paper; 193 × 148 mm.

of the charcoal stick caused it to splinter easily, and it was too broad a medium to be used satisfactorily on small-scale surfaces. These factors, together with its impermanence, are perhaps the main reasons why the early quattrocento draughtsman did not explore its possibilities as an alternative to silverpoint or pen for drawing on vellum or paper. It was when drawing onto the wall or panel, as a preliminary guide for the more definitive underdrawing for a fresco or panel painting, that charcoal really came into its own. Cennini advised that, over his charcoal sketch, the panel painter should draw the outlines in ink applied with a brush. The fresco painter, on the other hand, employed the red pigment, sinoper, from which the term *sinopia*, meaning the underdrawing of a fresco, was derived.

Until the middle of the fifteenth century, these preparations were made freehand. The artist worked from small sketches, and particularly in the case of frescoes, where the increase in scale could be enormous, he organised the composition and placed figures by employing compasses, plumb-lines, and thick string dipped in sinoper. This was held taut and 'snapped' against the wall to leave vertical and horizontal lines of pigment, which would help him to plot his design across the wall. The *sinopia* was, of course, covered by the fine top layer of plaster (*intonaco*), into which the fresco was painted. Its purpose, therefore, was to act as a general guide, rather than a highly detailed specification for the composition. With the wider availability of paper, and the discovery of the potential of black chalk for working on a large scale, the cartoon was developed as a means of transferring a detailed design from drawing to the surface prepared for painting. Cartoons were full-scale drawings, often worked across a number of sheets of paper, which accurately represented the projected design of the finished work. They were made for whole compositions, as well as for individual, important figures, and were drawn up in great detail before being transferred. Cartoons had themselves often been scaled up from smaller drawings by means of squaring. This entailed superimposing a regularly measured grid over the small drawing, so that the artist could transfer the design precisely, square by square, onto a similarly marked up larger-scale surface (67). Once fully drawn up, the outlines of the cartoon were pricked through (11,13) with a sharp instrument, and ground charcoal was pounced through the pin-pricks onto the surface. Naturally, this type of usage caused substantial wear and tear: all the surviving large-scale cartoons from the fifteenth century are only fragments, and many others must have been in such poor condition that they would either have been destroyed or discarded.

The main advantage of the cartoon was that it provided a blueprint of the drawing which was covered as painting proceeded on the wall. It provided the artist with a means of checking details which had previously been lost beneath the *intonaco*. This not only freed the artist from the need to use stock figures, allowing him to produce in great detail a wide variety of individual types, but it also gave him the opportunity to use with confidence much more complex poses and spatial settings than he might otherwise have risked. The increase in the use of cartoons added substantially to the workshop's bill for paper, which, though ever more accessible, was still far from cheap. But offering such important advantages, it was clearly a worthwhile investment, and by the late quattrocento the cartoon was in widespread use, not only for frescoes but also for panel paintings (13,61) and embroideries (11).

1 GENTILE DA FABRIANO (?)
Christ and St Peter (recto) [colour plate 1]
Drapery Sketch (verso)

Edinburgh, National Gallery of Scotland, D2259
Pen and ink on vellum
182 × 129 mm.

Drawing on the more costly and less easily prepared vellum became increasingly rare as the century progressed, because of the rapid expansion of the paper industry during the quattrocento. The majority of drawings made on vellum come, therefore, from the earlier part of the century, like this sheet which is often associated with Gentile da Fabriano.

The stretched and prepared skin has a smooth and fine texture which creates a very attractive surface to work on. Its high absorbency makes it particularly suitable for pen drawing, permitting rich tonal modulation within what is an essentially linear medium. Here, for example, the internal modelling of the complex drapery folds, falling from St Peter's right sleeve, or over Christ's shoulder, was built up with great subtlety. The folds seem to be defined by shadows of varying intensity, rather than by linear means, as for example in the case of Parri Spinelli (27,49). These shadows are, in fact, built up from a series of relatively fine pen lines, each of which has become diffuse as the ink was absorbed into the skin. The result is extraordinarily effective. The outlines contrast with the tonal use of the pen in the fine, crisp definition of the contours, although in some places, most noticeably St Peter's feet, the outline has become rubbed and the form partially obliterated.

On the verso, a drapery sketch shows the same approach to shadow building, although here the lines are longer and more flowing, which creates a strong sense of the looping curves of the material. The distinctive qualities of the two sides of the vellum, 'hair' (recto) and 'flesh' (verso) can be clearly seen.

The draughtsman exploits the potential of the pen for suggesting a variety of textures. The heads of Christ and St Peter, for example, are treated quite differently. St Peter's bushy beard and short curly hair are a complex interwoven mass of mobile S-shaped pen marks, interspersed with small jabs of ink in the depths of the curls on his head. By contrast, Christ's hair is much less intensely worked and a lighter, less frenzied touch characterises the loose waviness of his locks, while his beard is no more than a few rapid ticks of the pen along the jaw.

A previous attribution to Ghiberti is perhaps understandable, in view of the strongly sculptural quality of the figures. However, another drawing on vellum, representing *St Paul* (1a), is in the same style and technique, and is also often attributed to Gentile da Fabriano. In both cases, the drapery style bears a marked resemblance to Gentile's panel of the *Madonna and Child with St Nicholas and St Catherine* in Berlin (1b).

BIBLIOGRAPHY:
Andrews 55
Degenhart and Schmitt 76 (as Umbrian, third quarter of fifteenth century)
K. Christiansen, *Gentile da Fabriano*, London 1982, CXV, pp. 143–144 (as Copy after Gentile da Fabriano(?))
Parker and Byam Shaw 4

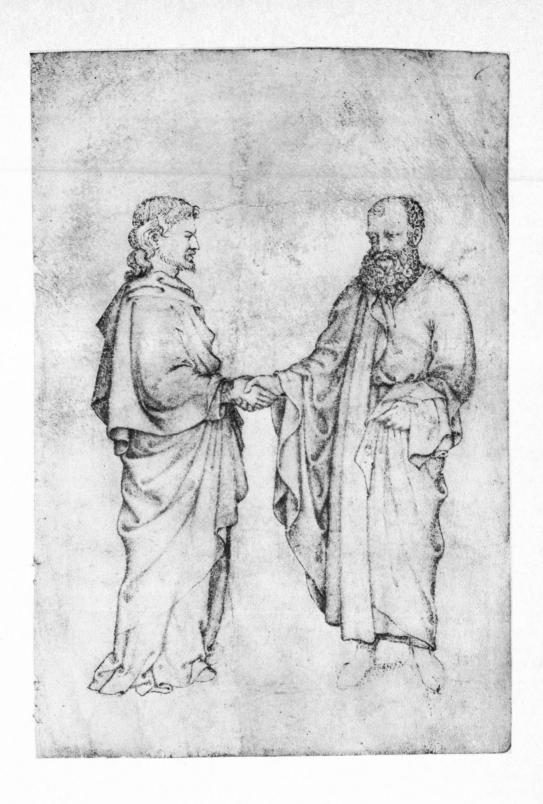

ABOVE 1b Gentile da
Fabriano, *Madonna and
Child with Saints and a Donor*.
Berlin, Gemäldegalerie,
1130. Tempera on panel;
131 × 113 cm.
BELOW 1a Gentile da
Fabriano (?), *St Paul*.
Berlin, Kupferstichkabinett,
5164 verso. Pen and ink on
parchment; 178 × 110 mm.

◁ 1 (verso)

2 ANTONIO PISANELLO
Rear View of a Boy with His Hands Held Behind His Back

Edinburgh, National Gallery of Scotland, D722
Pen and ink over faint traces of leadpoint, on paper
267 × 185 mm.

This is a very early example of the practice of drawing from a workshop
garzone or apprentice, which became standard later in the century (3,5,7,
10 etc.). It has been connected with Pisanello's fresco of *St George and the
Princess* for Sant'Anastasia, Verona, of the mid–late 1430s, in the background
of which a pair of hanged men dangle from the gallows (2a). But unlike his
other studies of this theme, which were obviously taken from hanging
corpses (2b), this drawing concentrates on a single figure, and has been set
up in the studio. One of Pisanello's assistants, posed as a hanged man, was
drawn from an angle similar to the figure on the upper right of 2b, although
actually standing on the ground.

Pisanello's swiftly moving pen line is confident and sure. Slight traces of a
leadpoint sketch guide him in the definition of the general outlines. The
anatomy of the back of the neck is described effectively, by short dashes of
the pen, organised into a shape that clarifies the bone and sinew structure
where the spine and tendons join the skull, and these contrast beautifully
with the freely moving curves which form the curls of the hair. The internal
modelling is rapid and varied, from repeated short ticks, hooks and S-curves,

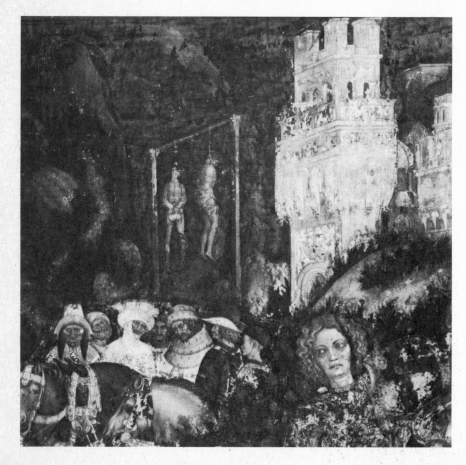

2a Antonio Pisanello,
St George and the Princess,
detail: left-hand side.
Verona, Sant' Anastasia,
Pellegrini Chapel. Fresco on
wall.

2 ▷

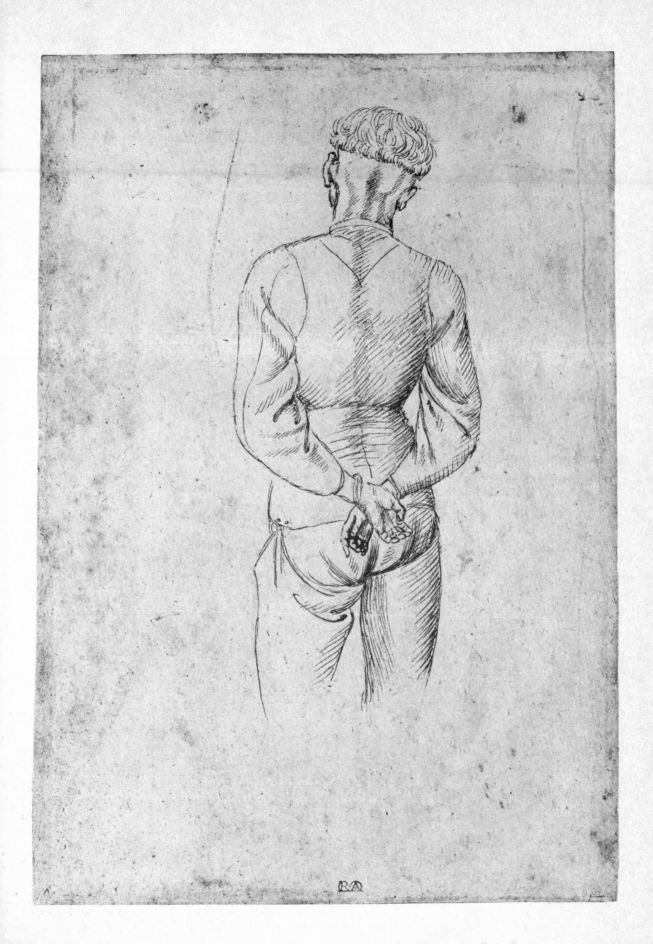

which describe the movement of the drapery on the left sleeve, for example, to the long, wispy strokes like those running down the inside right thigh. These denote a whole area of shade, and at the same time describe the nature of the fabric of the hose, and the general direction in which it is pulled. The same type of hatching is used to similar effect on the right sleeve. Areas of deeper shadow are created by an intensification of the hatching lines, and by the greater pressure applied to the pen, as we can see at the right of the waist, or where the material bunches at the buttocks as the leggings gather it in. Cross-hatchings, on the underside of the right sleeve and at the right buttock, also vary the quality of the modelling and suggest a more intense shadow. Compared with 1, the range and freedom of the movements of the pen, and of the effects achieved, is very great. Pisanello's versatile handling of the pen demonstrates in this drawing the wide range of possibilities inherent in the organic flexibility of the quill.

2b Antonio Pisanello, *Studies of Hanged Men*. London, British Museum, 1895–9–15–441. Pen and ink on paper; 283 × 193 mm.

BIBLIOGRAPHY:
Andrews 96
B. Degenhart and A. Schmitt, 'Gentile da Fabriano in Rom und die Anfänge der Antikerstudiums', *Münchner Jahrbuch für Bildenden Kunst* XI, 1960, pp.67, 137 n.30, 139 n.31
Fossi Todorow 82, pp.91–92
A.E. Popham in *Old Master Drawings* XI, 1937, p.66, pl.64

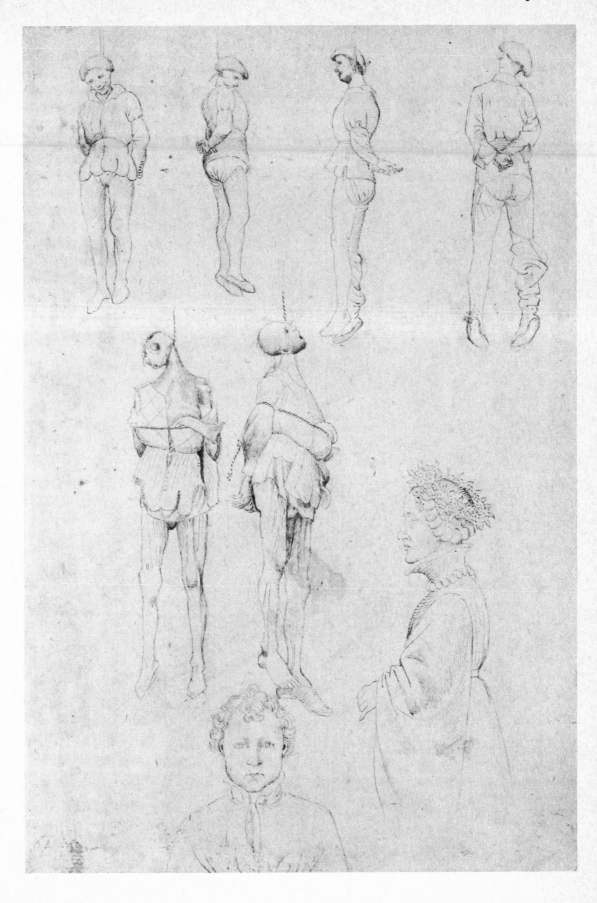

3 WORKSHOP OF MASO FINIGUERRA (?)
Seated Youth Drawing (recto)
Standing Youth (verso)

London, British Museum, 1895–9–15–440
Pen and ink, with wash, on paper
192 × 114 mm.

The *garzone* study on the recto of this sheet is interesting for a number of reasons. Firstly it demonstrates a particular handling of the pen, which may well be associated with the engravers whose studios were springing up in Florence around 1450–60. The work of one such craftsman, Maso Finiguerra, characterises the range of activities taking place in the engraver's workshop, which may help to determine the function of the type of drawing we see here. Finiguerra's origins were in goldsmithery, but he went on to develop a technique for making prints from *nielli*, silver plaques on which engraved lines were filled with a black sulphur compound (3b). The penline contour

3a Workshop of Maso Finiguerra, *Seated Youth Drawing*.
Florence, Uffizi, 120F recto.
Pen and ink with wash on paper; 180 × 120 mm.

3 (recto) ▷

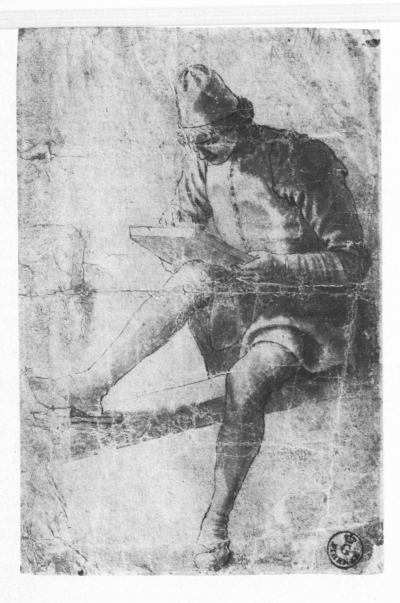

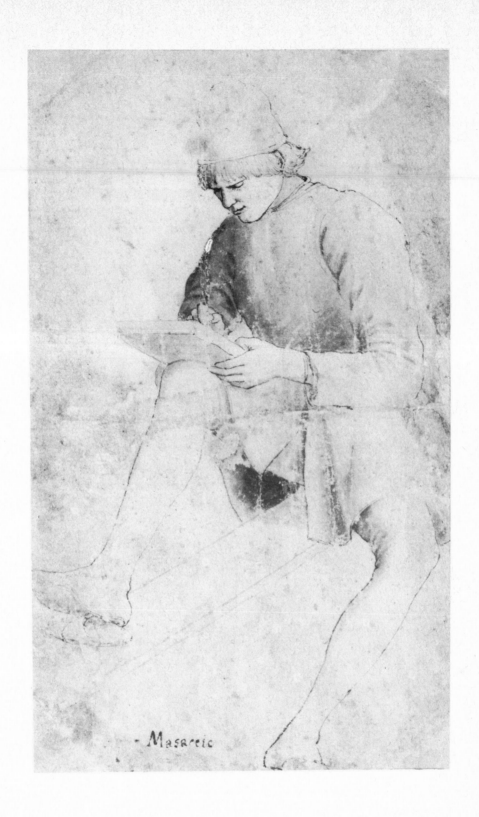

Masaccio

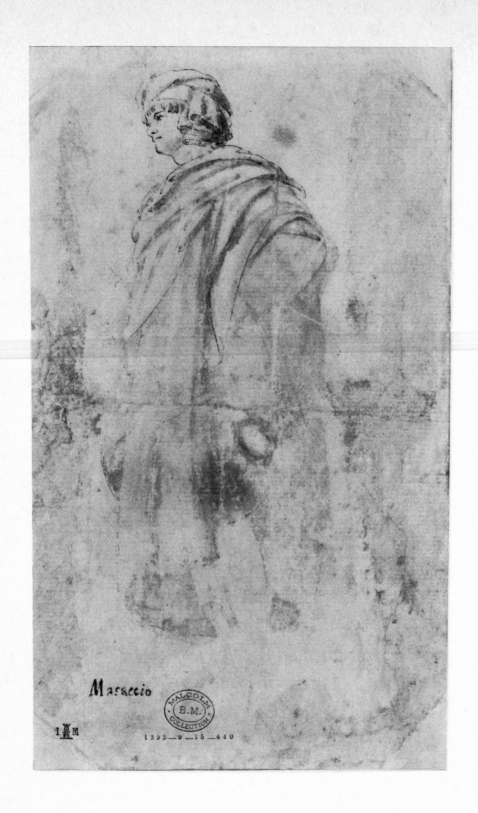

Masaccio

1895—9—15—440

3b Maso Finiguerra (?),
Coronation of the Virgin.
Florence, Bargello.
Niello plaque.

◁ 3 (verso)

which encloses the form in a drawing such as this seems analogous with the *niello*-print technique. In fact, the contour here is relatively uninformative, but the use of wash, added with the brush in a subtly varied manner, brings out the structure of certain areas, such as the torso and the arms.

Another interesting aspect of the recto is its subject. The seated youth has been described as writing, but he is probably drawing with a silverpoint on a prepared wooden tablet. Cennino Cennini had advocated silverpoint drawing on a boxwood tablet as the most rigorous training for a young draughtsman, since the technique demanded forethought, discipline and precision. Throughout the century, Florentine masters set their pupils to work in the way depicted here. This *garzone* study is closely linked to a sheet in the Uffizi (3a). The two drawings are clearly inter-related, but the quality of neither is high enough to make it clear which preceded the other. Indeed since the pose and lighting differ somewhat between them, they are more probably drawings made by two different assistants working from the same model at much the same time.

The brief drawing on the verso is a still weaker study of a standing figure. The technique is similar, but laboured, fading out below the waist. The old attribution to Masaccio inscribed on both sides of the sheet cannot, of course, be taken seriously.

BIBLIOGRAPHY:
Popham and Pouncey 278 (as Florentine, third quarter of the fifteenth century)
Berenson 1944C (as Antonio Pollaiuolo school)
Degenhart and Schmitt 1–2 p.427, figs.572–3 (as Florentine, mid-fifteenth century)

4 WORKSHOP OF MASO FINIGUERRA (?)
Youth Brandishing a Cutlass

Truro, Royal Institution of Cornwall
Pen and ink on irregularly cut paper with a slight brown wash
177 × 90 mm. (maximum dimensions)

A characteristic of figure studies produced by *niello* engravers is the use of a simple pen and ink outline. As in 3, the fluent, but not very expressive contour suggests that it can perhaps be associated with the circle of Maso Finiguerra, or another of the Florentine *niello* workers; indeed, this figure reappears, in reverse, as the executioner in a *niello* print of the *Judgment of Solomon* (4a). By comparison with the pen drawing of Antonio Pollaiuolo

(37a), to whose workshop this study has also been attributed, the line lacks vitality. The combination of the raised right arm, with its easily sketched information about the sleeve fastening and elbow gathering, and the internal movement of the folds, does however help to convey a sense of the movement of the arm beneath the drapery. Other areas, such as the legs and the feet, are much less competent, and the unbroken contour almost appears to be a traced outline. The anatomy is less than perfectly understood, in particular the way in which the right leg and buttock are joined.

It is possible that this drawing was copied from a workshop exemplar as was 37, which would explain the rather mechanical treatment of parts of the form, but it is more probably a drawing made directly from a workshop *garzone*.

LEFT 4a Maso Finiguerra (?), *The Judgment of Solomon*. Berlin, Kupferstichkabinett. *Niello* print, 69 × 51 mm.

4 ▷

BIBLIOGRAPHY:
Degenhart and Schmitt 1-2 p.616, fig.900 (as 'Finiguerra-gruppe')
G. Penrose, *Catalogue of Paintings, Drawings and Miniatures in the Alfred de Pass Collection*, Truro 1936, no.185
A.E. Popham, *Drawings from the de Pass Collection*, London (Arts Council) 1957, no.16, p.9

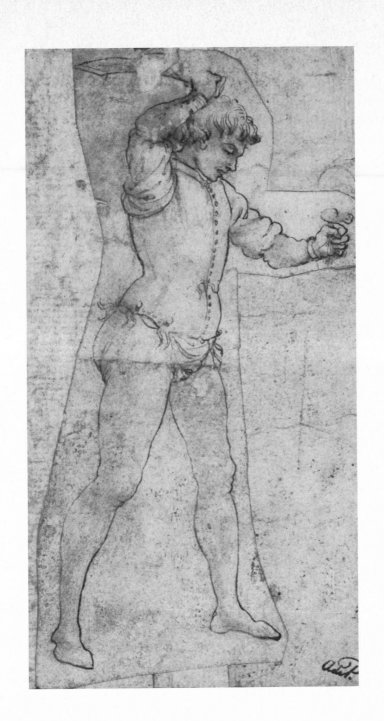

5 FRANCESCO GRANACCI (?) AND DAVIDE GHIRLANDAIO (?)
Four Draped Figures

Chatsworth, Devonshire Collection, 962 A, B and C
Silverpoint and white heightening on a variety of coloured prepared papers
A: 215 × 138 mm., B: 206 × 150 mm., C: 205 × 309 mm.
Mounted together by Vasari for his *Libro de' Disegni* with his attribution to
Luca della Robbia

These three sheets demonstrate well the traditional range of silverpoint techniques in the vocabulary of the late quattrocento Florentine draughts-man. The silverpoint contours are delicate, accurate and assured. Precision was essential, for the line of oxidised silver, deposited onto the preparation, was indelible. Consequently, the outlines are very controlled, and admirably suited to the task of depicting the calm and relaxed poses of these models. The inherently limited tonal range of the silverpoint itself caused draughts-men to explore different methods of creating tonal contrasts. Hatchings and cross-hatchings on the nearside of these figures, all of whom are lit from the left, describe the shadows which model the heavy folds of the drapery. These are tonally graduated by the variety of hatchings adopted. On the figure at the bottom right, for example, the hatching ranges from a series of swift, horizontal ticks across the lower part of the drapery which falls down over the arm, to painstakingly organised, fine diagonal lines placed parallel to each other. In the deepest recesses of the folds, these are spaced so closely that they become virtually indistinguishable as individual lines, and rather suggest an area of tone equivalent to a coloured wash. This can be seen to great effect in the long V-shaped shadow under the drapery gathered in the model's left hand.

Having created a tonal way of dealing with shadow, the draughtsman used the traditional white heightening to describe the highlights. The pig-ment was well diluted and applied fluently with a brush. The heightening was used not simply to describe highlights but was, in places, also employed to define the contour. The centre-right edge of the cloak worn by the seated figure at the bottom left is delineated entirely by a swift brushline of heightening, indicating that the light catches the fabric along its full length. The standing figure on the upper left also depends largely on this effect and, across much of the form, has been treated virtually as pure brush drawing. The tonal range of silverpoint drawing was further extended by the employ-ment of the pigmented paper in an active role. The coloured preparation of the paper provided a middle tone-value, between the grey of the silverpoint mark and the white heightening.

The draped figure posed in the workshop was a common subject for study in mid- to late-quattrocento Florence (Section III). The free handling and exploratory nature of these studies perhaps suggest that, rather than being model drawings to be preserved in the workshop portfolio for later reference and use, these drawings were made in silverpoint to preserve a record of the draughtsman's developing skill in handling the draped figure.

BIBLIOGRAPHY:
Berenson 906C (only lists 962C, as Francesco Granacci)
L. Collobi Ragghianti, *Il Libro de' Disegni del Vasari*, Florence 1974, p.45, fig.62
O. Kurz, 'Giorgio Vasari's "Libro de' Disegni"', *Old Master Drawings* XII, 1937–38, p.9
Ragghianti and Dalli Regoli 144–146, pp.120–121

LVCA DELLA ROBBIA SCVLT.

6 WORKSHOP OF ANDREA DEL VERROCCHIO
A Standing Bishop and Studies of Heads (recto)
Miscellaneous Sketches (verso)

Edinburgh, National Gallery of Scotland, D642
Silverpoint, pen and brown ink with wash, on pink prepared paper (recto)
Pen and wash on unprepared paper (verso)
285 × 201 mm.

The quality of the silverpoint figure-study of a standing bishop, on the recto, is somewhat distorted by the overlay of wash which may be a later addition. The brushwork is relatively free on the head and neck, but becomes more laboured on the lower part of the form, with rather angular brushstrokes unconvincingly shaping the drapery folds. As a result the figure is satisfactorily built up but completely lacks vitality. Beneath the wash, however, lies a highly accomplished study, demonstrating an immaculate control of the silverpoint. Neat and clear contours were drawn round the forms and the drapery folds, and fluent gradations of shadow were built up through almost imperceptible silverpoint hatching.

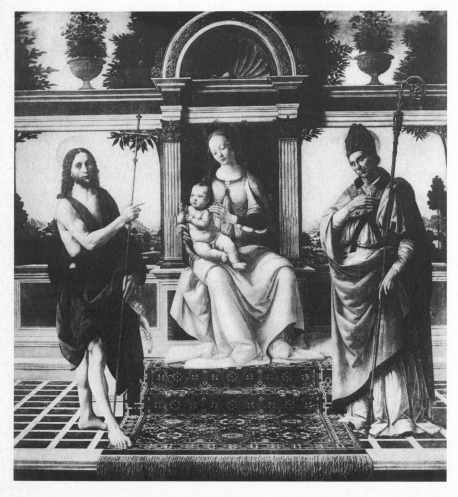

LEFT 6a Andrea del
Verrocchio and workshop,
*Virgin and Child with St John
and St Donatus*.
Pistoia, Duomo,
Oil on panel; 189 × 191 cm.

6 (recto) ▷

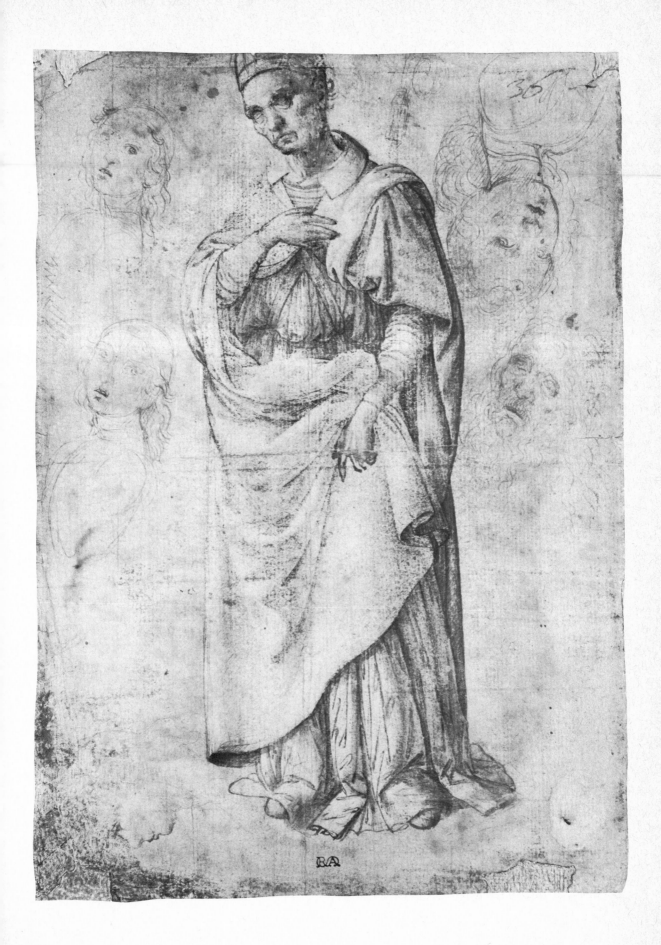

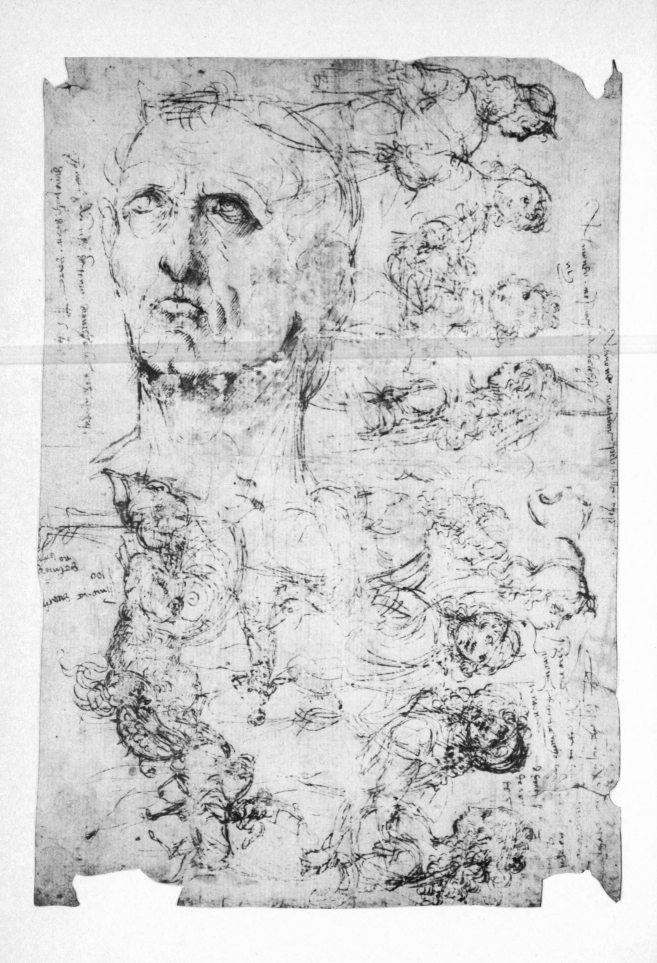

◁6(verso) The figure corresponds with that of St Donatus on the right of an altarpiece in the cathedral at Pistoia (6a). Commissioned from Verrocchio, probably in 1475, the Pistoia Altarpiece seems to have been executed in his shop under the guidance of Lorenzo di Credi, which strengthens that master's association with this sheet of studies. All the liveliness and freshness of handling, which is disguised in the figure of the bishop, is visible in the brief studies of heads repeated in silverpoint around the edges of the sheet. At least three of them appear to be quick sketches, probably from a workshop *garzone*; the fifth is an equally direct sketch of an aged man. These sketches show a strong feeling for the linear delicacy of the silverpoint, and demonstrate the draughtsman's finesse of touch.

The verso has no preparation and is almost entirely covered with pen and wash studies. Most of the drawings here are compositional sketches, loosely reminiscent of the type of rapid figure groupings that Leonardo da Vinci made when working out a composition. This, and the general similarity between the sheet and the so-called 'Verrocchio sketchbook' of Francesco di Simone (25), bind the verso firmly to the Verrocchio workshop in which Lorenzo di Credi, Francesco di Simone and Leonardo da Vinci were all pupils.

Although Andrews suggests that the features of the massive male head on the verso are identical to those of the model for the bishop on the recto, the character of this study seems to suggest a classical model. But there is an obvious connection between the repeated silverpoint study of the youth's head, turning outwards over his shoulder, on the recto, and the figures of youths in the compositional studies on the verso. General similarities of the figure types, such as these, may suggest that we should recognise the hand of one artist working in two very different ways. He has prepared one side of the paper to receive a very carefully considered silverpoint study, economised on paper by using the edges to practise the turning figure for another composition, and used a different medium on the verso for very rapid jottings of various figures and groupings.

BIBLIOGRAPHY
Andrews 43 (as Lorenzo di Credi)
G. Dalli Regoli, *Lorenzo di Credi*, Pisa 1966, 52 (as Lorenzo di Credi)
G. Gronau, 'Über das sogennante Skizzenbuch des Verrocchio', *Jahrbuch der Königlich Preussischen Kunstsammlungen* XVII, 1896, p.65
Parker and Byam Shaw 33 (as school of Verrocchio)

7 FILIPPINO LIPPI
Study of a Litter-bearer [colour plate 2]

Oxford, Christ Church, 0017
Silverpoint, with white heightening, on pink prepared paper
180×132 mm.

Seldom was silverpoint handled so spontaneously, yet so accurately, as in this beautiful study which demonstrates Filippino Lippi's exceptional skill in the control of the stylus. To allow his hand to move so fleetingly over the paper, and at the same time to produce so convincingly a representation of form in movement, required both courage and confidence. The easy fluency with which his silverpoint sketched the contours has more in common with Pollaiuolo's use of the pen (39), than with the silverpoint handling of his contemporaries, such as Lorenzo di Credi (40), or even the younger Francesco Granacci (5). A possible explanation for this unusual handling is that Filippino was so firmly rooted in the traditions of the Florentine painter's workshop, where silverpoint drawing was very much a central convention, that he still chose to use silverpoint even for a type of rapid sketching apparently quite incompatible with the range of accepted possibilities offered by the technique. Filippino here employs the traditional method to flout tradition, using the silverpoint with unprecedented flexibility and bravura. The fact that the *garzone* could not hold such an unstable pose for long was a very practical consideration governing the speed and vigour of the handling. The hatching across the thighs, right arm, shoulder and face was rapidly applied with a very positive, incisive touch, and this, together with the brief flecks of white heightening, enhances the fluency of the pose and effectively describes the swiftly changing movement of the model. The

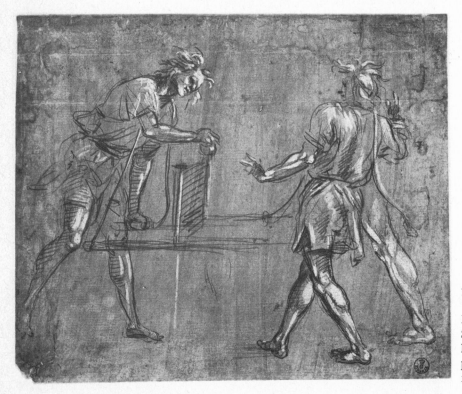

7a Filippino Lippi, *Study of Two Litter-bearers*. Florence, Uffizi, 185E. Silverpoint, with white heightening, on pink prepared paper; 185×240 mm.

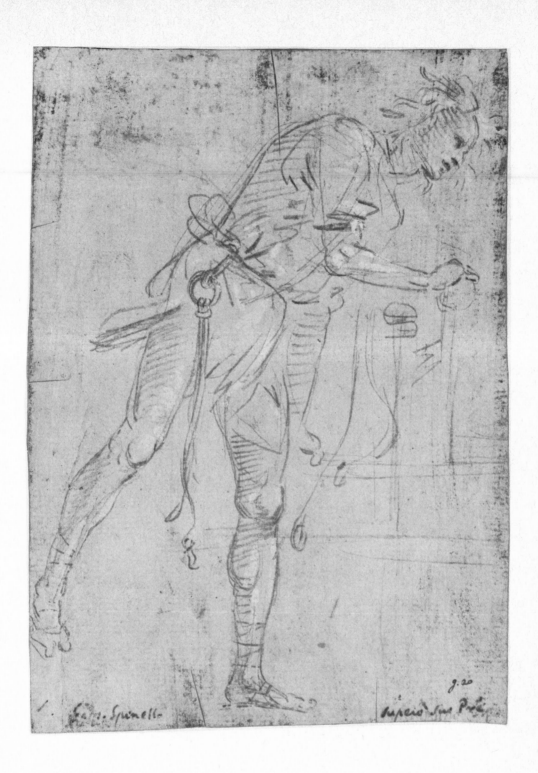

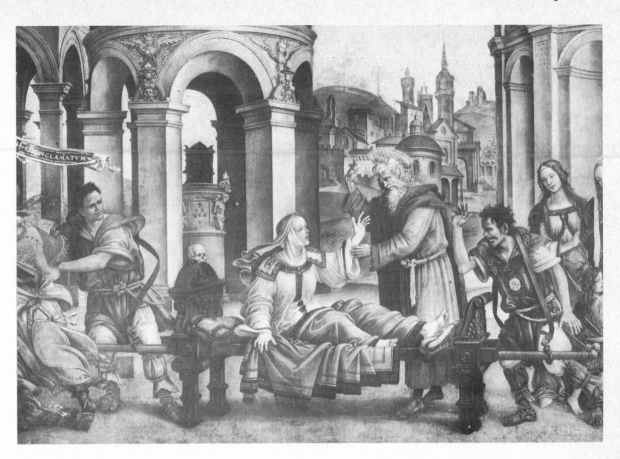

7b Filippino Lippi, *The Raising of Drusiana*, detail: central group. Florence, Santa Maria Novella, Strozzi Chapel. Fresco on wall.

draughtsman takes full advantage of the dramatic contrast offered by the limited range of tone-values possible in such a sketch. White highlights touch legs, arms and face lightly, confidently indicating the fall of light from the right, with abrupt but vividly effective contrast.

This drawing, and another in the Uffizi (7a), appear to be Filippino's early thoughts for the figures carrying the litter, on which Drusiana lies, in the fresco of the *Raising of Drusiana* in the Strozzi Chapel, Santa Maria Novella, Florence (7b). However, the figures finally painted in the fresco bear little direct relationship to either of these drawings.

BIBLIOGRAPHY:
Byam Shaw 35
Berenson 1354
Scharf 237

8 LEONARDO DA VINCI
Study of a Bear's Head [colour plate 3]

Private collection
Silverpoint on pale pink prepared paper
70×70 mm. (maximum dimensions)

Leonardo da Vinci, like Filippino Lippi (7), was no respecter of convention in the use of his drawing materials. The silverpoint here is handled with the graphic freedom and variety of a modern lead pencil. But whereas Filippino defied the technical capabilities of silverpoint to match and enhance the dynamism of his subject with a new rapidity of handling, Leonardo demonstrates in this little study his ability to bring hitherto unparalleled variety to the traditionally inflexible silverpoint technique.

He began by swiftly sketching the basic shape of the bear's head with a broken wavy outline, which is left unadorned to stand as the full description of the animal's crown and ears. On the muzzle, however, he worked over this rapid guide, delineating more firmly the contour of the forehead, snout and jawline. The internal modelling of this area is subtly characterised by such finely controlled hatching that the effect is purely tonal, and the complex facial structure is defined entirely in terms of light and shade, without the introduction of any heightening. Leonardo's ability to bend the technique to suit his needs is well seen in the sophisticated modulation of tone around the eye, the sensitive handling of which heightens the fine expression of the creature.

The differentiation in the texture of the fur on the animal's head and its neck is clearly stated by a further alteration in the character of the stylus mark. For the finer, short fur on its forehead a rapid, widely spaced series of ticks which follow the shape of the anatomy is used, while longer, more densely grouped, and more intensely worked, flowing lines describe with great accuracy the thicker, tousled coat around the ears and neck.

BIBLIOGRAPHY:
Berenson 1044C
A.E. Popham, 'The Drawings at the Burlington Fine Arts Club', *Burlington Magazine* LXX, 1937, p.87
A.E. Popham, *The Drawings of Leonardo da Vinci*, London 1946, 78A

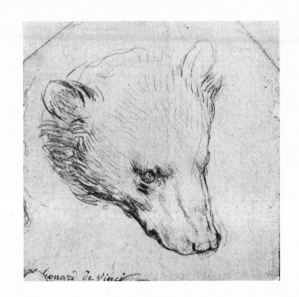

9 BARTOLOMMEO MONTAGNA
Figure of a Standing Crowned Man [*colour plate 4*]

Oxford, Ashmolean Museum, KP 25
Brush and blue watercolour, heightened with white, on blue paper
264 × 141 mm.

Brush drawing with watercolour onto blue paper (*carta azzurra*) had become very much part of the Venetian tradition by the end of the fifteenth century. In this sheet, Montagna seems to have been concerned to exploit the potential qualities of the brush. Light, pliant strokes delineate the contours in a manner that is suggestive of the forms, such as the slightly angular, scooped shapes which describe the creases of the boots, or the rhythmic peaking of the line which defines the edge of the cloak gathered up across the body with the left hand. Within these contours, the forms were carefully built up using soft, feathery striations of colour and white heightening, reminiscent of Carpaccio's handling (34), to show the structure of the torso and legs. The same technique is rather more loosely applied to describe the deep shadows under the mantle; and in some passages a lighter wash, not unlike that used in the Bellini workshop (33), was more broadly added. Modelling was built up by hatching and cross-hatching, with deeper-toned watercolour in the heavy pockets of shadow to either side of the figure's waist. Ultimately, however, the limitations of Montagna's technical control and his acceptance of the conventions of brush-drawing technique are evident in his insistence on the linear hatching in the legs and corselet, where a broader, tonally graduated effect would have been both possible and eminently more effective.

The brush-drawn lines which frame the figure on three sides indicate that, as was the case in a high proportion of surviving North Italian drawings of the fifteenth century, this sheet was made in connection with a specific project. The low viewpoint and the military bearing suggest that it might be a study for a ruler, such as Alexander the Great, or Constantine, for a series of *Famous Men*: but no evidence of Montagna's involvement in such a project now survives.

BIBLIOGRAPHY:
Parker 25
K.T. Parker, in *Old Master Drawings* IX, 1934, p.8, pl.9
K.T. Parker, *Disegni Veneti di Oxford*, Venice 1958, 9
L. Puppi, *Bartolommeo Montagna*, Venice 1962, p.149

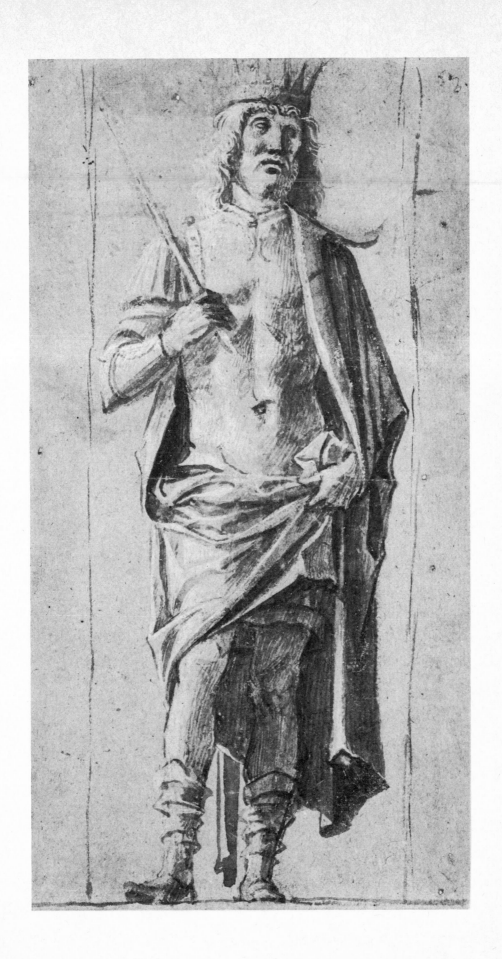

10 FLORENTINE DRAUGHTSMAN, c.1460
Youth Fastening His Hose

Oxford, Christ Church, 0052
Pen and ink, with wash and white heightening, on blue paper
223 × 104 mm.

A small group of Florentine mid-quattrocento drawings was made on blue paper, a surface more often associated with Venetian draughtsmen later in the century. The handling of this drawing is, indeed, closer to the Venetian manner of brush drawing (9,34) than to contemporary Florentine techniques. The timid pen lines serve little function beyond providing outlines to be 'filled in' with white heightening and coloured wash; but otherwise the character of the drawing depends on the brushwork. This is particularly true of the addition of the white heightening: the movement of the thick, well-loaded brush over the figure's right thigh and left arm adds a sense of energy found neither in the drawing of the contours, nor in the relatively cursory representation of internal form. Most effectively rendered, perhaps, is the play of light and shade over the angularities of the facial features. The form and structure of the wide cheekbone, the eyesocket, and the short sharp chin are keenly and spontaneously implied, by swift dabs of white against the light grey wash and the colour of the paper, which tints the heightening a pale blue where it is most thinly applied.

The draughtsman was clearly attempting to take advantage of the tone of the blue surface, just as the silverpoint artist used his coloured preparation. However, the heightening is often too thickly applied for the effect to be entirely successful, and the overall impression is of a slight tonal imbalance. In a series of drawings made in the Florentine workshop of Domenico Veneziano (10a), similar blue paper is used to extend the tonal range rather

10a Workshop of Domenico Veneziano, *Studies of Three Figures*. Paris, Louvre, 2688. Brush and brown pigment with white heightening, on blue paper; 183 × 324 mm.

10 ▷

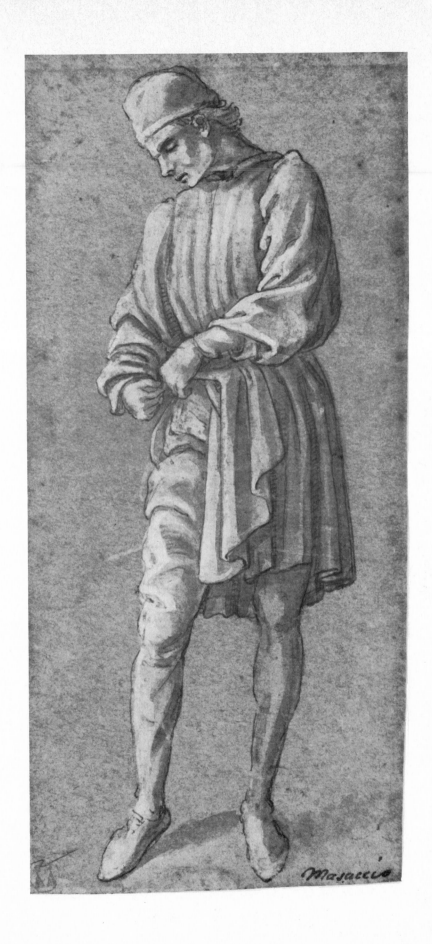

more effectively. The coloured wash, on the other hand, is generally more thinly applied, and on the left leg we can see an awareness of this interplay between medium and surface, as shin and kneecap are caught in the half-light described by the mid-tone of the paper colour.

This pen and wash technique is necessarily less spontaneous than the vigorous pen technique of Pollaiuolo (39), since the form is built up in three consecutive stages: outline drawing, coloured wash and white heightening. However, it can provide a fuller tonal description to increase both the flow of the design and the sense of volume, although here rhythmic characterisation of the form is rather impeded by the heavy-handed heightening.

BIBLIOGRAPHY:
Byam Shaw 6
Degenhart and Schmitt 1–2, p.430, fig.582

11 RAFFAELLINO DEL GARBO
Angel of the Annunciation

Rugby, Rugby School
Pen and ink on paper, with pink wash and touches of white heightening, over
black chalk: pricked for transfer
115 × 146 mm. (irregularly cut, maximum dimensions)

According to Vasari, Raffaellino del Garbo could not sustain the promise of
his youth and, as his art grew increasingly mediocre, he was reduced to
making a living by designing cartoons for embroidery, the only field in
which he could maintain a decent standard. Compared with other em-
broidery cartoons attributed to him (11a, 11b, V G), this example has been

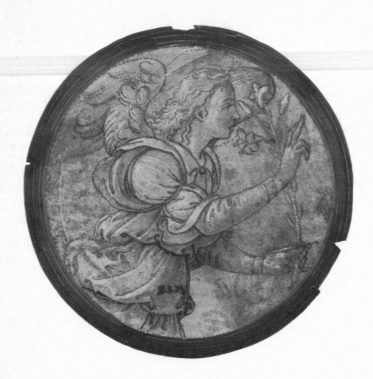

heavily worked over with wash and heightening, and the chalk outlines have
been redrawn with pen and ink. However, an examination of the verso
(11c), on which we can clearly see the pricked outlines where the contours
were transferred onto the fabric to be worked, reveals something of the
lightness and delicacy of the original chalk drawing.

 This sheet was probably used as a cartoon while still only a chalk drawing,
for the pen-drawn wings are continuous across the original framing arc
behind the figure, whereas the prick marks and chalk lines are confined
within it. This suggests that, after use in the transfer process, the cartoon was
repaired and worked over with pen and ink, wash and heightening, probably
to provide the embroiderers with clear, unambiguous instructions about the
important outlines, and to guide them in their choice of threads by describ-
ing as full a tonal range as possible. Why both the halo and the horizontal

11a Raffaellino del Garbo,
Angel of the Annunciation.
New York, Metropolitan
Museum of Art, Rogers
Fund, 12.56.5a. Pen and ink,
with white heightening, on
buff paper; diameter 90 mm.

11 ▷

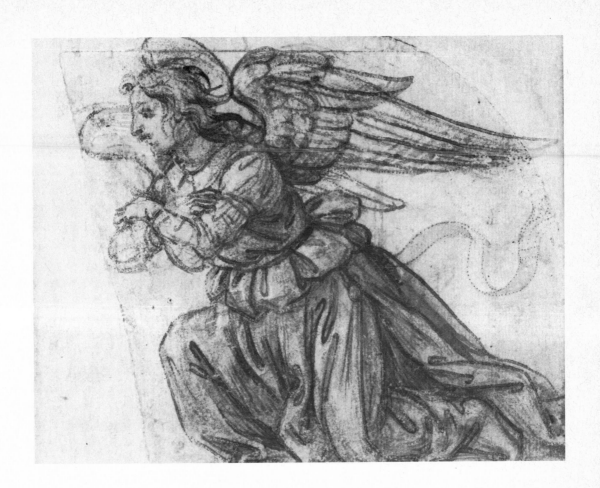

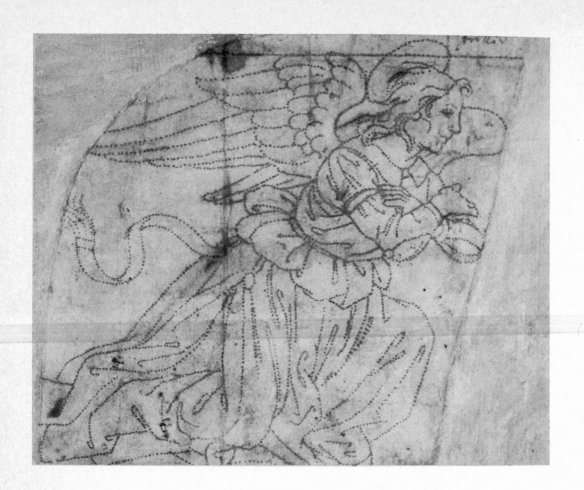

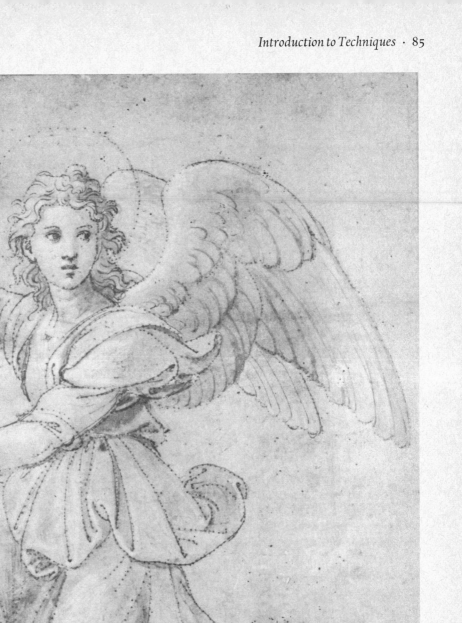

ABOVE 11b Raffaellino del Garbo, *Kneeling Angel*. Haarlem, Teylers Museum, A.32. Pen and ink with wash on paper, pricked for transfer; 215 × 189 mm.

LEFT 11c Raffaellino del Garbo, *Angel of the Annunciation*. Verso of 11. Rugby, Rugby School.

line bisecting it have been pricked through is, however, difficult to explain, unless the cartoon was used more than once and on one occasion had to be curtailed at the top edge.

BIBLIOGRAPHY:
Anne Popham, *The Bloxam Collection of Drawings, Rugby School* (Typescript, London, n.d. (ca.1938)) f.2

A. Schmarzow, 'Aus dem Kunstmuseum des Schule zu Rugby', *Jahrbuch der Königlich Preussischen Kunstsammlungen* IX, 1888, pp.132–6

12 PIETRO PERUGINO
Studies for Figures in an Adoration of the Magi
(recto and verso)

Oxford, Ashmolean Museum, KP 29
Black chalk on paper, recto strengthened with pen and ink
298 × 186 mm.

The delicacy of expression and handling of the black chalk in these studies is characteristic of Perugino's draughtsmanship. He does not seem concerned to take advantage of the tonal value of chalk, but rather uses it in a linear way, the result seeming closer to silverpoint than the softer, broader medium. Form is indicated by a delicate network of hatchings and cross-hatchings, rather than by the smooth blending of tones across an area of shadow, although the use of the broad side of the chalk stick to achieve this effect is one of the essential artistic benefits of the medium. Perugino does, however, exploit the greater flexibility of chalk, by varying the thickness and tonal strength of the line. The sweeping contours of the hat worn by the model on the recto, or the strengthening of the form of the left forearm of the figure on the verso, contrast with the generally low-key effect of the chalk lines. The soft, light handling may in fact explain why Perugino worked in pen and ink over some of the contours, and especially the facial features, of the figure on the recto. However disconcerting the contrast between chalk and pen lines may be, this is a way of asserting a greater confidence and firmness of expression.

These studies may have been associated with the preparatory work for the fresco of the *Adoration of the Magi*, which Perugino painted in the Oratorio dei Bianchi at Città della Pieve in 1504 (12a). They are characteristic of a large number of figure studies made in his studio from *garzone* models.

BIBLIOGRAPHY:
Parker 29
Fischel 86–87, pls.152–153

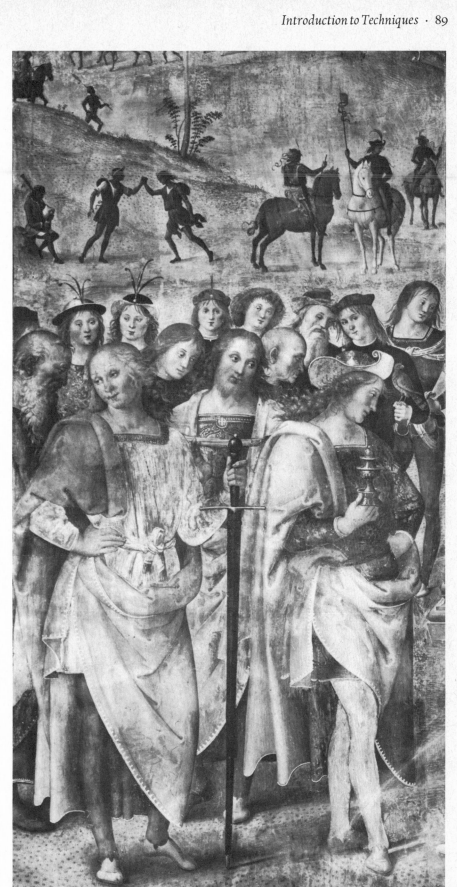

RIGHT 12a Pietro Perugino,
Adoration of the Magi, detail:
figures at left.
Città della Pieve, Oratorio
dei Bianchi. Fresco on wall.

◁ 12 (verso)

13 LUCA SIGNORELLI
Study of a Youth

Liverpool, Walker Art Gallery
Black chalk with white heightening, oxidised in places and perhaps retouched, on paper
410×215 mm.

This drawing shows well a number of characteristics of Signorelli's working procedure. It is a very large drawing for its type, and is both pricked through for transfer and squared up for enlargement. The pricking indicates that it was used as the full-scale cartoon for a specific painted figure which has not, however, been identified. The chalk grid seems to have been superimposed over the drawing of the figure, for where a passage of white heightening and the squaring coincide, for example, on the figure's forehead, the chalk line clearly lies over the area of heightening. This indicates that the drawing was reused at some stage on a different scale, the squaring acting as a guide to the artist in the transfer and enlarging process.

Having made his drawing from a *garzone* posed in the studio, Signorelli went on to contemplate both alterations, for example to the position of the left hand, and additions, such as the lightly sketched tunic and the equally brief extension of the right sleeve. Although the hand seems to have been redrawn before the study was first used, the costume adaptations probably belong to a later reuse of the pose, perhaps that for which the squaring was employed.

The skill with which the artist handles his medium here is exceptional. The fine, soft consistency of the chalk allows him the freedom and versatility of line and modelling alike. The outlines were first lightly sketched, re-inforced with a firmer (but still fluent) line, and then further intensified as the artist worked over his drawing, accenting the key points, such as the springy muscles in the right calf, or the strongly articulated profile. Areas of decorative embellishment, such as the drapery which falls back from the wrist, the head-dress, or the central seam on the tunic remain lightly handled.

The relationship between outline and internal modelling is extremely subtle and sophisticated. In the head, for example, the shadow across the neck was laid on broadly and was apparently rubbed a little to create a sense of its continuity. Over this the fluent, confident lines of the ear, jaw and neck tendons are reinforced with more incisive chalk marks. The overlay of fine lines onto a broad tonal area is also seen to magnificent effect in the handling of the hair, where rich, loose curls seem to spring freely from the thick weight of the mass of shoulder-length hair beneath. The hatchings and cross-hatchings across the body are applied in the same way over a tonal area of chalk, and the free, nervous movement of some of these, particularly in the legs, increases the sense of flexing in the muscle structure. The white wash which was applied freely and fluently must have originally given a subtlety in the lights equivalent to that of the chalk shadows.

BIBLIOGRAPHY:
Berenson 2509E, 12
M. Evans, 'A Signorelli Drawing for Liverpool', *Burlington Magazine* CXXIII, 1981, p.440
Parker and Byam Shaw 28, pl.6
A. Scharf in *Old Master Drawings* XIV, 1939–40, p.50 pl.46

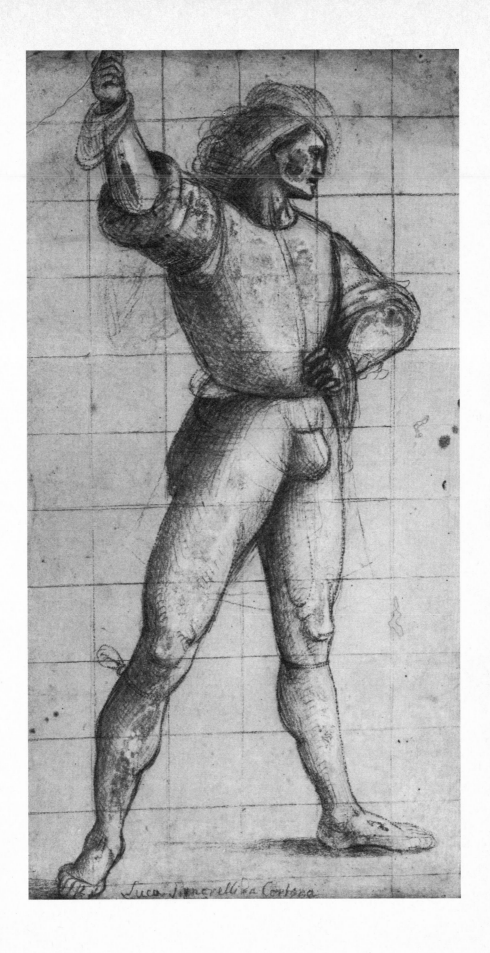

Luca Signorelli da Cortona

14 FRA BARTOLOMMEO DELLA PORTA
Study of the Mourning Virgin [*colour plate 5*]

Oxford, Christ Church, 0027
Red chalk, over slight stylus sketch, on paper
137 × 157 mm.

This is a preparatory sketch for the head of the Virgin in the *Pietà* (Pitti Palace, Florence) of 1516 (14a), and as such is rather later in date than any other drawing in the exhibition. It demonstrates not only the value of red chalk to the High Renaissance draughtsman for depicting form continuously modelled in light and shade, but also the material's particularly expressive qualities. The relatively light tonality and the appealing warm colour of red chalk give the medium an incomparable expressive range. The sentiment here demands a soft and delicate handling, so red chalk is ideal, and the slight additional reinforcement of the colour around the eyes is immediately indicative of the Virgin's grief.

Before laying on the chalk, Fra Bartolommeo made a brief outline sketch with the stylus which indented the paper slightly to provide a guide for the chalk drawing. These indentations can be seen where the chalk, handled very lightly, has not been worked into the shallow groove left by the stylus: along the profile of the Virgin's face, for example, or round the neckline of her robe. The chalk laid into the shadows of the folds of her gown is softened and merged into areas of colour, with a very delicate, atmospheric play of tones on her face and around her features, which both defines the fullness of form and creates an expressive coloured shadow framing her profile.

BIBLIOGRAPHY:
Byam Shaw 53
Berenson 460
H. von der Gabelentz, *Fra Bartolommeo und die Florentiner Renaissance* II, Leipzig 1922, 349, p.145

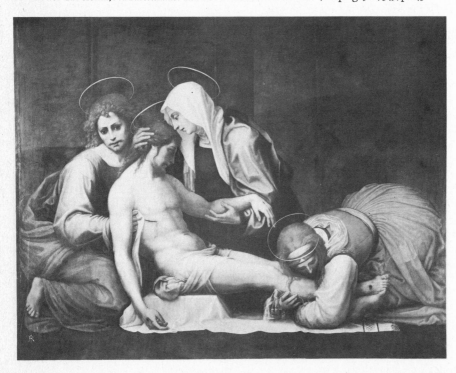

LEFT 14a Fra Bartolommeo della Porta, *Pietà*. Florence, Palazzo Pitti. Oil on panel; 152 × 195 cm.

14▷

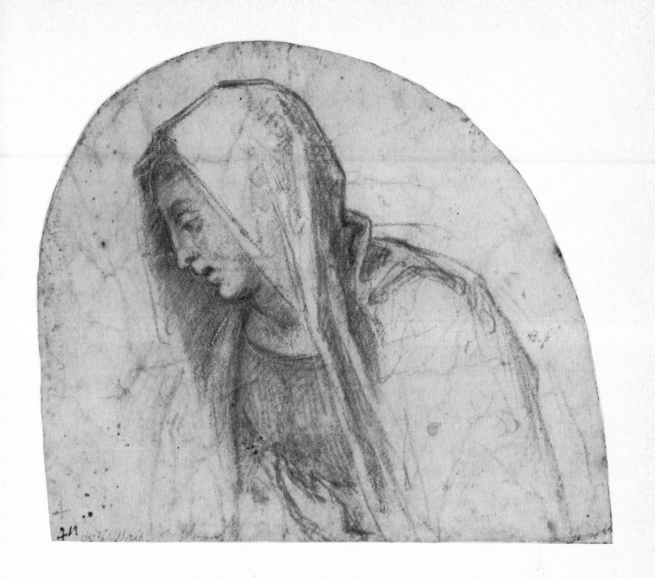

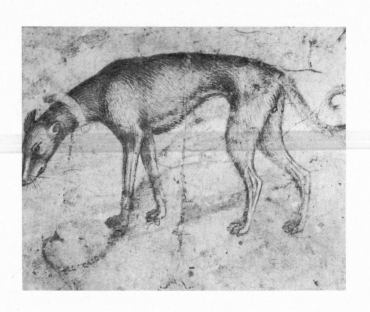

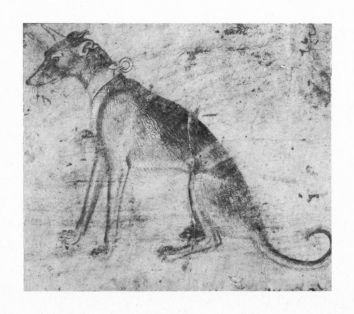

The modelbook was an indispensable item in the late Gothic artist's workshop. Its origins lay in the medieval patternbook, the bound collection of drawings in which the artist recorded forms, subjects and motifs for future reference. These drawings were rarely, if ever, made from nature, but were almost always copies of other works of art. Their specific purpose was to conserve images from various places which the master, his assistants and their successors could use in paintings and manuscript illuminations at a later date. The patternbook was therefore a compendium of stock examples ready to be transferred to paintings, and as such played a vital role in the transmission of both iconographic and formal ideas from generation to generation, place to place, and indeed from one workshop to another.

The Gothic modelbook was used in very much the same way. The studio artist would consult it for information about how to depict a particular motif. The range of contents of the typical early quattrocento modelbook was more restricted than that of the medieval patternbook. The concentration was heavily on natural form, and in Lombardy in particular the modelbook was used almost exclusively for studies of animals and birds. Some of the finest of these studies may have been taken from life, but drawing from other works of art was still very much the norm; working directly from nature, which has always been regarded as entirely natural by the post-Renaissance artist, was only infrequently practised *c.*1400. Cennini recommended that the artist should draw from nature as much as possible, but in practice he would more often prefer to copy an example of the desired breed and pose from another modelbook, even when the subject was a familiar animal such as a dog. In this way forms were transmitted from one studio to another, and we can trace, albeit incompletely, the dilution of a few specific motifs through this copying process. A modelbook sheet in Haarlem is now divided into two fragments each of which contains a study of a greyhound (IIA). Both are beautifully executed, accurate and sensitive observations, not only of the detailed physical appearance of the animal, but also of its characteristic stance and expression. Their quality is such that they may well have been made from life and have been the prototypes for other representations of the animal. The seated greyhound from a famous modelbook in Bergamo (IIB), and the standing dog on the upper half of a sheet in the British Museum (IIC), neither of which shows the same degree of sympathetic response to the animal, are both probably based on the Haarlem studies. The leopard studies 15 and 16 belong to a similar chain of inter-related motifs. It is however dangerous to assume that the most life-like study is necessarily the earliest and the source for all the others, for it is always possible that a talented artist redrawing a model at a later date would improve on the original.

IIA Lombard School, *c.*1400, *Two Greyhounds*. Haarlem, Teylers Museum, K.IX.25 and 22. Brush and wash with white heightening on parchment; 70 × 88 mm. and 73 × 86 mm.

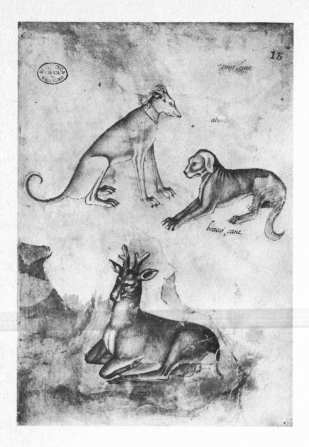

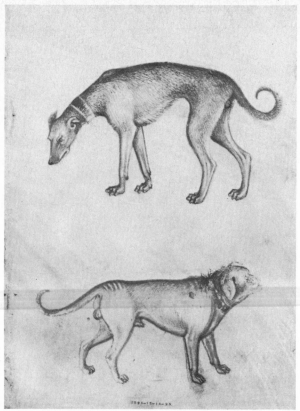

Since modelbooks were, in effect, the workshop's pictorial archive, containing definitive studies which could be used repeatedly and on which that studio could, therefore, be judged time and again, they were regarded not only as important but also as precious, were made of high-quality, durable materials, and were treated with great respect. This obviously helps to explain why such a surprisingly large number have survived. Most were of parchment or vellum, onto which the drawings were executed in fine materials with painstaking care. Wash and watercolour were often used to enhance details, such as the texture or the subtle gradations of colour of an animal's coat. The parchment leaves were bound together into book form before they were used, rather than being left as loose sheets of drawings to be gathered together later, and this again indicates that the studies were clearly thought of as important items of workshop property, to be preserved carefully.

The contents of the finest surviving modelbook, in the Biblioteca Civica in Bergamo (IIB, 15b) are entirely typical: studies of birds and animals for the most part, but also a few groups of human figures and some decorative designs. The drawings are made on vellum, in pen and ink with wash and watercolour, and are so uneven in quality as to suggest the participation of a number of different hands. The involvement of artists working in the studio at different times underlines the essentially practical function the model-book was intended to serve. The name of Giovannino de' Grassi, the Lombard illuminator, is inscribed on one of the leaves of the Bergamo book, which may either suggest that it came from his workshop, or that he was

IIB Workshop of Giovannino de' Grassi, *Seated Greyhound*, *Dog and Stag*. Bergamo, Biblioteca Civica, Cod. Δ. VII.14, f.15 recto. Pen and ink with wash and watercolours, on parchment; 260 × 175 mm.

IIC Lombard School, *c.*1400, *A Greyhound and a Bulldog*. London, British Museum, 1895-12-14-95 recto. Brush and wash, with bodycolour, on parchment; 154 × 115 mm.

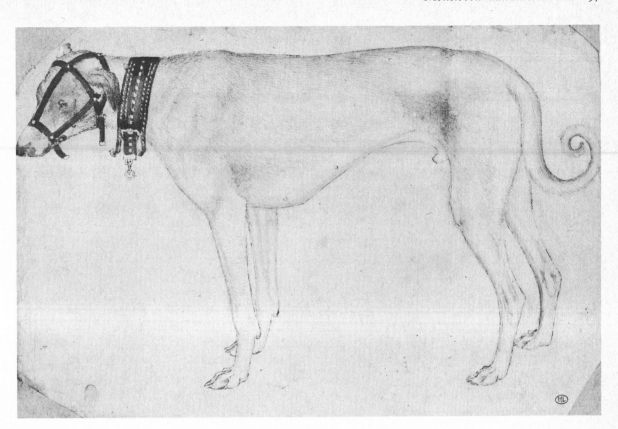

IID Antonio Pisanello,
A Hunting Dog,
Paris, Louvre, 2435.
Pen and ink with
watercolours,
on paper; 165 × 260 mm.

responsible for the original studies from which the modelbook drawings were copied.

Because their function was to convey detailed information about the physical appearance of the animals depicted, it was important that the pages should be designed to allow for the greatest clarity. A format of two drawings on each page, one above the other, showing the forms in profile so that the outlines could be emphasised, became almost standard. It was important that the subject should be described accurately, and overlapping forms were avoided so that no detail was obscured, which created a rather formal, impersonal page. But it removed any possibility of ambiguity in the interpretation of what had been drawn, and left the model encapsulated on the page, waiting to be selected for interpolation into a painting.

The generation which inherited the traditions of this type of modelbook drawing included Antonio Pisanello, the most talented and adventurous draughtsman of the first half of the fifteenth century. In his hands modelbook drawing was transformed. He produced pure nature studies which remained unrivalled until Leonardo da Vinci. His study of a *Wild Boar* (15a) or his handsome *Hunting Dog* (IID) demonstrate his enormous talent for the sensitive perception of natural form. They mark the magnificent climax of the history of Italian modelbook drawing.

But Pisanello was acutely aware of the limitations of this type of drawing. His muzzled hound is studied in every detail from life, and yet it remains lifeless. His range and versatility, particularly with the pen, was, however, extensive, and whereas on the one hand he could produce such detailed

'still-life' nature studies, precise to the last whisker, he could on the other hand create, in a few rapid strokes of the pen, creatures which are vibrant with life and energy (17a).

The liberation of technique which permitted this freedom of handling must surely have been stimulated by Pisanello's contact with the slightly older Stefano da Verona, whose lively and rapid handling of the pen can be seen in 26. Dating from the 1420s and 30s, these drawings are quite unlike anything else to be found in North Italy at that time. Pisanello matched this new graphic exuberance with a desire to explore imaginative ways of describing form, and it is in the resulting studies that we find the roots of an entirely new tradition of drawing. Spontaneous, exploratory and inventive, works such as these belong to a different species from the modelbook drawings with which, in Pisanello's work, they co-exist. No longer stock examples which would be used and reused in workshop projects, these sketches reveal the artist at work, sometimes evolving ideas about compositions or figures within a composition, sometimes jotting down his observations in rapid notation, to capture a characteristic expression or a momentary pose, arbitrarily working across the page as his ideas developed. Often he had no other end in view than the sheer pleasure of learning about the nature of his subject, as he followed its movements.

But the transition from modelbook to sketchbook was not as strictly defined by chronological progression as this might suggest. Even in the case of Pisanello himself, it is impossible to associate the modelbook-style drawings exclusively with his early years, or the sketches with his later phase. Clearly, however, his career as a draughtsman represents a pivotal moment between model drawing and sketching. Drawings such as 18 recto and IIE, both from a travel sketchbook (*taccuino di viaggi*) used in the Roman workshop first of Gentile da Fabriano and later of Pisanello, indicate by dramatic contrast some of the radical rethinking about the function of drawing that was in the air.

Although the importance of modelbook drawing, with its almost obsessively myopic view of natural form, gradually declined in favour of a more experimental and broadly-referenced type of sketching, modelbooks and, more and more frequently, pattern drawings assembled less formally in portfolios, continued to be fairly widely used throughout the century. In Venice, for example, we find the use of pattern drawings, both as exemplars from which apprentices could copy and, in the best modelbook tradition, for transfer directly to paintings, persisting right through until the end of the century. Gentile Bellini's *Study of a Turkish Woman* (IIF), one of many studies of orientals made during his visit to Constantinople in 1481, even has notes on the colours, appended for the guidance of any artist wishing to include it in a painting. Not surprisingly, such high quality pattern drawings still display the type of limitation already seen in modelbook drawings, that airless refinement which holds them at a distance from life. At the same time, however, the very artists responsible for these immaculately precise, yet bloodless studies (34, IIF) produced some of the freest, boldest and most vital compositional jottings, which go far beyond the factual description of the elements of the composition, their rapid flurry of suggestive marks powerfully conveying the atmosphere of the moment depicted (57, 58).

11E Workshop of Gentile da Fabriano and Antonio Pisanello, *Sheet of Sketches Including a Copy of One of the Dioscuri*. Milan, Ambrosiana, 214 inf. f. 10 verso. Pen and ink on parchment; 230 × 360 mm.

Further south, in Tuscany, experimental sketching evolved at a rather different pace and along a different route. The survival of no more than one modelbook that can be shown to have been of Tuscan origin, dating from *c.*1450, is probably a fair indication of the relatively slight interest in this form by comparison with its popularity in Lombardy. This is not to say that nature study was neglected in central Italy; Vasari writes that Uccello made drawings of birds and animals, and both Ghiberti and della Quercia are recorded as using such models. But it is clear that the modelbook as a format never held the same attraction for Florentine artists. This is perhaps partly because the conservatism inherent in the copying of set patterns was of less interest to a more individualistic middle class patronage, than it was to the aristocracy of the north Italian courts. But it was certainly to some extent because the impetus to create fully integrated compositions, which reflected nature as a whole, rather than as a tapestry of beautifully observed details, was much stronger and asserted itself earlier in central Italy (Section V).

A sketchbook made in the workshop of Benozzo Gozzoli, of which 22 is a page, offers some idea of the wide variety of types of drawing practised in a Florentine studio *c.*1460. It contains animal studies in the modelbook tradition, copies of other works of art, including some taken from drawings by Gozzoli himself, studies of figures relating to specific compositions, and some purely exploratory drawings both of individual figures and of groups. The range of style and quality of these drawings suggests that the sketchbook was used quite freely by assistants and apprentices, who would try out ideas across its leaves. This more casual use of the studio sketchbook is symptomatic of a progressively more informal attitude towards drawing, which is

IIF Gentile Bellini, *Study of a Turkish Woman*. London, British Museum, Pp.1–20. Pen and ink on paper; 215 × 175 mm.

further indicated by the increased use of portfolios of working drawings on loose sheets as an alternative to the sketchbook. The portfolio could be used more flexibly than a bound modelbook, could be added to or subtracted from more freely, and could provide a home for drawings made for a variety of purposes. Numerous studies were made of studio assistants posed in the workshop, and many of the *garzone* drawings in the exhibition belonged to

such portfolio collections. Some were made in connection with particular projects (2, 7, 12), some purely for the exercise of drawing from a posed model, perhaps to prove useful at a later date (30, 38, 40, 41), and some were preserved as patterns to act as teaching guides for young apprentices in the studio (34, 34b, 37, 37a).

Bound books did however continue to be used, some even quite formally. Indeed, as late as *c.*1500 members of Ghirlandaio's workshop were responsible for the compilation of the *Codex Escurialensis*, in which antique motifs were gathered together as a specialist collection (44b). Although now made on paper and exclusively concerned with classical antiquity, thus strongly reflecting a serious contemporary interest, the drawings in this book are descended from the medieval patternbook tradition of copying other works of art, a tradition which had passed down through the quattrocento in occasional volumes, such as the *taccuino di viaggi* from the studio of Gentile da Fabriano, with its copies of antique statuary (18 verso). But examples such as 23, 24 and 25, all of which are sheets from late fifteenth-century sketchbooks, demonstrate both the freedom and the informality with which these books came to be used, and the way in which the rejection of model and pattern drawing, in favour of freer graphic experimentation, imbued each book with a character of its own. This obviously increased when the sketchbook ceased to belong generally to the workshop at large, but became the personal possession of the individual artist. The sketchbook as an intimate *aide-mémoire* was very much a feature of High Renaissance drawing practice, and particularly of Leonardo da Vinci who had precisely this type of book in mind when he wrote that artists should

. . . take pleasure in seeing and considering the actions of men . . . Make a note of them with a few lines in your little book which you should always take with you. Its pages should be of coloured paper, so that you cannot rub your sketch out, but will have to change from an old page to a new when the old one is filled. For these are not things to be erased but preserved with great care, because these forms and actions are so infinite in number that the memory is not capable of retaining them, where–fore keep your sketches as your aids and teachers.'

(Leonardo/McMahon I, p.107)

15 LOMBARD SCHOOL, early fifteeth century
Two Cheetahs or Hunting Leopards (recto) [colour plate 6]
An Eastern Goat and a Ram (verso)

London, British Museum, 1895–12–14–94
Brush drawing on parchment, coloured with bodycolour
156 × 115 mm.

This sheet demonstrates a number of elements characteristic of the Lombard late-Gothic modelbook. The studies were made on fine quality parchment, for durability was an important consideration. A book whose main function was to preserve records of stock forms had to withstand use by successive generations in the workshop. The care and precision of the draughtsman's technique, and the addition of bodycolour, also indicate that these were thought of as definitive studies and expected to be of lasting value. The very neatness of the finished drawings again indicates that the draughtsman's concern was to produce models which assistants or other studio artists could study and copy.

Animal and bird studies were the principal subject matter of North Italian modelbooks and, in Lombardy especially, draughtsmen were noted for their ability in nature study. However, like many modelbook drawings, these studies were probably copied from other drawings, rather than from the animals themselves. But they are quite fresh and vital and are, therefore, probably closer to the original model (perhaps an animal carcass) than the anatomically less accurate and aesthetically less engaging 16. The draughtsman here seems particularly sensitive to the quality and texture of the animals' coats. The long, shaggy fleece of the ram on the verso is delicately and painstakingly rendered, hair by hair, with a thin, mobile interweave of fluent brushstrokes; the texture of the coarser hair on the back and neck of the goat is evoked by the overlay of shorter, straighter strokes, and the silkiness of its long ears by a broader handling of the lights. The leopard studies show a similar concern with surface texture. The sense of fur has been conveyed by the application of wispy, white brushstrokes over the animals' spots. However, by comparison with Pisanello's exquisite study of a *Wild Boar* (15a), surely made from the animal itself, these studies do appear

LEFT 15a Antonio Pisanello, *A Wild Boar*. Cambridge, Fitzwilliam Museum, PD.124–1961. Pen and ink on parchment; 97 × 167 mm.

15 (recto) ▷

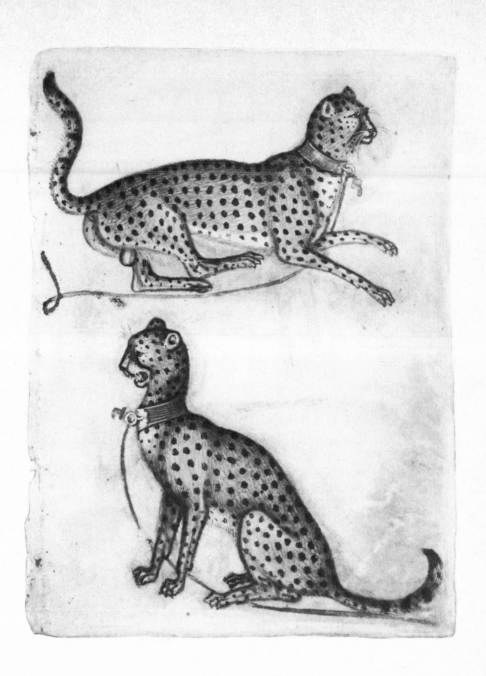

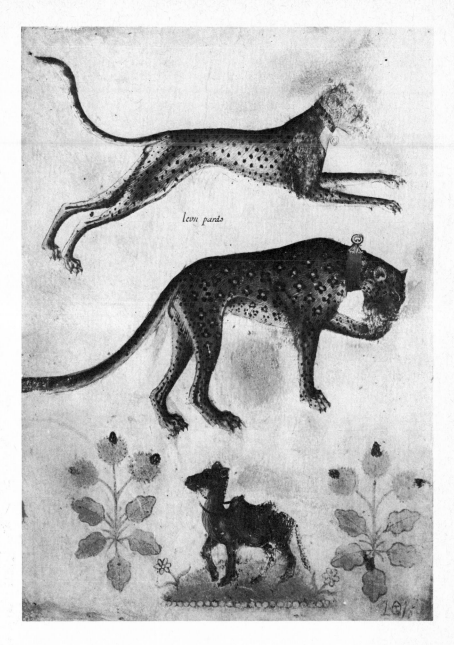

leon pards

ABOVE 15b Workshop of Giovannino de' Grassi, *A Leopard and Other Animals*. Bergamo, Biblioteca Civica, Cod. Δ.VII.14, f.15 verso. Pen and ink, with wash and watercolours, on parchment; 260 × 175 mm

◁ 15 (verso)

stylised: the animals' anatomy and texture seem only superficially and inadequately understood.

Although not as high in quality, this sheet is stylistically close to a number of drawings in a sketchbook in Bergamo (15b) which bears the name of Giovannino de'Grassi. He was probably responsible for the original drawings from which the studies in the Bergamo book were copied, and perhaps even some of those drawings themselves. It is also very similar to two sheets in the Pierpont Morgan Library, and to another in the British Museum (II C). It is indeed possible that all four sheets may have belonged to one book, similar to the intact volume at Bergamo.

BIBLIOGRAPHY:
Popham and Pouncey 290
R.W. Scheller, *A Survey of Medieval Modelbooks*, Haarlem 1963, p.143
A. van Schendel, *Le Dessin en Lombardie jusqu'à la Fin du XVe Siècle*, Brussels 1938, pp.42–45

16 LOMBARD SCHOOL, early fifteenth century
Two Hunting Leopards

Oxford, Christ Church, 1908 and 1909
Pen and brown ink on two fragments of paper
Upper fragment: 53 × 77 mm. (maximum dimensions)
Lower fragment: 73 × 115 mm. (maximum dimensions)

Probably fragments from the same modelbook, these two studies of hunting leopards come from precisely the same tradition as those on 15 recto. Indeed, they may even derive from the same original model, being two variants of the pose of the leopard on the upper part of the British Museum sheet. If so, it may be that these studies are of much weaker quality because the draughtsman worked from a copy which was itself at several further removes from the original. On the other hand, he might simply have been a less talented artist.

Another delightful study of a *Leopard*, in the Ambrosiana, Milan (16a) is also evidently at some distance from the living animal. Although bearing a closer resemblance to a rather stout domestic pet than to a ferocious carnivore, it is nonetheless full of character; and, by comparison, both the leopards in 16 seem very lack-lustre, and remote from any kind of vitality. Unlike both the Ambrosiana leopard and those depicted in 15, no sense of the surface texture of the animal's fur is conveyed in these studies: shadow and texture are merely indicated by cursory and very sketchy hatching. The draughtsman has only a very superficial awareness of the anatomy of the animals, which look distinctly unfeline. The ears of another animal intrude at the bottom edge of the lower fragment, indicating that it belonged to a typical page of animal studies from a modelbook.

BIBLIOGRAPHY:
Byam Shaw 1058 and 1059

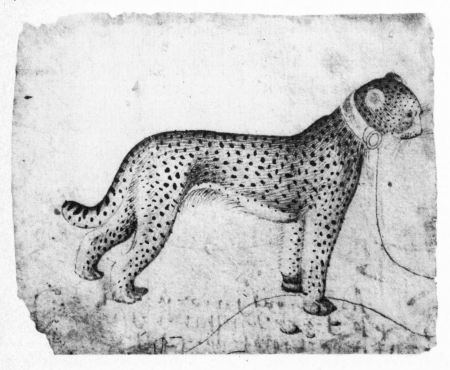

LEFT 16a Lombard School, *c.*1400. *A Leopard.* Milan, Ambrosiana (not in inventory). Brush and watercolour on paper; 610 × 620 mm.

16 ▷

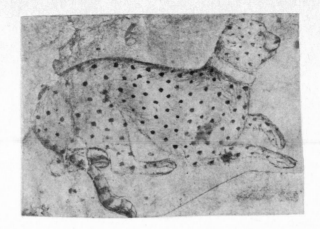

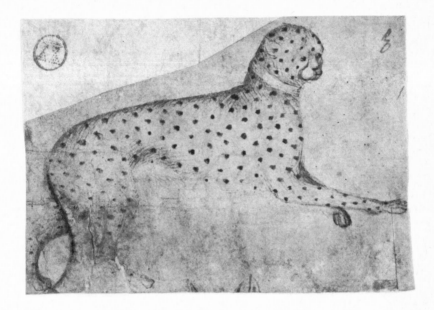

17 NORTH ITALIAN, first half of fifteenth century (?)
A Peacock [colour plate 7]

Chatsworth, Devonshire Collection (uncatalogued)
Pen and watercolour, heightened with white, on paper
178 × 200 mm.

In his detailed concern with the description of the physical appearance of the bird, the draughtsman of this sheet was working very much within the North Italian modelbook tradition. However, his sensitivity to, and fine discrimination between, textures, colours and types of feathers, suggest that he made his drawing from nature. In this respect the sheet is closest to the nature studies made in watercolour and pen by Pisanello and his assistants in the so-called *Vallardi Codex* (17b).

The pen-drawn outlines are extremely fine and delicate. Around the legs and claws particularly, the draughtsman attempted to keep his contour to an unobtrusive, hairline thinness while ensuring that it was continuous. In the beak and head, where stronger drawing was required, the outline was reinforced, and a very precise linear hatching was added to shape the beak and the nostrils. The body outline is less continuous, with the ink here stroked on very lightly and evenly, an effect which successfully conveys the 'unfocused' edge of the feathers. Beneath the tail, it is actually the watercolour wash which creates the impression of outline, and the pen is used to suggest the texture of the feathers. A similar effect can be seen on the bird's neck, where the pen is used over the wash to create a sense of the variety in these short, downy feathers. These in turn are subtly strengthened and gradually transformed into the longer, wispy strokes of heightening, which describe the plumage on the bird's breast. The draughtsman used a combination of pen and fine watercolour lines across the back, but described the wing shape and its internal patterns using watercolour alone in softly mottled browns, in places laying on the washes so thinly that the colour of the paper itself becomes part of the tonal harmony of the wing. The internal

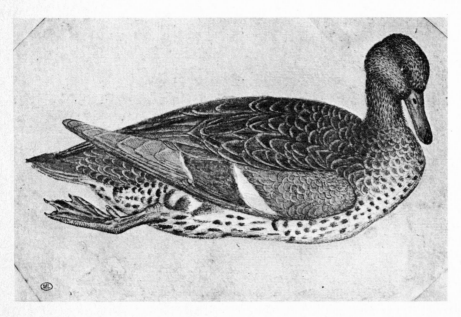

LEFT 17b Antonio Pisanello,
A Duck. Paris, Louvre, 2461.
Pen and ink with
watercolours, on paper;
140 × 214 mm.

17 ▷

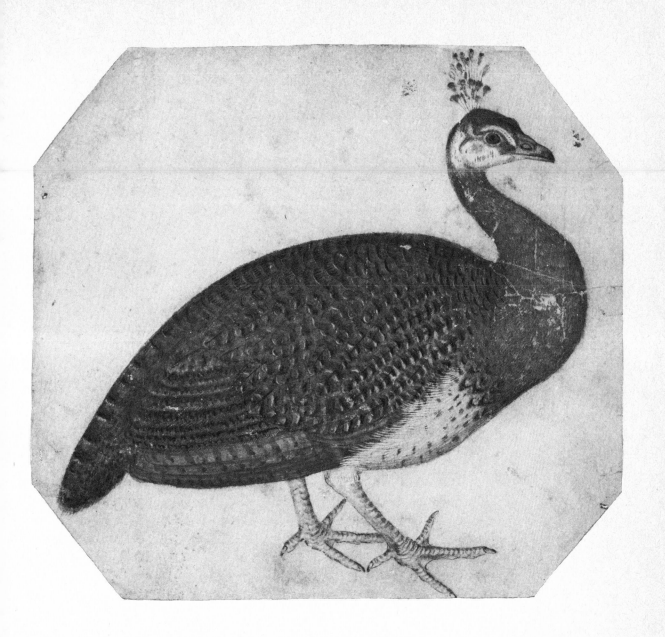

modelling is created by the varying rhythms and directions of the water-colour marks, which distinguish flight feathers from underbelly, or from the surprisingly unflamboyant tail plumage.

This is a refined, high quality drawing of its type, produced by a draughts-man who knew how to put a wide range of technical effects to excellent use. It shows masterful control of both pen and brush, and a lovely sense of tonal and colour modulations. However, the draughtsman's interest has not really extended beyond the bird's physical appearance. The peacock is marooned in the centre of a blank page, neither standing on the ground, nor set within a described environment. Unlike Pisanello in his sheet of rapid studies of a peacock (17a), the draughtsman here displays no curiosity about the be-haviour, movements, or characteristic gestures of the bird. It is, in effect, a beautifully observed *nature morte*. The proper date for drawings such as this is impossible to postulate with any certainty, for they continued into the sixteenth century to fulfil the function of workshop models, alongside the development of freer, more rapid studies from nature.

BIBLIOGRAPHY:
Chatsworth Exhibition II, 1

17a Antonio Pisanello, *Studies of a Peacock*. Paris, Louvre, 2390 verso. Pen and ink on pink tinted paper; 254 × 190 mm.

2590

18 WORKSHOPS OF GENTILE DA FABRIANO AND ANTONIO PISANELLO
Studies of Costume (recto)
Studies after the antique (verso)

Oxford, Ashmolean Museum, KP 41
Pen and ink with watercolour washes on vellum (recto)
Pen and ink (verso)
183 × 240 mm.

This is a page from a sketchbook probably begun in Gentile da Fabriano's workshop during his period in Rome, working at San Giovanni in Laterano in the mid-1420s, when the antique studies on the verso would have been made. After Gentile's death in 1427, the *taccuino* apparently continued to be used in the workshop, later headed by Pisanello, and the costume studies on the recto were made about a decade after the drawings on the verso.

This type of shared drawing book kept in the workshop and used over a period of time has its origins in the modelbook tradition. But the range of the subject matter and variety of handling seen on either side of this sheet, and on 11 F which comes from the same book, characterise the beginning of a change in the usage of drawing books. From the storage of finished patterns for certain forms (15, 16) evolved the freer use of a sketchbook as a jotting pad, in which members of the workshop could note down observations which might later stimulate ideas or experiments. The choice of vellum, as well as the painstaking attention to detail on the verso, links this sheet with the former type, while the more rapid, broader treatment on the recto, connects it more with the personal sketchbook of the later quattrocento artist.

The earlier studies on the verso are carefully recorded observations of figures from classical reliefs such as 18a. This helps to explain the curious distortion of the forms which are flattened out, an effect particularly noticeable across the shoulders and torsos. Furthermore, the draughtsman seems to have studied the details of the forms in a piecemeal way, so that the final impression is of two extraordinarily misproportioned figures. The pen work is very controlled and rather lifeless. The shadows are conscientiously but laboriously worked up, and the draperies curve and arabesque uneasily in a fashionable gothic rhythm around the nude forms.

The later studies on the recto were produced by a much more fluent pen. The folds of the complicated cloak of the figure on the left were very hastily sketched in and boldly enlivened with watercolour washes. The shorter cloak of the second male figure on the right is similarly treated, and here rapid ticks with the pen describe effectively the fur which edges the garment, in an idiom comparable with the handling in 2. Although this figure's head is rendered in greater detail, he is in general still very sketchily observed, and there is little doubt that the artist's primary intention was to study the costume *per se*. The elaborate coiffure is, likewise, his overriding interest in the treatment of the female figure in the centre.

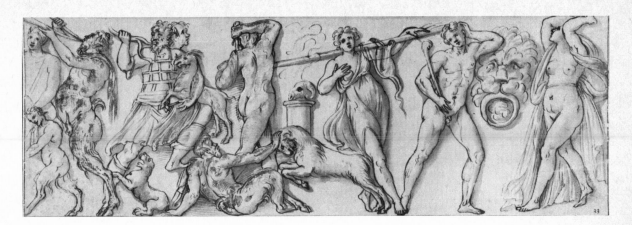

ABOVE 18a Roman Draughtsman, seventeenth century, *Drawing of a Lost Sarcophagus Relief*. London, British Museum, Cassiano dal Pozzo *Museum Chartaceum* I, f.58 no.66. Pen and ink with wash on paper; 146 × 430 mm.

◁ 18 (verso)

BIBLIOGRAPHY:
Parker 41
K. Christiansen, *Gentile da Fabriano*, London, 1982, L XVII, pp.145–148 (as Pisanello?)
B. Degenhart and A. Schmitt, 'Gentile da Fabriano in Rom und die Anfänge der Antikerstudiums',
 Münchner Jahrbuch für Bildenden Kunst XI, 1960, 59–151, especially pp.108, 134 and pl.73 (verso),
 pl.22 (recto)
Fossi Todorow 190, p.131

19 ANTONIO PISANELLO AND ASSISTANT
Study of a Cock (recto) [*colour plate 8*]
Study of the Crucified Christ (verso)

Private Collection
Pen and ink on reddish tinted paper (recto), with wash and white
heightening (verso)
175 × 205 mm.

It was quite usual for studio artists, other than the master, to make contributions to a workshop modelbook or sketchbook. And so it is not uncommon to find two different hands at work on the recto and verso of the same sheet, as is clearly the case here. The cock on the recto is a finely executed study, in which Pisanello not only keenly recorded the structure of the bird's anatomy, but also captured much of its character, through his sensitive and expressive use of the pen. In handling it is not unlike his study of the *Wild Boar* (15a), although the differences in texture and absorbency of paper and parchment result in rather different qualities of pen line.

The head is described in the greatest detail, the cock's comb, wattles, cheeks and beak drawn with a precise outline, then more rapidly modelled, their shape determined by the direction of the hatching. The folds and creases in the wattles are particularly effectively handled, with a lovely sense of rhythm created in their hanging fleshiness. In contrast to the closely and neatly described head, the bird's plumage provided Pisanello with an opportunity to display his enormous talent for swift characterisation with the pen. The cascade of feathers down the bird's neck, across its back and down into its tail, is formed by a continuous sequence of long, flowing, V-shaped penlines which follow the shape of its body. Wing feathers are described by looped lines which are lengthened towards the tip. The underbelly is defined with more closely-spaced rapid lines, shorter behind the legs, longer on the breast and body. The ease with which the pen flowed is recorded in the variation of ink colour, which seems to follow a very natural rhythm of rise and fall in the pressure of the hand. This is a drawing of great confidence and exuberance.

By comparison, the study of the crucified Christ on the verso is feeble. The outline and the treatment of elements such as the hair is conventionalised, the enclosing penline is heavy and lacking in vitality, and the handling of expression is rather gauche. Some variety has been attempted within the sepia wash and white heightening, but these are often thickly applied and overworked, particularly in the torso. The assistant responsible for this pedestrian study copied the figure of Christ from Fra Angelico's fresco of the *Crucifixion with St Dominic* from San Marco, Florence (19a).

BIBLIOGRAPHY:
B. Degenhart and A. Schmitt, 'Gentile da Fabriano in Rom und die Anfänge des Antikerstudiums',
 Münchner Jahrbuch für Bildenden Kunst XI, 1960, p137 n.30
Fossi Todorow 209 (as Circle of Pisanello)
A.E. Popham, 'The Drawings at the Burlington Fine Arts Club', *Burlington Magazine*, LXX, 1937,
 p.87

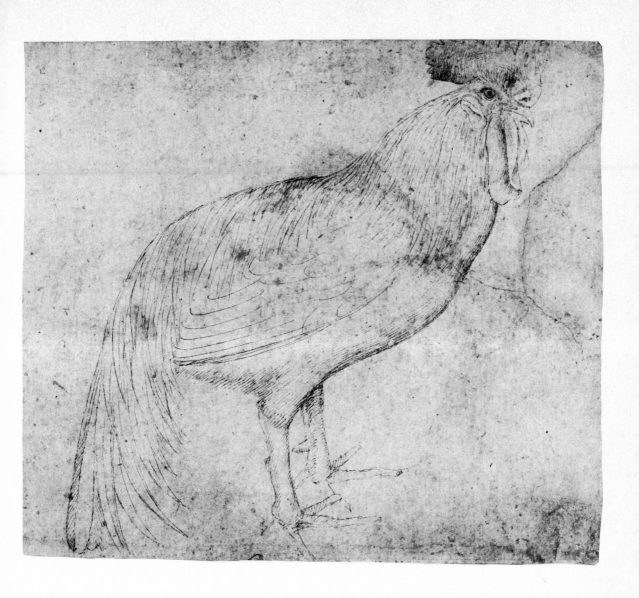

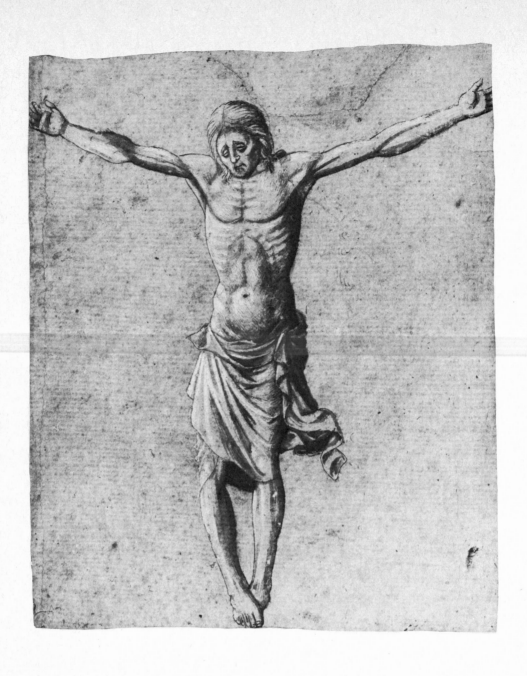

RIGHT 19a Fra Angelico,
*The Crucified Christ with
St Dominic*. Florence,
Convent of San Marco.
Fresco on wall.

◁ 19 (verso)

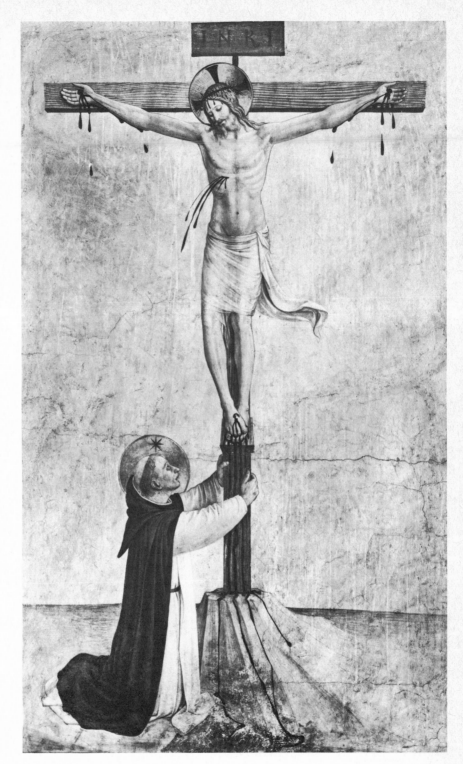

20 WORKSHOP OF BENOZZO GOZZOLI
*Madonna and Child with Angels; Studies for a Saint,
an Angel and a Seated Figure Seen from Behind* (recto)
A Group of Shepherds and a Seated Nun (verso)

London, Victoria and Albert Museum, Dyce 173
Pen and ink, with wash and white heightening, on reddish-pink tinted paper
150×200 mm.

The variety of handling on this sheet of studies may suggest either that
different draughtsmen were contributing to a workshop sketchbook, or that
one draughtsman was using the sheet on different occasions over a period of
time. Certainly it is clear that the various studies on the recto do not belong
to a coherent group, with their discrepancies in scale, unrelated subjects and
differences in handling. This free use of the sketchbook page for miscel-
laneous studies is characteristic of later quattrocento Florentine workshop
practice.

The addition of a reddish-pink wash to the paper, a technique also used by
Pisanello at a slightly earlier date (19), has the same effect as a pigmented
preparation for silverpoint drawing, in providing an extra tone value against

BELOW 20a Workshop of
Benozzo Gozzoli; *A Sheet of
Figure Studies*. Cambridge,
Fitzwilliam Museum, 3007A.
Brush, with wash and white
heightening, on rose-pink
tinted paper; 190×235 mm.

20 (recto) ▷

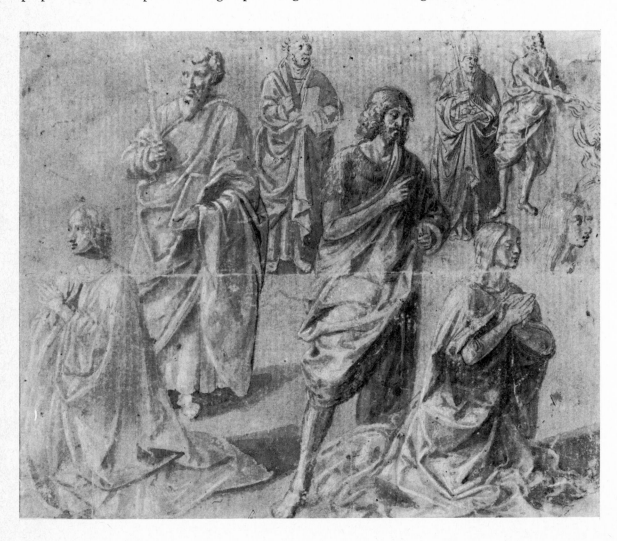

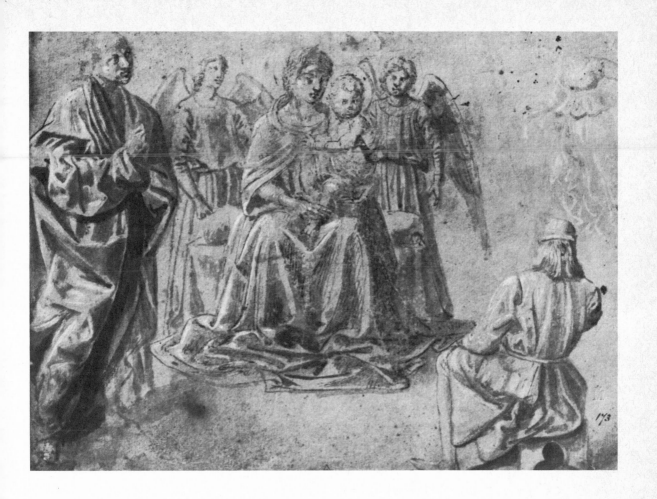

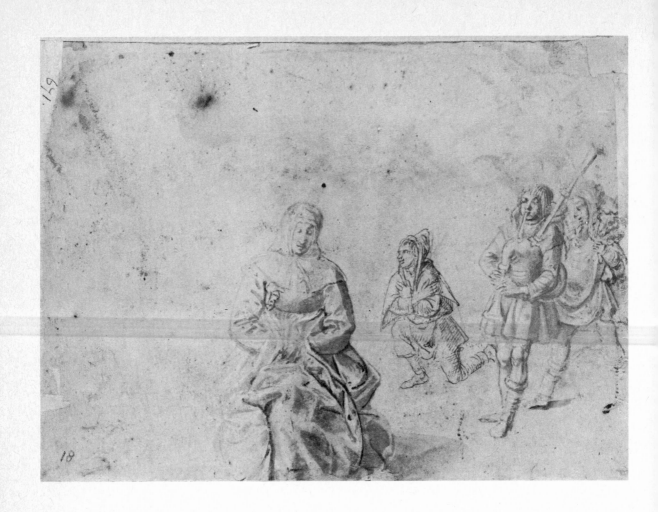

◁ 20(verso) which the ink, wash and heightening stand out. The deep shadows of the drapery folds around the seated Virgin's knees are reinforced with hatched penlines, but otherwise the shapes are indicated solely with wash. The modelling in the draperies of the standing, awkwardly proportioned saint on the left is of thick and rather coarse wash. But on the angels standing behind the Virgin and on the seated figure (probably a workshop *garzone*) in contemporary dress, the wash is lighter and more fluent. Most effectively handled of all, however, is the brief sketch of a running angel at the top right. This figure is only hastily indicated, the fluent movement of the light draperies marked in with a few quick dabs of white heightening.

The shepherds and the seated nun on the verso also vary in technique and scale. The kneeling figure, lacking in wash and hatched with a pen using a different ink, was probably added later, his incomplete left foot tucked in behind the bagpiper. This further indicates that this sheet, like others from the same book (20a), was being used to try out or briefly record ideas which might act as stimuli to the artistic imagination later on.

BIBLIOGRAPHY:
Ward-Jackson 6
Berenson 544
Degenhart and Schmitt 433

21 BENOZZO GOZZOLI
Studies of Standing and Kneeling Figures; Sketch of
Hands and an Ear (recto) [*colour plate 9*]
Madonna and Child in a Tabernacle (verso)

Harewood House, Yorkshire, Earl of Harewood Collection
Pen and brush with ink and wash, white heightening and traces of gold paint,
on pink tinted paper (recto)
Pen and ink over black chalk on pink tinted paper (verso)
169 × 179 mm.

One of Gozzoli's most beautiful drawings, this sheet shows well the indi-
vidual technique he developed for figure studies and other similar working
drawings. Like 20, it probably came from a fairly large sketchbook in
which all the leaves were prepared by brushing on a pinkish wash. Within a
simple, economical pen outline, the forms were built up with the brush so
subtly and delicately that the light wash seems to merge softly with the tone
of the ground. White highlights were then added smoothly along the edges
of the drapery folds, with fine wispy strokes to suggest the sheen on the
fabric of the garments and the lights touching the curls of the hair. These are
carefully contemplated studies: the models are in poses which could be held
for a long time without discomfort. This permitted a relatively slow,

BELOW 21a Benozzo
Gozzoli, *Adoring Angels*.
Florence, Palazzo Medici
Chapel, detail. Fresco on
wall.

21 (recto) ▷

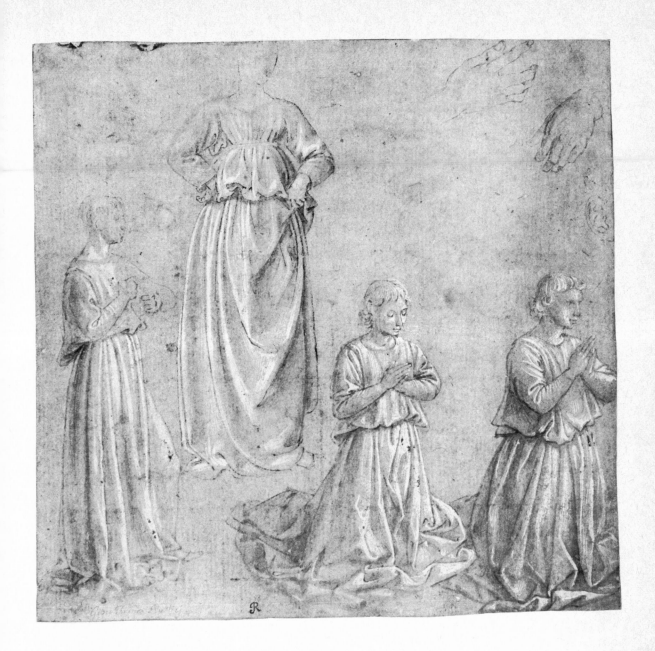

◁21 (verso) polished handling, and a curious lack of concern for the potential spon-
taneity of the penline which, used in this way, seems almost akin to silver-
point. The largest, frontally posed figure on the recto is lit from the left, the
others from the right: this suggests that the studies were made at different
times.

The use of gold paint, traces of which can still be seen on the bodice of the
largest, central figure, further indicates the draughtsman's desire to produce
a beautifully wrought, highly finished study. Powdered gold was a pigment
still fairly new to artists in Florence when this drawing was made in the late
1450s. As recently as 1441 Matteo de' Pasti had written to Piero de' Medici
from North Italy, describing its use in Venetian studios, and mentioning that
he himself had begun to use it in a work commissioned by Piero. It may not,
therefore, be fortuitous that the kneeling figures on the recto of this sheet are
studies for the angels to the left of the altar niche in the Cappella Medici,
which Gozzoli decorated for Piero de' Medici in 1459–60 (21a). That neither of
the studies related to the Medici commission is exactly comparable with
the figures in the fresco indicates their preliminary function, and their high
quality points to the authorship of Gozzoli himself.

On the verso, the use of black chalk to establish all the main forms is
unusually extensive for the date. A few details of the architectural structure
were then strengthened with pen and ink, while the drapery forms and
figures themselves were largely redrawn with the pen. Clearly Gozzoli
regarded chalk as a medium to be used broadly, to build up the tonal
strength of areas like the inner walls of the tabernacle. For the precision
required in the detailed working-up of forms and the fine delineation of
features, the pen was still considered to be the more appropriate tool. The
quality of the drawing on the verso seems inferior to that on the recto, less
clearly articulated and less expressive. This may be because, as a composi-
tional design for a Madonna di Loreto, it was probably drawn from the
imagination rather than from a model.

BIBLIOGRAPHY:
Berenson 544B
Degenhart and Schmitt 417
A. Padoa Rizzo, *Benozzo Gozzoli Pittore Fiorentino* Florence 1972, p.123, fig.105 (recto only)

22 BENOZZO GOZZOLI AND ASSISTANT
Bearded Man on Horseback; Two Studies of a Head
(recto)
Youthful Saint in a Niche (verso)

London, British Museum, Pp.1–6
Pen and ink, with wash, on paper
231 × 157 mm.

This sheet comes from a large workshop sketchbook, much of which sur-
vives in Rotterdam. On the verso is a carefully finished study of a figure,
probably of St Severus, standing within a niche. The pen is here used neatly
and under tight control, especially in the intricate detailing of the architec-
tural forms of the niche, and a light wash is added to suggest the internal
space of the niche behind the figure. Pen and wash are again lightly used on
the figure; a touch of cross-hatching on the left forearm, and brief hatching

BELOW 22a Domenico di
Michelino (?), *Procession of the
Magi*. Strasbourg, Musée des
Beaux-Arts, inv.261.
Tempera on panel;
64 × 69 cm.

22 (recto) ▷

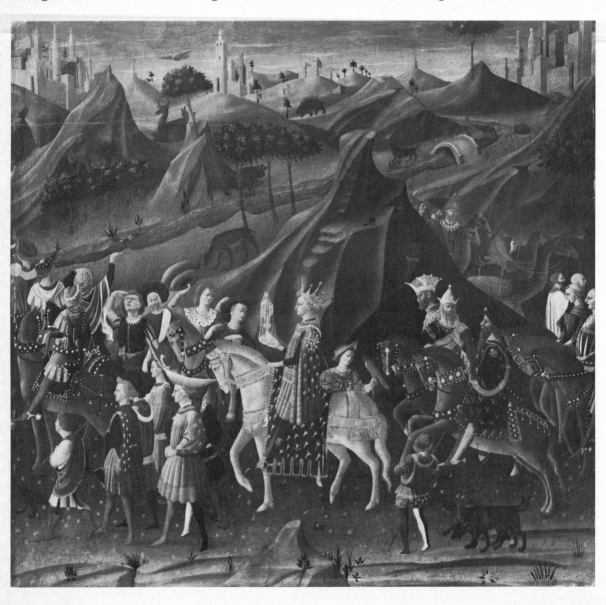

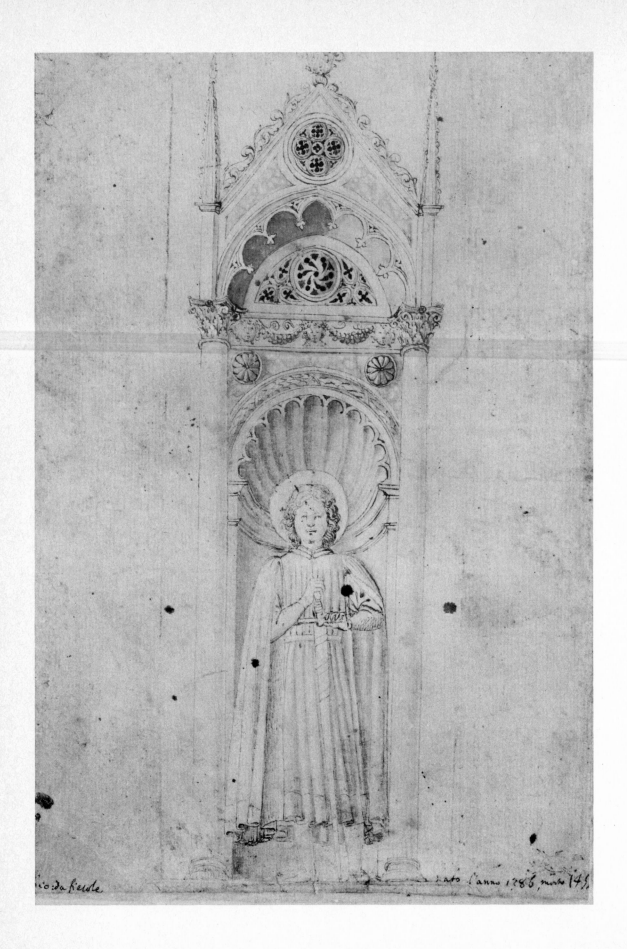

co da fiesole ato l'anno 1286, morto 14

◁ 22 (verso) within the shadow of the cloak, are supplemented by this wash. The twists of the hem of the cloak around the figure's calves are studied in more detail and with stronger strokes of the pen. Indeed, this passage suggests better than any other the three-dimensionality of the saint's form, which otherwise is flat and unarticulated.

The sketches on the recto are weaker in handling. The penlines around the two studies of a monk's head are dull, and the structure of the form is poorly grasped. Both these sketches and the drawing of the bearded rider are probably copies by an assistant of limited talent from original Gozzoli drawings, perhaps made in relation to a *Procession and Adoration of the Magi*. It has, for example, been associated with a *Procession of the Magi* in Strasbourg, often attributed to Domenico di Michelino (22a). The handling of the pen is again tight but now monotonous; the contours are too precise to add any vitality to the forms. The saint on the verso is, however, an autograph study for a fresco in San Francesco, Montefalco, painted by Gozzoli in 1450–52. The connection between a number of studies in the sketchbook and the Montefalco frescoes may suggest that the book was in use around 1450, although it is, of course, very unlikely that its usage was confined to only a short period in Gozzoli's career.

BIBLIOGRAPHY:
Popham and Pouncey 87
Berenson 1751 (as Domenico di Michelino)
Degenhart and Schmitt 409

23 FOLLOWER OF ANTONELLO DA MESSINA
Five Studies of Compositions (recto)
Miscellaneous Sketches (verso)

London, British Museum, 1929–1–3–1
Pen and ink on pink tinted paper
245 × 123 mm.

The studies on the recto of this sheet can all be connected either with compositions or with the stylistic interests of Antonello da Messina. For this reason, Fiocco attributed them to the Sicilian master while working in Venice in 1475–76. However, the quality of the drawing does not reflect any of Antonello's strength as a painter, and the individual sketches relate to compositions and stylistic preoccupations which belong to quite disparate periods in his career. Furthermore, the miscellaneous sketches on the verso, some of which are tenuously linked with details in works by the master, are of extremely modest quality.

These observations seem to suggest that an artist in Antonello's circle made rapid sketches on this sheet, recording certain details of the master's compositions. The Madonna and Child (recto, centre right), for example, can be related to the central group from the *San Cassiano Altarpiece* (23a), while Antonello's documented *Disputa di San Tommaso*, which was destroyed by fire in 1849 but whose composition is reflected in two Sicilian pictures (23b), seems to be echoed again in the two 'sermon' sketches (recto, lower left). The sketch at the top of the sheet may relate to another lost Antonello, for the receding tiled floor and the tiny landscape seen through a window are

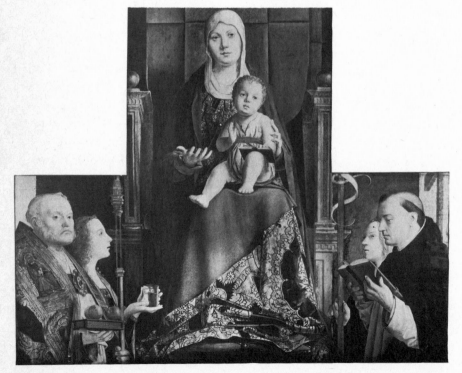

BELOW 23a Antonello da Messina, *Madonna and Child with Saints* (fragments of the *San Cassiano Altarpiece*). Vienna, Kunsthistorisches Museum. Oil on panel, in three fragments; 115 × 65 cm (centre panel), 59.9 × 35 cm (left panel), 56.8 × 35.6 cm (right panel).

23 (recto) ▷

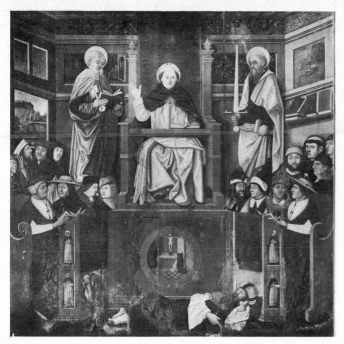

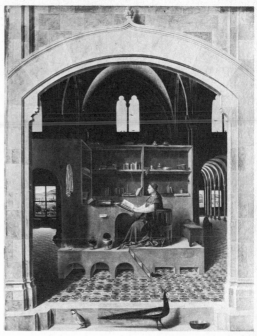

ABOVE LEFT 23b Messinese
School, late fifteenth century (?),
*The Disputation of
St Thomas Aquinas.*
Syracuse, Palazzo Bellomo.
Oil (?) on panel; 150 × 185 cm.

ABOVE RIGHT 23C
Antonello da Messina,
St Jerome in his Study.
London, National Gallery,
1418. Oil on panel;
45.7 × 36.2 cm

◁ 23 (verso)

motifs favoured by the artist (23c), while the Virgin seated close to the ground
in a domestic interior is reminiscent of contemporary Flemish painting in
which Antonello had a profound interest.

The sheet, which is trimmed at both left and right edges, was almost
certainly originally a page in a sketchbook. The layout of the drawings,
particularly on the recto, and slight changes in the colour of ink, indicate that
the artist went back to reuse blank areas of the sheet for further sketches,
having previously made only partial use of the surface area of the paper. The
sketchbook was, it seems, employed quite freely as a jotting pad. The range
of studies, from compositional sketches to single figures, details of stance and
notations of specific motifs, demonstrates something of the versatility of the
pen for sketching. The speed of the technique, with swift, scratching strokes
of the pen used to describe form and volume, suggests that on the recto the
artist was making very rapid notes, probably from memory, of Antonellian
compositions. On the verso, motifs which may or may not derive from the
master, intermingle with what seem to be best described as doodles.

BIBLIOGRAPHY:
Popham and Pouncey 333 (as North Italian, c.1475)
Antonello da Messina, Exhibition catalogue, Messina, 1981, 44
S. Bottari, *Antonello da Messina*, Milan 1953, p.86
G. Fiocco, 'I Disegni di Antonello', *Arte Veneta* IV 1950, pp.49–54
J. Wright, 'Antonello da Messina – the Origins of his Style and Technique', *Art History* 3, 1980,
 pp.41–60

24 MARCO ZOPPO
Studies of the Madonna and Child (recto and verso)

London, British Museum, 1904–12–1–1
Pen and ink on paper
274 × 182 mm.

The repetition of the Madonna and Child theme on both recto and verso of
Zoppo's sheet illustrates the experimental approach characteristic of artists
working in Mantegna's circle. This allowed Zoppo to consider carefully a
variety of ways of treating a particular subject, and to extend the range of
composition beyond the more usual working models. In grouping the
figures together in a variety of poses, interrelationships and settings, Zoppo
has produced what is tantamount to a compendium of Madonna and Child
compositions for future reference and use. A number of distinct types are
brought together here: the Virgin of Humility (verso, upper and lower
right), the Madonna and Child enthroned, either set against the architecture
of a throne (verso, lower left), under a canopy (recto, upper right), or within a
garland supported by putti (recto, lower left), and the Madonna supporting
her child on a little parapet in front of her, a common Venetian motif. The
same theme is further expanded, varied and experimented with in two
sheets of less heavily worked pen and wash studies in Munich (24a).

The handling is swift, and in the accessories (the angels, canopies and
architecture), fluent and mobile. The main figures in each sketch are more
heavily worked, and although the outlines and hatching remain rapid, dark
pockets of ink are worked in to describe the darkest shadows and the deepest
recesses of the drapery folds. Because of this, the version on the upper left of
the verso has become rather wooden and stilted, despite the playful intimacy
of the pose.

BIBLIOGRAPHY:
Popham and Pouncey, 261
L. Armstrong, *The Paintings and Drawings of Marco Zoppo*, New York/London 1976, D.9, p.406
E. Ruhmer, *Marco Zoppo*, Vicenza 1966, p.70, pls.66–67

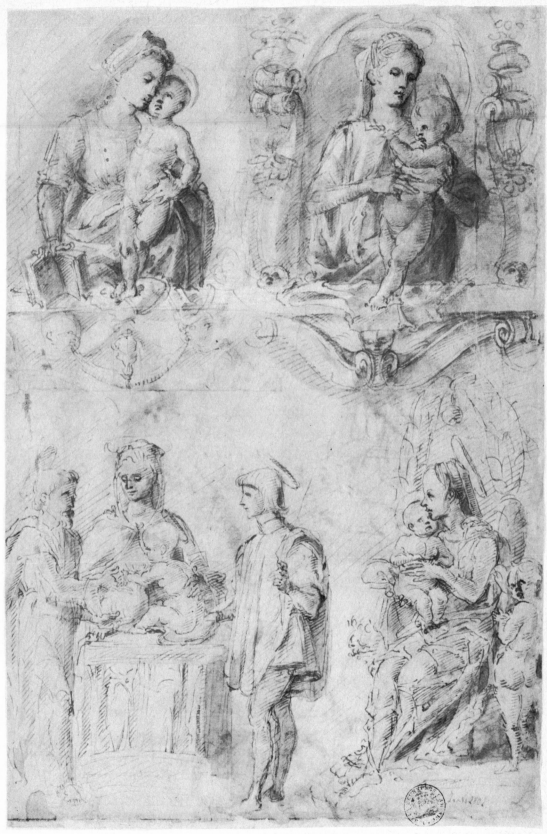

ABOVE 24a Marco Zoppo, *Studies of the Madonna and Child*. Munich, Graphische Sammlung, 2802 verso. Pen and ink on pink tinted paper; 286 × 196 mm.

25 FRANCESCO DI SIMONE FERRUCCI
*Studies of an Infant Christ Child
and Other Sketches* (recto)
Two Studies of Nude Men Holding Swords (verso)

London, British Museum, 1875–6–12–15
Pen and ink, over some black chalk underdrawing, on paper
255 × 185 mm.

This is one of a group of some thirty sheets which have been identified as belonging to a sketchbook used probably by Francesco di Simone Ferrucci, a sculptor who worked as an assistant in Verrocchio's studio. Three of the sheets are dated 1487–88, but this does not help to date the sketchbook in its entirety with any great precision, as it was common practice for workshop

sketchbooks to be kept 'open' for long stretches of time. This sheet, characteristic of the whole sketchbook, shows the way in which Francesco di Simone used the page itself as a stimulus to his consideration of an artistic problem. In a series of sketches on the recto, he studied the figure of the standing blessing Christ Child. The pose was repeated with only slight variations, which suggests that it was small details of stance, proportion, or expression that needed clarification. The left leg, for example, seems to have presented difficulties and was, therefore, studied separately three or four times. Subsequently he filled in the blank spaces on the recto with sketches of other forms.

Francesco di Simone's chief concerns as a sculptor are clearly reflected in the studies of the infant Christ. It was important to establish the chubbiness of the child, both by lighting his model from the far side (so that the hatching emphasised the form on the nearside, throwing it into greater relief), and by employing finely graduated hatching strokes which seem to follow the roundness of the baby's body. The firmly rounded contours themselves,

LEFT 25a Andrea del Verrocchio, *Madonna and Child*. Florence, Bargello. Terracotta, partially pigmented; 86 × 66 cm.

25 (recto) ▷

◁ 25 (verso) which follow the natural creases of the child's form, are also responsible for the sense of solidity which is created in these studies. Although the pose cannot be associated with a specific commission, it is closely related to the type of Christ Child blessing found in the popular half-length reliefs of the Virgin and Child produced by Verrocchio and his followers (25a).

The briefer sketch of a seated man may be related to the two sketches on the verso, also of male nudes holding swords, the upper one heavily and laboriously worked over with thickened, coarse contours, the lower one a much looser, anatomically more convincing study.

BIBLIOGRAPHY:
Popham and Pouncey 56
G. Gronau, 'Über das sogenannte Skizzenbuch des Verrocchio', *Jahrbuch der Königlich Preussischen Kunstsammlungen* XVII, 1896, pp.65–72

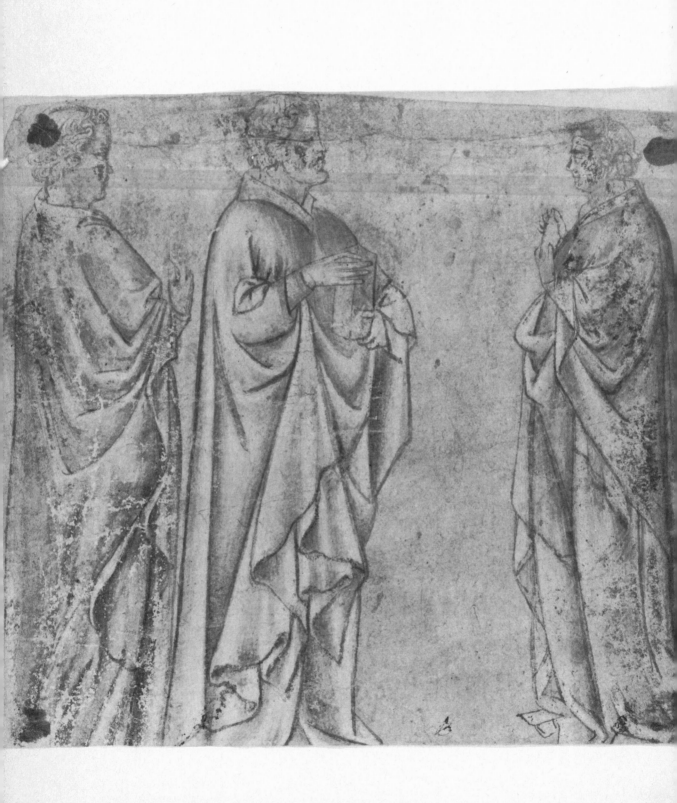

During the fifteenth century, a major change took place in the Italian artist's attitude towards human form, and hence also towards the pictorial function of drapery and the draped figure. Early in the century, when the painter was less concerned to represent anatomical form realistically, he tended to use drapery as an opportunity for personal graphic expression. By the end of the century, however, drapery was used primarily to demonstrate the form of the body beneath and to articulate its movements, as well as to emphasise the expressive character of the figure. These changes were prompted by a new interest, recorded by Alberti in *Della Pittura* (1436), in the rational presentation of narrative. In turn, draughtsmen were stimulated to explore the expressive possibilities of realistic drapery and of anatomically convincing draped figures.

Writing in about 1400, Cennino Cennini assumed that the artist would draw from a draped, rather than from a nude, model. 'Take the silver style and go over the outlines and accents of your drawings, and over the dominant folds, to pick them out . . .; with a wash of ink in a little dish proceed to mark out the course of the dominant folds with[the] brush; and then proceed to blend the dark part of the fold, following its course . . .' (Cennini/ Thompson p.17). These instructions reflect late fourteenth-century workshop attitudes: figure-study was approached by observing the draped surface, rather than by investigating the anatomical structure over which drapery was added. Cennini's concern was simply to build up a drapery pattern fold by fold, adding wash shading to the contours. This technique can be seen in late fourteenth- or early fifteenth-century figure-drawings such as III A, in which solid forms are defined by the drapery which completely muffles the articulation of the limbs beneath. The resulting figures are monumental, but motionless and expressionless.

Such concentration of attention on the shell within which neglected anatomical forms were encased stimulated draughtsmen to evolve personal, idiosyncratic drapery-fold patterns. By taking on a life of its own, the drapery could itself become an expressive element, unfettered by the demands of the human figure within it. Indeed, in the hands of some draughtsmen, drapery gained such freedom that the body beneath was manipulated out of recognition, resulting in bizarre, irrational figures. The best examples of the liberties taken for eccentric expressive ends are perhaps the figure-drawings of Parri Spinelli (27), in which the human form is capriciously elongated for the sake of the decorative curvilinear patterns generated by the drapery's lively mobility. Effects developed by these untamed fold-patterns may be forceful (26) or prettily intricate (1), but they clearly did not include concern with the inherent expressive value of the human form itself.

III A Tuscan Draughtsman, second half of fourteenth century, *Three Standing Figures*. Oxford, Christ Church, 0001. Pen and ink, with wash and white heightening, on pink tinted paper; 185 × 199 mm.

The early Renaissance theory of narrative required the reversal of these attitudes. Artists affected by the school of thought summed up in Alberti's treatise came to consider the human figure itself as the essential agent of meaning and expression. Drapery became merely an adjunct to the figure which would clarify, but should on no account conceal, the form's structure and movements. It might also be permitted supplementary expressive value, but could not be allowed to dominate or distort the figure beneath. 'For a clothed figure', wrote Alberti, 'we first have to draw the naked body beneath and then cover it with clothes' (Alberti/Grayson, para. 36, p.75). Full understanding of the correct articulation of the nude form in movement, so that both form and movement were convincingly rendered, had to come before the addition of appropriate dress. In the notes for his *Trattato della Pittura*, Leonardo da Vinci followed up and amplified these views early in the sixteenth century. 'Draperies that clothe figures should show that they cover living figures', he wrote. 'Show the attitude and motion of such a figure with simple, enveloping folds, and avoid the confusion of many folds . . .[make] the parts that cling to the figure show its manner of movement and attitude' (Leonardo/McMahon I, pp.203,206).

Leonardo also wished the narrative painter to represent a range of different drapery textures: 'in some, make the folds with smooth breaks, and do this with thick fabrics, and some should have soft folds with sides that are not angular but curved. This happens in the case of silk and satin and other thin fabrics, such as linen, veiling and the like. Also, make draperies with few but large folds in thick fabrics . . .' (Leonardo/McMahon I, pp.204,205). Associated with his concern with the definition of fabric textures is Leonardo's requirement that 'the garments of figures should be in keeping with age and decorum' (Leonardo/McMahon I, p.208), from which it follows that the fabrics and dress appropriate to an individual's status should be carefully distinguished through the nature of the fold-patterns. Leonardo da Vinci's advice on these matters indicates that all these aspects of the use of drapery had become common preoccupations of draughtsmen during the second half of the quattrocento.

The currency of these views on the potential of drapery to emphasise aspects of narrative and meaning gave rise to different types of drapery study. In order to understand better the relationship between drapery and anatomical structure, some draughtsmen made numerous studies directly from the model in both relaxed and dynamic poses. Drapery was often studied independently of a human form, to gain a clearer understanding of the fold-patterns natural to different fabrics. Finally, the experience gained from these sorts of study was applied to the preparation of draped figures for finished pictorial compositions. One other type of drawing which evolved out of these explorations was the drapery pattern-drawing, held in a workshop portfolio for reuse when appropriate to a composition under preparation.

Almost as many drawings of the clothed *garzone* as of the nude model survive from Florentine workshops of the last third of the quattrocento. Sheets such as those mounted together by Vasari (5), or the draped-figure studies which jostle for space alongside the nudes in 38, suggest that the need for the young draughtsman to train his eye by making rapid sketches of the draped model was just as pressing as the need for regular nude study.

This type of training was not, however, part of a North Italian apprentice-ship, although Carpaccio's quickly noted observations of Venetian types (59), made not in the studio but outdoors, indicate an analogous attitude to sketching the draped figure. The favoured technique for Florentine draped-figure studies, silverpoint and white heightening on pigmented prepared paper, suggests the artists' desire not only to examine relationships between form, movement and drapery, but also to study the fall of light on complex fold-patterns. Indeed, the touches of highlight on the folds, for example in 30, positively enhance the expressive movements of the forms beneath. This type of study was therefore of great importance, as the means by which both apprentice and master could feel their way towards complete con-fidence in drawing the draped figure.

The study of drapery patterns divorced from a human model also became a standard part of workshop training. A length of fabric dipped in plaster and set up for study, perhaps over a lay-model with jointed wooden limbs, could

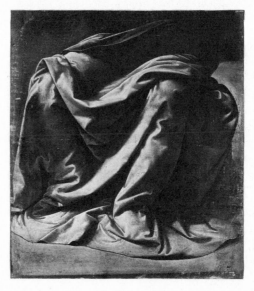

IIIB Leonardo da Vinci, *Study of Cast of Drapery for Seated Figure.* Paris, Louvre, 2255. Brush, with white heightening, on linen; 266 × 234 mm.

be considered and reconsidered thoroughly, and at leisure. The classic examples of such study are those made in Verrocchio's workshop by Leonardo da Vinci and his peers (IIIB). Drawn with the brush on prepared linen (a technique intentionally very similar to that of panel-painting), they show a conscientious precision of execution, which suggests that the faithful emulation of the texture and fall of fabrics was a top priority in the work-shop. These 'cast drapery' studies were probably primarily made for train-ing in the observation of texture, pattern and the fall of light. They have the exquisite precision of modelbook drawings, however, and likewise were sometimes used as models for draperies in finished paintings (IIIC), or as exemplars for copy-drawing (IIID).

A portfolio of draped-figure studies was often a stock property of the late fifteenth-century painter's workshop, just as the modelbook of animal drawings was essential to the workshop of *c.*1400. Careful studies of drapery formulae were thus kept for use and reuse when the occasion demanded, and valuable solutions for the drapery appropriate to particular contexts or individuals were copied and transmitted from workshop to workshop. A type invented by Fra Filippo Lippi (29) was frequently used in Domenico

Ghirlandaio's workshop (III E), and also reappears in works by other artists (III F). Sheets of drawings of draped figures were copied and recopied in Venetian workshops, so that each assistant may have collected his own stock of *simile* drawings like that from Carpaccio's workshop (34). Drawings of Oriental figures copied in the workshop of Gentile Bellini were widely disseminated in Venice, and were even used by Pinturicchio in frescoes in Rome and Siena (III G, III H).

These Venetian examples are, however, less drapery-studies than patterns of whole figures. Study of drapery did not reach as sophisticated a level in Venice as in Florence, if only because in Venice drawings were normally specifically associated with the preparation of paintings. In Tuscany the growing practice of making free studies in the workshop, or out-of-doors, as an inherent part of training the eye, led painters to develop a far greater sensitivity for the structure of a figure beneath his clothing, and for the response of the drapery to his pose and movement. The results of this training were a keener appreciation both of the rhythmic movements of draped figures, and of the patterns and structures of folds of different fabrics. The draughtsman also came to see how to distinguish more clearly the status of an individual through the characterisation of both fabrics and costume. Finally, he used drapery more effectively to reflect the expressive character of pose, movement, or emotional state, and thus to emphasise with greater strength the dramatic point in a narrative composition. The communication of a story in a manner which was at once rational, intelligible and affecting was the highest aim of the Renaissance artist, and the disposition of drapery on the actors in his pictorial drama was an important means at his command to achieve that end.

ABOVE LEFT III C Domenico Ghirlandaio, *Madonna and Child with Saints*, detail of Madonna. Florence, Uffizi, 881. Tempera (?) on panel; 200 × 191 cm. (complete).

ABOVE RIGHT III D After Leonardo da Vinci, *Copy of Cast Drapery Study* (III B). London, British Museum, 1895–9–15–459. Brush with white heightening, on pink prepared paper; 264 × 218 mm.

OPPOSITE BELOW LEFT III G Workshop of Gentile Bellini, *Standing Oriental*. Paris, Louvre, 4655. Pen and ink on paper; 301 × 204 mm.

OPPOSITE BELOW RIGHT III H Bernardino Pinturicchio, *Pope Pius II Arrives in Ancona*, detail. Siena, Cathedral, Libreria Piccolomini. Fresco on wall.

ABOVE RIGHT
IIIE Workshop of
Domenico Ghirlandaio, *Two
Female Figures*. Whereabouts
unknown. Pen and ink on
paper; 220 × 150 mm.

ABOVE LEFT
IIIF Maso Finiguerra? *The
Resurrection and the Three
Maries at the Tomb*,
London, British Museum,
1845.8.25.11B. *Niello* sulphur
cast, 56 × 41 mm.

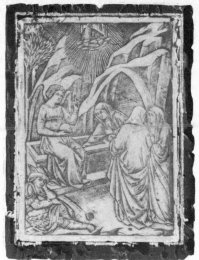

26 STEFANO DA VERONA
Seated Prophet in Profile (recto)
Seated Prophet Looking Up (verso)

London, British Museum, 1895–9–15–788
Pen and ink, over black chalk sketch, on paper
232×210 mm.

The two sketches of seated, draped figures on this sheet are drawn with the uninhibited zest typical of Stefano da Verona's graphic style. Of all distinguishable early quattrocento draughtsmen, Stefano swept his pen across the paper with the greatest vivacity and incisiveness. This is clear here in the the way that the curved flurries of line create a dynamic pattern around and across the forms, and generate an excited personality for each figure. On the recto, the fluent curves of the Prophet's turban reflect the broad swathes of the drapery folds across his back and round his waist, and the forceful movements of these folds emphasise the tempestuous concentration already hinted at by his hunched shoulders and furrowed brow. The draughtsman used his pen almost violently in his desire to characterise the figure's state of mind, rather than to demonstrate through the forms and movements of the drapery folds the anatomical structure beneath. The Prophet's body is exaggeratedly elongated, especially in the lower half, which is merely implied by a series of rapid thrusts of the pen, and the undisciplined contours are thickened to stress the tension of the pose.

On the verso, too, a sense of aggressive concentration is developed both by the expressive face and by the restless play of long sweeping curves against the harsh verticals and against the slashing diagonals of the hatching. Both sketches are powerfully personal in handling: although it has been suggested that they might have been initial ideas for *Evangelists* painted in fresco by Stefano in San Francesco, Mantua, they seem to be experiments in individual graphic style, rather than studies from the model with some particular purpose in mind. The mood developed stands in sharp contrast to the authoritative grandeur of Benozzo Gozzoli's *Isaac* (28): Stefano's two *Prophets* are swept up, through the dramatic energy of his pen, in their profound but tortured meditation.

BIBLIOGRAPHY:
Popham and Pouncey 254
G. Fiocco, 'Disegni di Stefano da Verona', *Proporzioni* III, 1950, pp.56–64
M. Fossi Todorow, *I Disegni dei Maestri: l'Italia dalle origini a Pisanello*, Milan 1970, p.91
K.T Parker, *North Italian Drawings of the Quattrocento*, London 1927, p.23, pl.4(recto only)

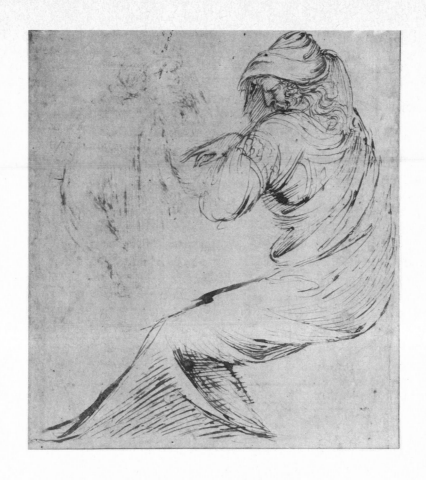

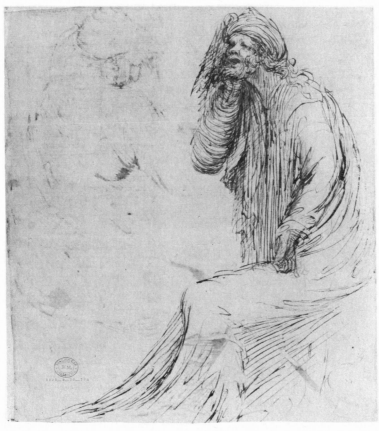

27 PARRI SPINELLI
St Peter (recto)
The Risen Christ (verso)

London, British Museum, 1895–9–15–480
Pen and brown ink on paper
274 × 130 mm.

Parri Spinelli's very individual graphic style is especially evident in the drawing of *St Peter* on the recto of this fragmentary sheet. The fluent, curvilinear contours of the exaggerated drapery forms were generated by bold, free penstrokes. In contrast, the fine cross-hatching laboriously builds up an impressive tonal range in the shadows, merging into a rich depth of darkness under the freestanding loops of fabric. On the verso, the tonal range is smaller and the drawing is rather freer, although the proportions of Christ's distorted anatomy are no less exaggerated than St Peter's. The extra layer of drapery thrown loosely over Christ's arm is more boldly, even brusquely, executed with the thicker, angular strokes of a correcting pen. Spinelli here exploited the versatility of the pen line, ranging from these hurriedly dashed strokes to the very fine, careful lines of the cross-hatching in the shadows.

In both drawings, Parri Spinelli was concerned essentially with the fold-patterns of a totally irrational fabric, fluttering across an insubstantial, greatly attenuated form. The simplified, almost careless, treatment of the form and surface of Christ's bare torso indicates the draughtsman's relative lack of interest in representing either anatomical structure or surface textures. These drawings were probably not made in preparation for any

BELOW 27a Parri Spinelli, *Two Saints*. Florence, Uffizi, 8E verso. Pen and ink on paper; 291 × 408 mm.

27 (recto) ▷

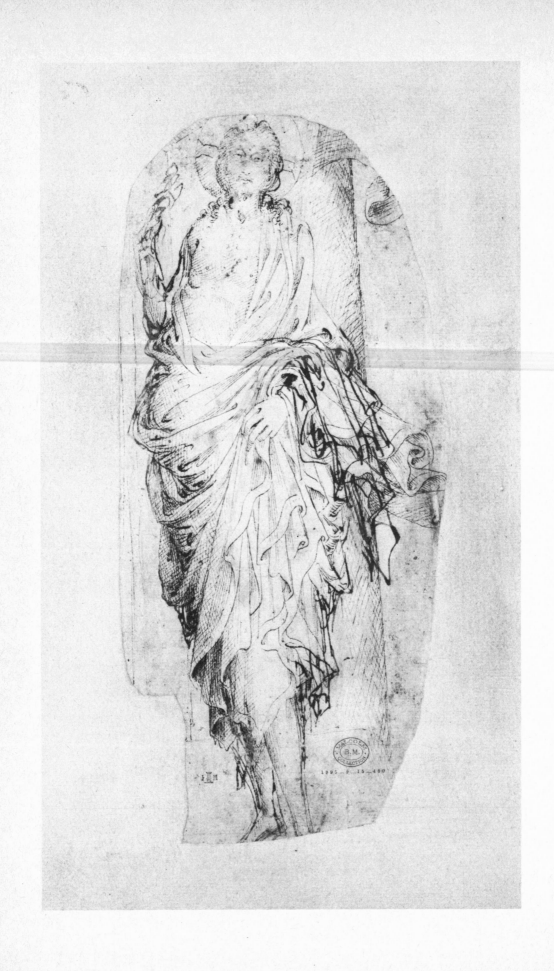

◁27 (verso) particular work, but are examples of Spinelli's study of the decorative fall and three-dimensional movement of drapery folds. This fragment probably came from a sheet of a sketchbook of such studies, several pages of which survive, principally in the Uffizi, Florence (27a). Another sheet from the same sketchbook is 49 in this exhibition.

BIBLIOGRAPHY:
Popham and Pouncey 186
Berenson 1837G
Degenhart and Schmitt 212

28 BENOZZO GOZZOLI
Study for the Patriach Isaac (recto)
Sketch of a Youth, from Chest Down (verso)

Edinburgh, National Gallery of Scotland, D.1249
Pen and wash, with white heightening, on pink tinted,
discoloured paper (recto)
Black chalk (verso)
163 × 67 mm.

This is a fine example of a fully worked-up preparatory study for a draped
figure. Gozzoli's pen mapped out the complex twists and angles of the old
man's voluminous drapery, anticipating Leonardo da Vinci's advice to the
draughtsman to 'make many folds . . . for old men in positions of authority
who are heavily clothed' (Leonardo/McMahon I, p.207). These lines, in
themselves rather lifeless, are given strength and character by the pen
hatching which follows the structure of the folds in the hollows of the
crumpled drapery. In turn, these shadows are reinforced by the application
of a light wash. The three-dimensional fullness of the folds is further stressed
by the white heightening which touches the forward rims of the folds below
the right elbow, and demonstrates where light reaches into the hollows of
the drapery falling across the waist and down the right leg.

This drawing is a study for the figure of Isaac in the fresco of the *Story of
Esau and Jacob* (28a) painted by Gozzoli in the Camposanto at Pisa between
1469 and 1474. Gozzoli was clearly concerned that the drapery should be

BELOW 28a Benozzo
Gozzoli, *Story of Esau and
Jacob*, detail: Isaac.
(Engraving by C. Lasinio
after fresco in Pisa,
Camposanto).

28 (recto) ▷

◁ 28(verso) appropriate to the figure depicted, for this heavy, voluminous drapery emphasises the authoritarian stature of Isaac. Paradoxically, the monumental effect created by the full drapery folds is not reflected by Gozzoli's feeling for anatomical structure: the proportions are unconvincing, and the hands and face are ill-articulated and lack expressiveness. On the other hand, the pen was used rhythmically to develop the effective contrast between the twists of Isaac's hair and the soft texture of his beard, which is stressed by a light wash and faint touches of white heightening.

On the verso is a slight sketch of a youth, concentrating on the lower half of the figure where the forms are finely hatched. This is an unusual example of Benozzo Gozzoli sketching in black chalk, articulating the figure's right arm and fingers with brisk, angular strokes.

BIBLIOGRAPHY:
Andrews 58–59
Berenson 533A
L. Collobi Ragghianti, *Il Libro de' Disegni del Vasari*, Florence 1974, p.65, fig.174
Degenhart and Schmitt 423

29 WORKSHOP OF FRA FILIPPO LIPPI
Study of Drapery [*colour plate 10*]

Oxford, Ashmolean Museum, KP 22
Silverpoint, with light brown wash and white heightening, on orange-pink prepared paper
175×99 mm.

In order to reach a fuller understanding of the play of light over the draped figure, the draughtsman took full advantage of the middle tone provided by the coloured ground. Against this he built the forms using the darker tone of the silverpoint line and the light, white heightening. Some of the shadows are further emphasised by the application of a light brown wash of diluted ink. This time-consuming technique gives the drawing a static though delicate monumentality. Almost invisibly fine silverpoint lines suggest the shadowy forms of the figure's head and shoulders. Within calm, fluent contours, the drapery forms were carefully constructed with short parallel hatching which gives rise, for example, to the shadow beneath the fold of drapery below the right elbow. White heightening was applied with a very fine brush in an equally conscientious manner. The highlights emerge softly from the middle-tone of the preparation, and the heavy folds of lustrous fabric are rendered by close, highly controlled hatching. This is an immaculate but laboriously executed drapery study, applying the complex 'three-tone' silverpoint technique to the detailed examination of fold-patterns over an undefined form.

Although very delicate, and of high technical quality, this drawing has the character of a formal workshop exercise, rather than of an experimental or preparatory study. Its relationship with a figure in Fra Filippo Lippi's *Miraculous Birth of St Ambrose* (29a) is therefore likely to be second-hand: it appears to be a copy by a very able workshop assistant of a drapery-study by

BELOW 29a Fra Filippo Lippi, *Miraculous Birth of St Ambrose*, Berlin, Gemäldegalerie, 59B. Tempera on panel; 280 × 510 mm.

29 ▷

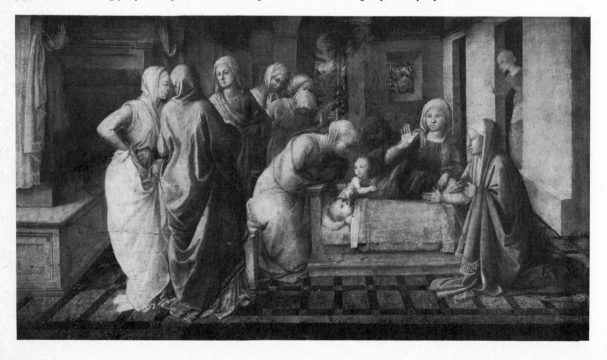

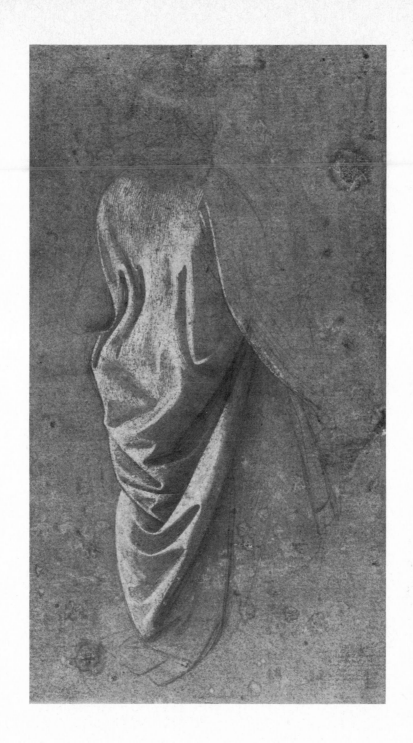

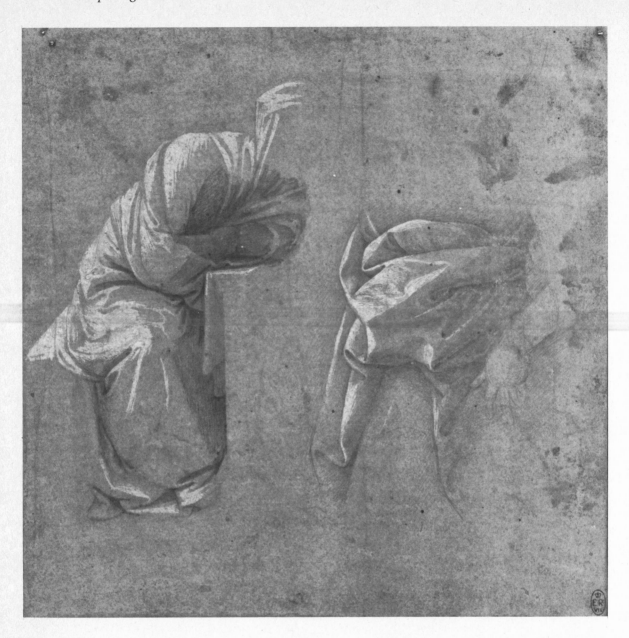

Filippo Lippi, rather than the preliminary study itself. It may be by Francesco Pesellino, one of Lippi's most talented assistants; it is certainly of higher quality than two other silverpoint drawings which derive from preparatory studies for the same predella panel (29b, 29c). The range in quality, and probably in date, of this group of drawings suggest that Lippi kept in his workshop a portfolio of drapery studies, from which his apprentices made copies as part of their training in the workshop techniques and style.

29b Workshop of Fra Filippo Lippi, *Studies of Drapery*. Windsor, Royal Library, 12753. Silverpoint and brush, with white heightening, on grey prepared paper; 200 × 200 mm.

BIBLIOGRAPHY:
Parker 22
Berenson 1387B
Degenhart and Schmitt 524 (as Pesellino)

29c Workshop of Fra Filippo
Lippi, *Drapery Study*.
Berlin, Kupferstichkabinett,
5081. Silverpoint, with white
heightening, on light blue
prepared paper;
174 × 148 mm.

30 FILIPPINO LIPPI
A: *Study of a Standing Youth* [colour plate 11]
B: *Study of Two Heavily Draped Men*

Chatsworth, Devonshire Collection, 886 A and B
A: Silverpoint, with white heightening, on pinkish-terracotta prepared paper
182 × 87 mm.
B: Silverpoint, with white heightening, on salmon-pink prepared paper
197 × 174 mm.

These two sheets show well the vigour and spontaneity of Filippino Lippi's use of the silverpoint in figure-study, and the variety of his handling of white heightening. In A, white pigment was brushed on very thinly in fine parallel strokes, to develop a range of tone which depends on the colour of the preparation showing through in places. The *garzone's* simple tunic is thus rapidly but convincingly depicted, the thicker folds on his arms clarified by quick twists of the brush. In B, on the other hand, especially on the right-hand figure, a thicker brush was used and drier paint was dragged in broad planes across the drapery forms. Filippino here perceived and recorded with confident speed the play of light over the fabrics' heavy folds. This free, even brusque, handling complements the verve of Filippino's silverpoint drawing. The lines which characterise the heads, features and hair, are springy and loose: the contours are bold and angular, cutting across forms already laid out as Filippino went over his earlier work with the forceful movement of a thicker stylus. The direct immediacy of action and correction contrasts noticeably with the gentler, more considered handling of Francesco Granacci (5), but is typical of Filippino's unconventional handling of the silverpoint.

These quick sketches, analogous to Filippino's nude study in 38, are fine examples of the late fifteenth-century Florentine draughtsman's concern to record fleeting impressions of draped workshop models. This practice enabled him both to build up a portfolio of samples, and to enhance and refine his visual responses as a guide to subsequent practice, when evolving figures for use in pictorial compositions. Filippino Lippi was remarkable amongst his contemporaries for the ease and fluency with which he handled the traditional Florentine painters' technique of silverpoint and white heightening, in his pursuit of these goals.

BIBLIOGRAPHY:
Chatsworth Exhibition II, 33
Parker and Byam Shaw 30
Ragghianti and Dalli Regoli 2, p.74 (A only)
Scharf 217 (B only)

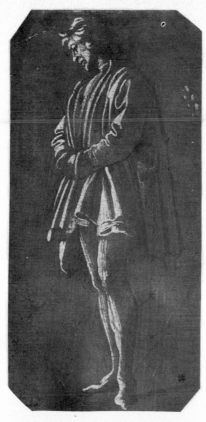

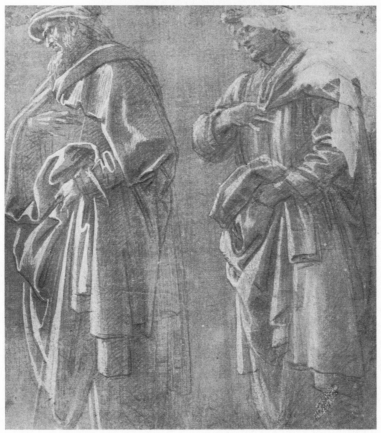

31 FOLLOWER OF LEONARDO DA VINCI
Study of Drapery for a Kneeling Figure

Oxford, Christ Church, 0048
Silverpoint, with white heightening and some brown wash, on grey-blue
prepared paper
251 × 187 mm.

The draughtsman of this fine study imitated in silverpoint the handling of
drapery studies drawn with the brush on prepared linen (III B), which were
basic to the training followed by Leonardo da Vinci and fellow apprentices
in Verrocchio's workshop. The upper part of the figure, facing to the right, is
briefly sketched, as though to provide the justification for the pattern in
which the drapery falls. Lower down, however, the folds apparently flow
across two steps which bear little relation to the pose of the kneeling figure.
The cloth was evidently supported in some contrived manner, and may
have been a 'cast' of a length of fabric dipped in wet plaster, thrown over a
support and drawn when dry.

The silverpoint lines indicating the contours of the principal forms are
bold and free, as is the hatching, strengthened by wash, in the hollow
between the figure's back and robe. The articulation of the folds was built
up, within these silverpoint lines, by the addition of extremely delicate
hatching with the brush and white heightening. Thus the crumpled folds
stand proud of the grey-blue background: the thicker the hatching, the
higher the relief. The draughtsman has achieved a pleasingly subtle play of
light across the surface of the fabric, which takes on a fine, silky sheen. The
resulting drawing has the character of a high-quality underpainting, being
essentially a careful brush drawing within light contours. Such a study as
this might well have been made as a training exercise in preparation for
painting on panel. In style and handling, it is directly comparable with a
study (31a) for the drapery of Christ in a painting of the *Resurrection* in Berlin
(31b). This relationship indicates that the function of such drawings was
specifically preparatory, and that the technical parallel with under-painting
on panel was deliberate.

BIBLIOGRAPHY:
Byam Shaw 23

31a Follower of Leonardo da
Vinci, *Study for Drapery of
the Risen Christ*.
London, British Museum,
1895–9–15–485. Silverpoint,
with white heightening, on
grey-blue prepared paper;
180 × 156 mm.
31b Follower of Leonardo da
Vinci, *Resurrection of Christ*,
detail of Christ. East Berlin,
Gemäldegalerie, 90B.
Oil on panel;
230 × 183 cm. (complete).

31 ▷

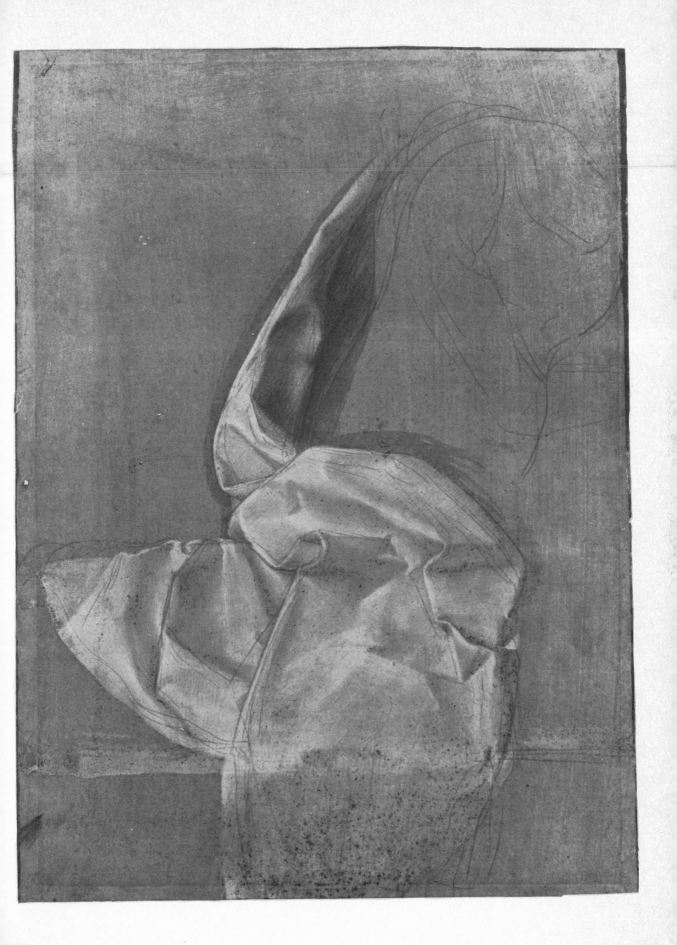

32 BARTOLOMMEO MONTAGNA (?)
A Virgin Martyr

London, British Museum, 1946–7–13–35
Red chalk on paper, faintly squared in black chalk
253×118mm.

This figure-study demonstrates very well the amplitude of red chalk, and its value for conveying broad effects of form and drapery. The static grandeur of the figure results in some distortion of normal female proportions, and the elongation between waist and knee is emphasised by the jagged, almost crystalline folds which lie across the figure's thigh in broad planes juxtaposed at sharp angles. At the foot, lines and hatching are freely drawn to produce a solid, columnar structure, supporting the more carefully articulated forms above. At waist level, two sharp-edged folds, as unbending as sheet-metal, form an arrowhead of line and colour, to focus attention on the head and the hand holding the martyr's palm. By using strong tonal contrasts in the lower half of the figure, the draughtsman ensured that the monumental three-dimensional forms would show through the faceted drapery, although he failed to differentiate entirely satisfactorily between the limbs and their positions. In contrast, the tonal range of the upper half of the body is slight, and the arms and hands are weakly articulated.

The handling of red chalk here is generally analogous to the handling of the oil medium by painters in Giovanni Bellini's circle. This can, for example, be sensed in the tonal gradient which builds up the forms of the left shoulder and of the area around the waist, the right breast and the hip, which is tucked away behind the shadow-casting flange of drapery. The squaring in black chalk indicates that this study was transferred onto the larger scale of a finished painting: it seems therefore to have been a preparatory study, in which red chalk and voluminous drapery were exploited to convey an impression of pious and dignified resignation.

BIBLIOGRAPHY:
Popham and Pouncey 177
L. Puppi, *Bartolommeo Montagna*, Venice 1962, p.146

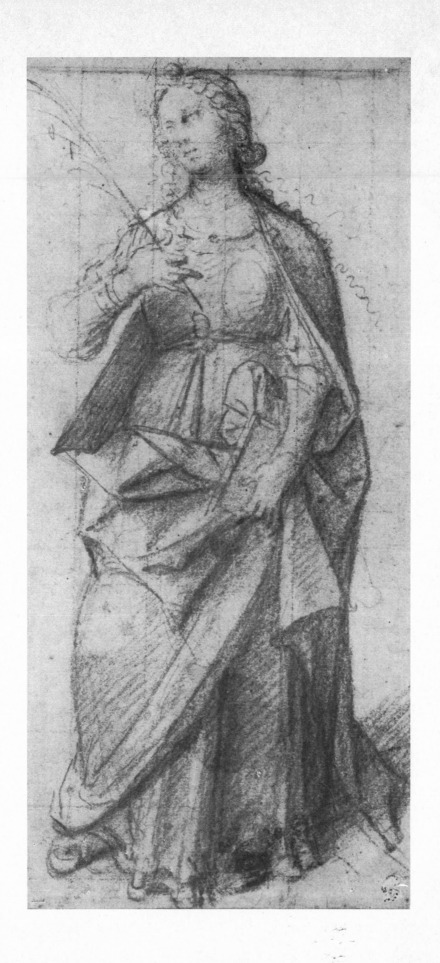

33 WORKSHOP OF GIOVANNI BELLINI
St Paul

Oxford, Ashmolean Museum, KP 3
Pen and ink, with wash, on paper
170×95 mm.

The richly draped figure of the ageing St Paul provided a valuable subject for a workshop assistant's exercise in the handling of wash. As befits the venerable authority of this figure, the drapery folds here are long and full. This drawing is, however, weak in a number of respects, and is probably an apprentice's copy of a figure-study by Giovanni Bellini. It is tentative and rather laborious, and lacks conviction in both form and expressive strength. However, within the unvaried contours, which are sometimes harsh and angular, sometimes timidly unpredictable, wash is applied conscientiously to build up a range of tones. A good example is in the shadows beneath the fold of drapery falling from St Paul's right arm. Although the copyist seems to have misunderstood this fold and how it relates to the form beneath, the brushstrokes which carry different strengths of wash build up the depth of shadow with neat precision. Similarly, the way that the wash is touched on lightly over the left arm and leg to fill out the drapery folds indicates the apprentice's developing deftness in handling the brush. His maturing skill shows at its best in the way that he emphasised the craggy features of the saint's pensive face with soft touches of the brush, which he also exploited successfully to suggest the contrasting textures of hair, beard and fabric.

BIBLIOGRAPHY:
Parker 3

34 WORKSHOP OF VITTORE CARPACCIO
Two Youths and an Old Man (recto)
Two Figures (verso)

Oxford, Ashmolean Museum, KP8
Brush and wash, with white heightening, on faded blue paper
218 × 268 mm.
Mounted by Vasari for his *Libro de' Disegni*, with his attribution to Giovanni
Bellini.

This sheet of five figure-studies is characteristic of the style and technique of
simile drawings probably copied from original studies of the model by
Carpaccio. The technique of laying on long, thin parallel strokes with a fine
brush, to build up both shadow and highlight against the middle-tone blue
of the paper, was often used in Venetian workshops, especially Carpaccio's
(ID, 70). In these studies, however, the handling of the brush in rendering
tonal modelling between the rather ponderous, thickened contours is
laboured and mechanical. The articulation of form beneath the drapery
folds is neither confident nor very accurate, and the facial types are over-
simplified and expressively unconvincing. Furthermore, the incompleteness
of the youth on the verso seems to imply that the copyist was working from
painted or drawn exemplars, rather than directly from the model. This
makes an interesting contrast with the liveliness of the draped-figure studies
from the model, produced at much the same date in Filippino Lippi's
workshop (30).

Despite the rather laborious quality of these workshop copies, the
characteristics of Carpaccio's drapery style are evident, especially in the
heavy planes of fabric in the mantle of the full-face man on the verso. The
figures on the recto wear thinner fabrics which are pulled into sharp-angled,

34a Vittore Carpaccio,
*St Ursula Taking Leave of her
Parents*, detail: figures in
background.
Venice, Accademia, inv. 369.
Oil on canvas;
280 × 611 cm. (complete).

34 (recto) ▷

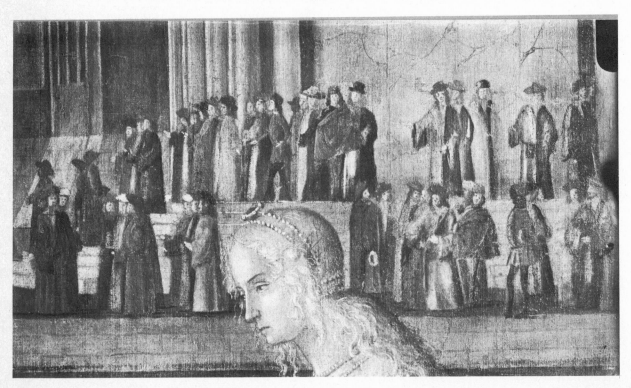

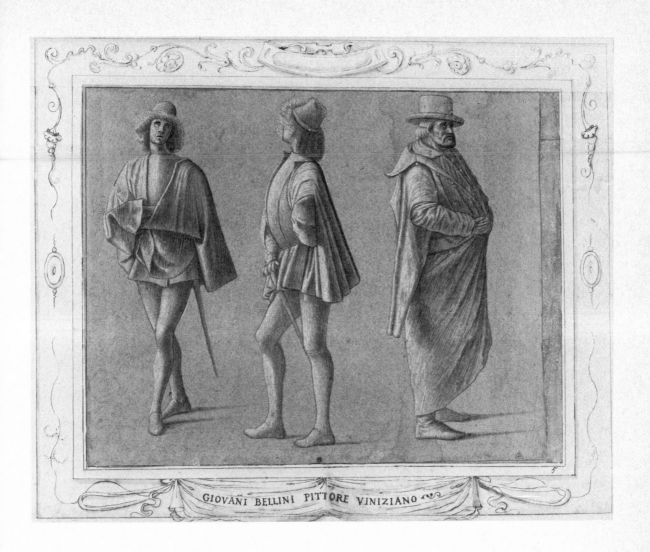

GIOVAÑI BELLINI PITTORE VINIZIANO

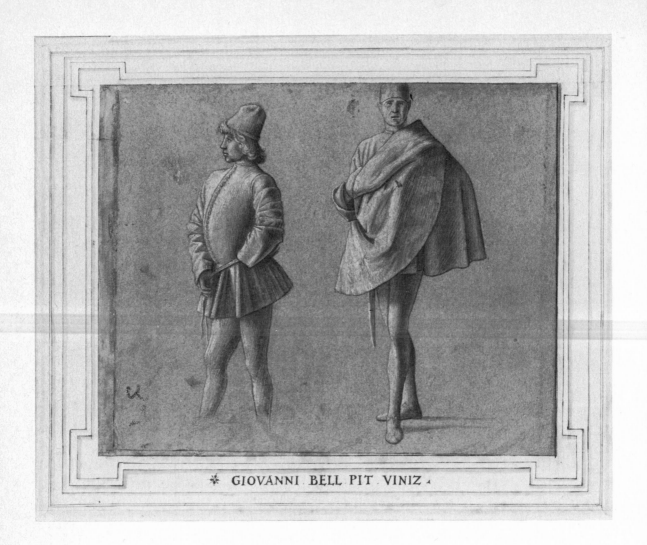

✳ GIOVANNI BELL PIT. VINIZ ◂

34b Workshop of Vittore
Carpaccio, *Studies of Two
Figures*. Vienna, Albertina,
20 verso. Brush and wash,
with white heightening, on
blue paper; 220 × 276 mm.

◁ 34 (verso)

linear folds, for instance over the old man's pot-belly, and across the arms and torso of the youth at the left. The prototypes of these copies were probably worked up by Carpaccio as finished studies from compositional sketches like 58. Closely similar drapery formulae, perhaps transferred from the same prototypes, appear in three figures in the background of *St Ursula Taking Leave of her Parents* (34a). Two of the figure-drawings on a companion sheet (34b), of almost the same size and apparently the same provenance as 34, reappear in the *Miracle of the True Cross* in the Accademia, Venice. These two sheets of figure-studies were evidently copied from preparatory drawings made by Carpaccio and retained in his workshop stock to serve as exemplars for apprentices' exercises.

BIBLIOGRAPHY:
Parker 8
L. Collobi Ragghianti, *Il Libro de' Disegni del Vasari*, Florence 1974, p.71, figs.195–196
Lauts 39, p.274
Muraro p.67
K.T. Parker, *Disegni Veneti di Oxford*, Venice 1958, 6
Tietzes 649

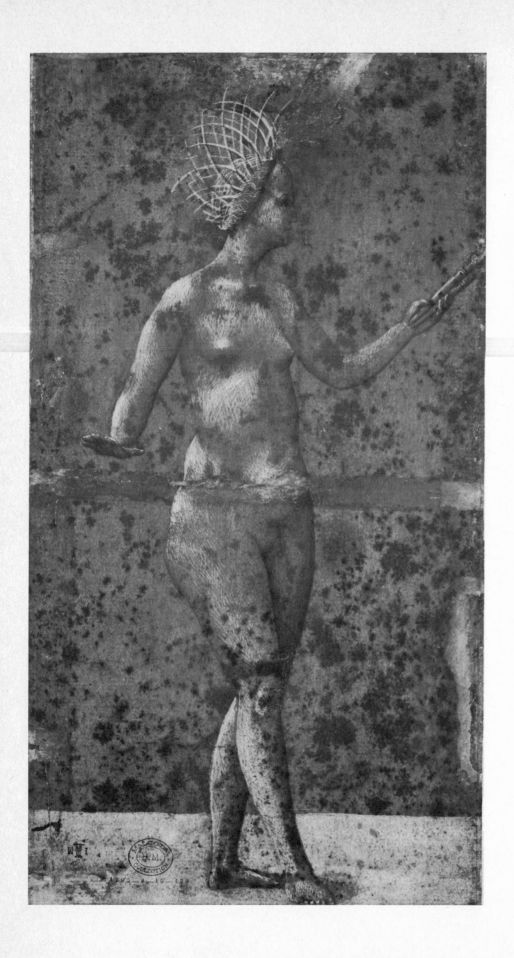

IV The Nude Figure

The study of the nude figure reflects the development of artistic and intellectual interests during the course of the quattrocento perhaps more directly than any other aspect of early Renaissance graphic practice. At the beginning of the century very little life drawing was made anywhere in Italy, yet by its end drawing from the nude model was probably the most practised exercise in draughtsmanship, and was recognised as playing a vital role not only as a training for apprentices, but also as a regular discipline for all the artists in the workshop.

The evolution of nude study is obviously linked to the way in which thinking about the aims of art developed as the century progressed. It was a fundamental belief of the Renaissance artist that art should strive to make a convincing representation of perceived reality, at the centre of which, of course, was man. To represent the human form as realistically as possible, and to involve him in credible interaction with others and with his environment, the artist required a detailed knowledge of human anatomy and physique, at rest and in motion. This he could only acquire by close study of the nude form set in different poses and drawn from different angles. The stimulus for this approach to realism in figure drawing came first in Florence, when in *Della Pittura* Alberti set out, and gave practical guidance for the application of, the most important contemporary ideas about aesthetics. It is here that we find detailed discussion of the best methods for exploring human form through drawing from the nude. It is surely no coincidence that there is little evidence of nude study being practised in Florence until after 1436, when *Della Pittura* was in circulation. Nor can it have been by chance that Florentine artists became the pioneers of life drawing as an exploratory, educative process.

Early in the century the small amount of nude study that was done was both tentative and arbitrary. The Veronese artist of 35, whose cautious inexperience is seen in the halting pen marks with which he delineated the figure, had no real interest in the depiction of the rhythms and movements of musculature. One is almost hesitant to describe the work as 'life drawing', for it can bear little anatomical resemblance to what the draughtsman was actually looking at, supposing that there was a model there at all. A Tuscan draughtsman working in the 1430s (IV A) was, on the other hand, clearly working from a posed model, and was obviously concerned to describe the fullness and palpability of the form by using soft shading and by applying his heightening as lightly and subtly as he could. But his observation of the figure was fragmentary and superficial, for although details, such as the foreshortened right hand and arm, and the fleshy plumpness of the waist and hips, are successful, the figure seen as a whole is oddly misproportioned.

IV A Tuscan Draughtsman, c.1430, *Study of a Female Nude Holding Two Torches*. London, British Museum, 1895–9–15–439. Brush with brown and white pigment, on olive-green prepared paper; 249 × 136 mm.

Had he had the benefit of Alberti's advice that 'in assessing the proportions of a living creature we should take one member of it by which the rest are measured' (Alberti/Grayson, para.37, p.75), he would have produced a very different looking figure.

By the middle of the century significant changes in attitude to nude study can be seen, particularly in Florence. As artists increasingly wanted to penetrate beneath the surface detail, so they began to examine volume and structure in a more sophisticated way by drawing much more frequently from live models posed in the studio. Living figures had an inherent advantage over the antique sculptures which had acted as the first models for systematic study of the nude. They actually possessed a skeleton to which the muscles, sinews and flesh were attached, and thus supplied an important element, missing from statuary, which Alberti had encouraged artists to take account of:

> ... it will help, when painting living creatures, first to sketch in the bones, for, as they bend very little indeed, they always occupy a certain determined position. Then add the sinews and the muscles, and finally clothe the bones and muscles with flesh and skin . . . just as for a clothed figure we first have to draw the naked body beneath and then cover it with clothes, so in painting a nude the bones and muscles must be arranged first, and then covered with appropriate flesh and skin in such a way that it is not difficult to perceive the positions of the muscles.
>
> (Alberti/Grayson, para.36, p.75)

A group of typical studies can be seen on a sheet such as 36. The draughtsman worked across the page studying each of the poses in turn, analysing the way in which the musculature adapts itself to perform varying tasks. A chalk drawing of a figure posed as the victorious David, attributed to Domenico Veneziano (IVB), shows a similar interest in the underlying structure of the anatomy, but in the hands of the more accomplished artist the form is treated with far greater subtlety and innuendo, particularly in the inter-relationship between light and shade. The softness of the skin texture, the litheness of the young limbs and the firmness of the flesh are all convincingly evoked by the gentle chiaroscuro.

Draughtsmen also continued to work from antique statuary, some taking heed of Alberti's suggestion that 'from sculpture we learn to represent both the likeness and the correct incidence of light' (Alberti/Grayson, para.58, p.101). However, the artists working in Gentile da Fabriano's workshop who produced 18 verso and IIF channelled their energies into copying the pose, describing details, and suggesting the nature of the surface rather than of the anatomical structure of the forms they copied. As a result the figures are strangely proportioned and seem dislocated and unco-ordinated in their movements. In a study of a classical *Female Torso* (IVC), on the other hand, a member of Benozzo Gozzoli's studio ably demonstrated how the subtle use of light and shade amplifies the volumes and suggests the structure of the forms, without ever becoming harsh or intrusive. But, ultimately, working from sculpture was of limited value to the artist whose desire was to represent Nature, since he was necessarily hindered by its unyielding surfaces and frozen poses (compare 42 with 43). Although the copying of antique figures was avidly practised by those with antiquarian interests (43,44), and collections such as the *Codex Escurialensis* (44b) were compiled,

IVB Attributed to Domenico Veneziano, *Nude Youth Posed as David.* New York, Metropolitan Museum of Art, Gift of Cornelius Vanderbilt, 1880 (80.3.115). Black chalk, with white heightening, on grey paper; 213 × 95 mm.

IVC Workshop of Benozzo Gozzoli, *Study of a Classical Female Torso.* New York, Cooper-Hewitt Museum, 1901.39.2971. Silverpoint, with white heightening, on grey prepared paper; 172 × 92 mm.

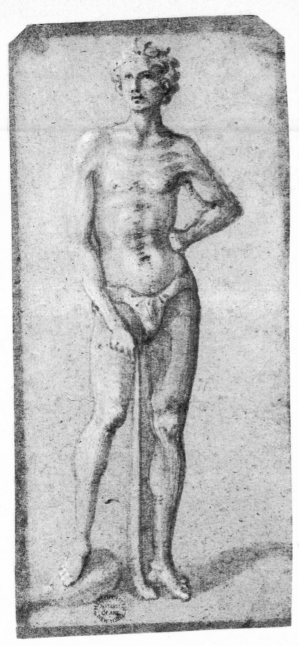

the live model was generally pursued with much greater and more wide-spread enthusiasm. But just as Pisanello's modelbook-style animal studies (IID) failed to 'come to life', for all the care lavished on their detailed depiction, so also the key to realism in figure drawing did not lie simply in the accurate articulation of the limbs and detailed delineation of the musculature. The draughtsman working from the posed model came to realise that the description of characteristic movement, expressive gesture, and the rhythms of the body in action, were vital to a truly naturalistic representation of man.

The desire to depict the figure in motion led artists to explore the use of new materials and novel ways of handling conventional ones. Filippino Lippi's silverpoint and heightening (38) is stretched to the limits of its

capabilities and is used with unprecedented rapidity and immediacy. The fleeting nature of some of these poses is skilfully echoed by the economy and speed of his handling. The pen, naturally responsive to rapid handling, was well suited to the depiction of a figure involved in violent action, such as Antonio Pollaiuolo's *Hercules* (39 recto), where it is used brilliantly to suggest great dynamism and vigour. The quill's organic flexibility could also be exploited to create a fresh and lively outline as it explored the contour of a figure, reflecting in its rhythms the fluent movement of the draughtsman's hand (IV D). But when it came to exploring the complexities of muscle structure, whether completely relaxed (41), or subjected to agitated movement or great strain (42), nothing was as effective as chalk. Its soft texture and fine consistency offered the artist the possibility of rendering changes in tone absolutely smoothly and consistently across an area of form. Furthermore, its breadth and directness permitted a spontaneity which gave the artist an ideal medium for the depiction of the nude in movement. Although chalk became increasingly popular after *c.*1460, its particular suitability for nude study does not seem to have been fully exploited until the end of the century. This may be due to the weight of tradition in Florentine studios, where nude study in silverpoint had become a cornerstone of workshop practice. And it is perhaps telling that the first artist to realise the full value of chalk for figure drawing was Luca Signorelli, working in Umbria and Tuscany, but outside the mainstream Florentine tradition.

In North Italy a very different approach to life drawing prevailed. Largely because of the continued use of the modelbook, nude studies, like other drawings, were intended to be finished, definitive statements of a specific form (IV E). This naturally inhibited the use of drawing for exploratory or educational purposes. Furthermore, since Venetian drawings were usually directly related to specific paintings, there was little opportunity or desire to use them for experimentation in form.

Another by-product of the modelbook tradition was that North Italian artists had a highly developed sense of surface texture. In a drawing such as Jacopo de' Barbari's so-called *Cleopatra* (IV F), the result of the combination of surface awareness with the lack of real concern about underlying structure can be seen in the matching of the soft, plump flesh with an anatomical structure which leaves much to be desired. The proportions of the female nude in an *Allegorical Subject*, attributed to Bernardo Parentino (IV G), are similarly awry: her overlong legs, small, high-set breasts and straight unwaisted torso produce a rather androgynous appearance. This drawing was made on vellum, which remained in use in North Italy long after it fell from favour in Tuscany: another indication of the persistence of the modelbook and its conservative traditions. However the Venetians too had their own uses for new materials. Whereas Signorelli used chalk to enhance the description of volume and structure and of vigorous movement and tensions in his nude studies, his North Italian contemporaries used its softness and breadth to emphasise rather different qualities. In his study of a *Male Torso for a Pietà* (IV H), for example, Carpaccio stroked his chalk across the form very softly, but with a nonetheless relentless verticality which seems to drag the skin downwards and suggest its 'deadness', transferring to the draughtsman's living model a quality demanded by the finished subject.

ABOVE LEFT IV D Andrea Mantegna, *Studies for a Flagellation*. London, Home House Trustees Collection. Pen and ink on paper; 234 × 144 mm.

ABOVE RIGHT IV E Jacopo Bellini, *Samson*. Paris, Louvre, 1549. Silverpoint on prepared parchment, reinforced with pen and ink; 427 × 290 mm.

BELOW LEFT IV F Jacopo de' Barbari, *Cleopatra* (?). London, British Museum, 1883–8–11–35. Pen and ink on paper; 205 × 174 mm.

BELOW RIGHT IV G Attributed to Bernardo Parentino, *Allegorical Subject with a Female Nude and a Child Trampling a Serpent Underfoot Before an Altar*. London, Victoria and Albert Museum, Dyce 149. Pen and ink on vellum; 242 × 171 mm.

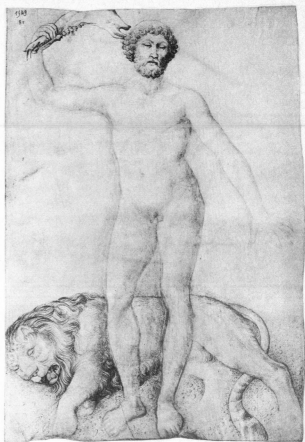

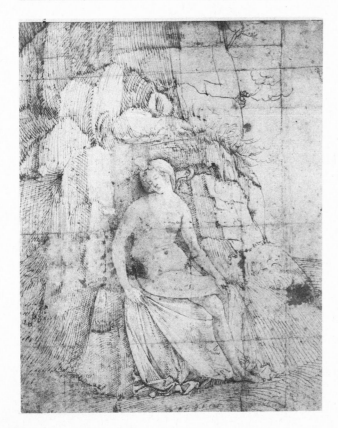

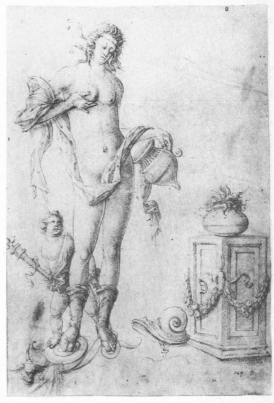

LEFT **IVH** Vittore Carpaccio, *Study of a Seated Male Nude.* London, British Museum, 1946–7–13–3 verso. Black chalk on green paper; 197 × 220 mm.

RIGHT **IVI** Leonardo da Vinci, *Leg and Torso of a Male Nude in Profile.* London, British Museum, 1886–6–9–41. Red chalk on salmon-pink prepared paper; 252 × 198 mm.

Alberti's advice about the clothing of the skeleton with sinews, muscles, flesh and skin, was taken to its ultimate conclusion by Leonardo da Vinci. The number of his nude studies which can be classified as pure life drawing is in fact relatively small by comparison with the vast collection of anatomical drawings he made, but his conviction that detailed anatomical study was essential for the artist wishing to depict the human form is clearly set out in his writings from around 1500.

It is a necessary thing for the painter, in order to be good at arranging parts of the body in attitudes and gestures which can be represented in the nude, to know the anatomy of the sinews, bones, muscles, and tendons. He should know their various movements and force, and which sinew or muscle occasions each movement, and paint only those distinct and thick, and not the others, as do many who, in order to appear to be great draughtsmen, make their nudes wooden and without grace, so that they seem a sack full of nuts rather than the surface of a human being, or indeed, a bundle of radishes rather than muscular nudes.

(Leonardo/McMahon I, p.129)

Many of his anatomical drawings were obviously made from dissections which he witnessed, perhaps at the Ospedale di Santa Maria Nuova in Florence, as related by the Anonimo Gaddiano. But many other studies of the human figure, or parts of it, lie half way between anatomical study and life drawing, demonstrating just how far a scientific analysis of the structure informs and enhances the depiction of the outer appearance (IV I).

Leonardo's questioning mind, acute eye and powerful intelligence are matched by his formidable manipulation of materials. Never had chalk modelling been so suggestively or subtly exploited, nor pen and ink used to

describe tonal variations so softly, rendering flesh all but touchable (45). Although the majority of Leonardo's nude studies come from after the turn of the century, and are usually regarded quite properly as masterpieces of High Renaissance art, they also hold an important place at the apex of an earlier tradition of nude study, giving brilliant form to so many of the quattrocento draughtsman's aspirations.

35 VERONESE SCHOOL, early fifteenth century
Nude Male Figure Throwing a Ball (recto)
Two Naked Children Attacked by a Serpent (verso)
[*not illustrated*]

Oxford, Christ Church, 1256
Pen and ink on pink tinted paper
215 × 175 mm.

Unlike his Florentine counterpart, the North Italian draughtsman seldom made life drawings. Generally he did not use nude study as a vehicle for anatomical exploration in order to learn how to represent the human form more realistically, but drew from the model only if the subject to be depicted demanded nudity. This work is therefore unusual because of both its early date and its North Italian origin.

The anonymous draughtsman's inexperience in the study of nude form is all too apparent. Indeed, one wonders whether this figure was actually drawn from a life model, or whether it was invented from the artist's memory. Not only is the figure hopelessly misproportioned, with its tiny head, elongated torso and nipped waist, but lack of close observation of the individual parts has resulted in such extraordinary characteristics as the 'dislocated' ankle and prehensile toes. All the outlines have been worked over and strengthened, which creates an impression of tentativeness, particularly where a double outline shows. The internal modelling is worked in a similarly gingerly way. The hatching is applied in thin, wispy strokes, which give the figure an unfortunately 'hairy' appearance, and the draughtsman's lack of real understanding of muscular structure is very evident in his failure to describe muscle movement accurately in his modelling.

Although the Veronese artist's anatomical knowledge is negligible and his talent limited, this drawing does display an interest, unusual at such an early date, in representing the human form in movement. The right arm and hand holding the ball may be inadequate as life study, but a sense that the ball is about to be thrown is created by the figure's stance, the direction of his glance and the slight tension suggested in his legs and feet.

BIBLIOGRAPHY:
Byam Shaw 685

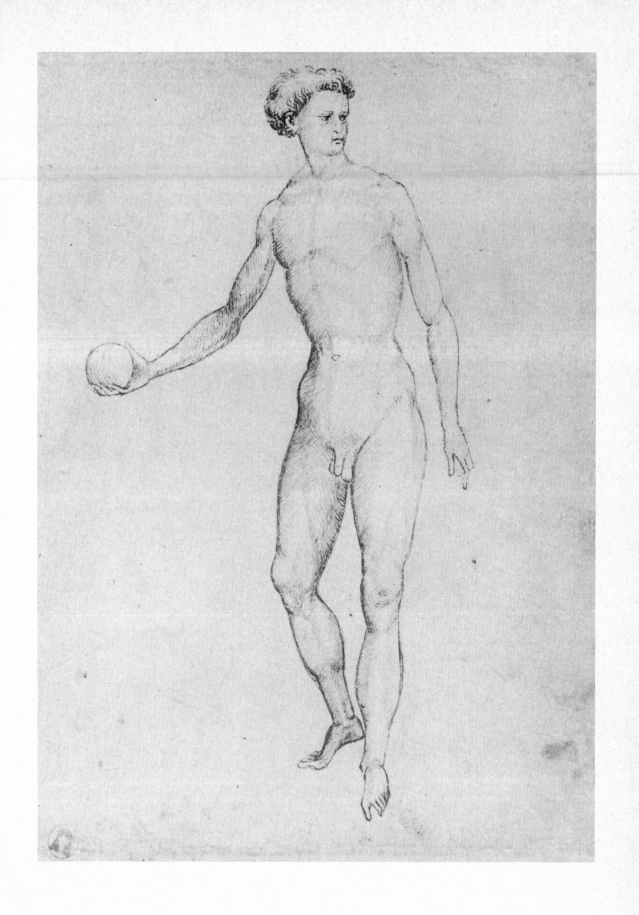

36 WORKSHOP OF BENOZZO GOZZOLI
Study of Four Nude Figures

Oxford, Christ Church, 0015
Pen, wash and white heightening on orange-brown tinted paper
182 × 275 mm. (irregularly cut at the base)

Drawing from the nude became an increasingly popular practice during the course of the fifteenth century in Florentine workshops. This sheet of studies of four male nudes, probably produced in the workshop of Benozzo Gozzoli, is a typical example of the way in which the nude model, posed in the studio, was studied by Florentine workshop assistants around 1450–60.

The outlines are drawn rhythmically enough, but the figures lose credibility as articulated anatomical forms through the somewhat laborious process of modelling with wash and thickly applied white heightening. This is especially true of the figure to the right, which is the least successful in any case, being overworked and rather heavily handled. The relief of the forms is keenly observed, if rather exaggerated in the building up of the musculature (especially of the seated, begging model), but the proportions are awkward and the figures lack vitality. This may perhaps be the result of the artist's concentration on the surface modelling, which overrides any feeling either for the underlying structure or for the subtlety of the whole figure as a dynamic unity. The greater brevity of the seated figure, however, anticipates the increased freedom of handling for the study of the nude in the workshops of Filippino Lippi, Francesco Granacci and others.

BIBLIOGRAPHY:
Byam Shaw 5
Berenson 559
Degenhart and Schmitt 475

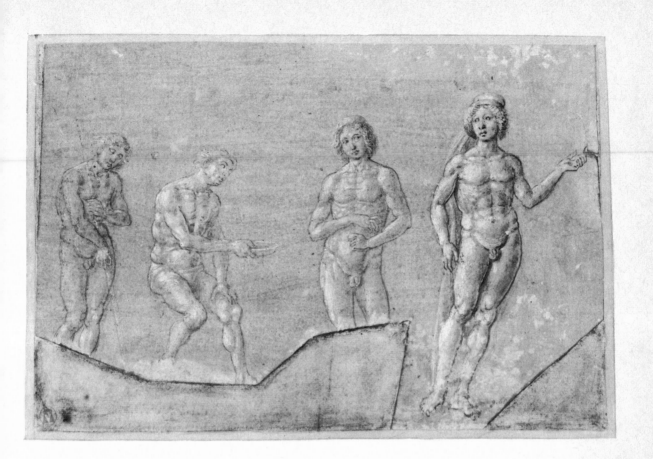

37 WORKSHOP OF ANTONIO POLLAIUOLO
Nude Man Seen from Front, Side and Back

London, British Museum, 1885–5–9–1614
Pen and ink on yellow parchment
255×281 mm.

This is the most complete surviving copy of a much imitated drawing of a nude man seen from three different angles, the original of which is a sheet in the Louvre (37a) inscribed: '*Antonii Jacobi excellentissimi ac eximii florentini pictoris scultorisque prestantissimi hoc opus est. Umquam hominum imaginem fecit vide quam mirum in membra redegit.*' (This is the work of the excellent and famous Florentine painter and outstanding sculptor Antonio, son of Jacopo. When he depicts man, look how marvellously he shows the limbs).

Only the second sentence of the inscription is copied onto the drawing exhibited here, and the right hand side is trimmed through the inward-facing pose. This sheet is perceptibly weaker in handling than the Paris drawing. The hatching is more mechanical, and the dark zones which punctuate both internal and external contours of the original, where the freely moving pen has hesitated and deposited more ink, are almost entirely absent in the more restrained, more slowly executed workshop copy. However, the assistant responsible has apparently grasped one of the main

37a Antonio Pollaiuolo,
*Nude Man Seen from Front,
Side and Back*.
Paris, Louvre, 1486. Pen and
ink on paper; 264×351 mm.

37 ▷

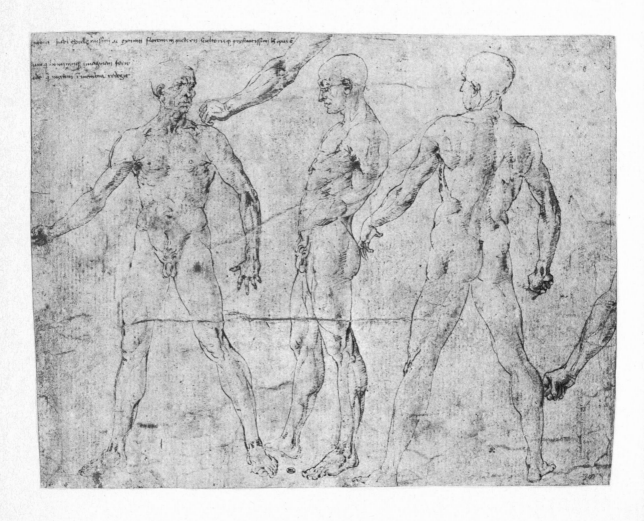

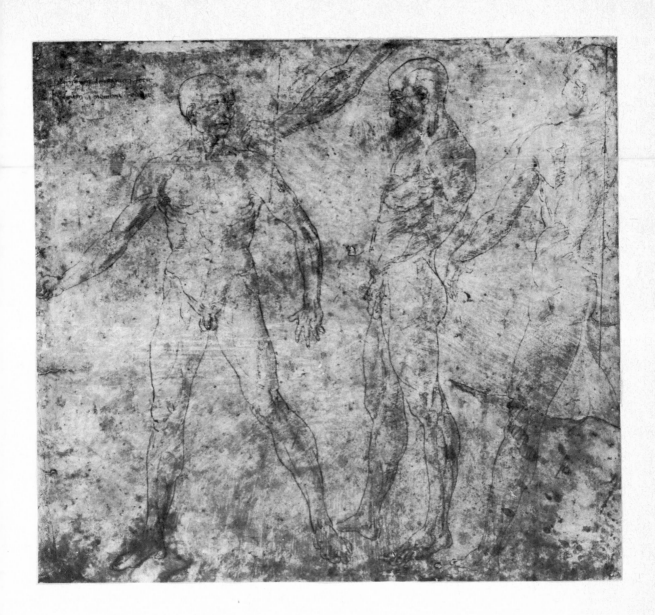

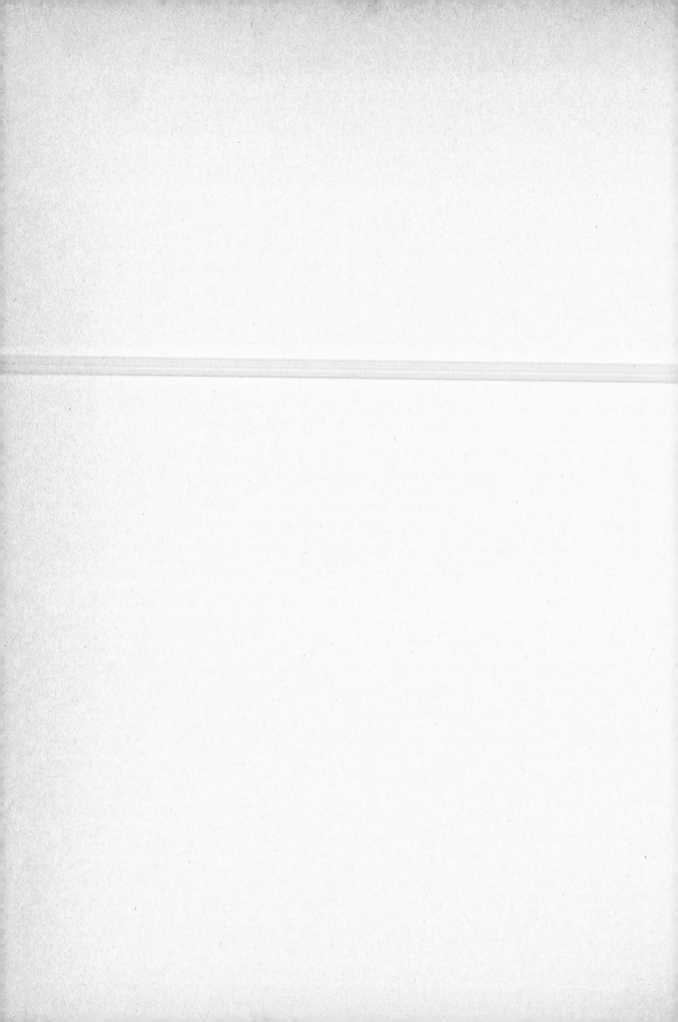

principles of Pollaiuolo's style, which exploited the organic flexibility of the quill to great effect (39). The slight thickening of contour lines to suggest muscle tension, for instance along the outer edge of the right leg in the full-face pose, or the buttock in profile, is a lesson learned from the master, but again executed with the caution of a copyist.

Why was this version of the Louvre drawing made? If the apprentice in Pollaiuolo's studio was set to copying his master's drawings as part of his training, as was common practice in the early Renaissance Florentine workshop, why is it on expensive parchment? It is possible that it was made to serve as an exemplar for another workshop. As in the case of many model-book drawings, parchment may then have been used for reasons of durability, to ensure the longest possible survival rate, despite heavy usage as a model for workshop copying; and the poor condition of the sheet perhaps supports this suggestion.

The model is seen in the same pose from three different angles. Antonio Pollaiuolo was, as the inscription on 37a states, a highly talented and extremely active bronze sculptor, and so it is perhaps to be expected that his practical interest in three-dimensional form should manifest itself in his approach to drawing. In fact, this triple view of a single pose is a kind of graphic equivalent to the making of a wax model or *bozzetto:* indeed it may be that the original version was drawn from a sculptural model rather than from a posed *garzone*. The artist could explore the way in which the muscle structure is disposed across a number of planes seen from different angles, which would help him in his understanding of the complexity of the structure when tackling sculptural projects.

BIBLIOGRAPHY:
Popham and Pouncey 226
Berenson 1944B
L.D. Ettlinger, *Antonio and Piero Pollaiuolo*, Oxford 1978, 37
L. Fusco, 'The Use of Sculptural Models by Painters in Fifteenth-Century Italy', *Art Bulletin* LXIV, 1982, pp.175–194.

38 FILIPPINO LIPPI
Studies of Nude and Draped Figures (recto and verso)

[*verso: colour plate 12*]

Oxford, Christ Church, 1339
Silverpoint and white heightening on slate-blue prepared paper
565 × 450 mm. (overall dimensions)
207 × 415 mm. (upper), 207 × 408 mm. (lower)
Mounted together by Vasari for his *Libro de' Disegni*

These two sheets of figure studies probably came from early in Filippino Lippi's career, around 1480. They are drawn on both sides, and fragments of a third sheet, bearing closely related studies of the same models on a similarly coloured preparation, have been joined to them: in this condition they were mounted by Vasari. It was a standard part of Filippino's studio practice to make a series of rapid, fleeting sketches from a posed model, working across the prepared paper and starting a new drawing as the model moved. This had two important consequences. In the first place it encouraged an increased facility in the handling of materials: Filippino used the silverpoint with a dexterous immediacy previously unknown, and stroked on the white heightening with fluent, easy accuracy. Secondly, it sharpened the acuteness of his perception of form, both draped and nude, resulting in a more highly developed feeling for the body's natural movements and rhythms (7). This

BELOW 38a Workshop of Botticelli (?), *Studies of a Male Nude*. Lille, Musée des Beaux-Arts, 82. Silverpoint, with white heightening, on pink prepared paper; 190 × 277 mm.

38 (recto) ▷

Filippo Lippi Pittor' Fior:

FILIPPO LIPPI P.

practice of training eye and mind in the observation and understanding of anatomical structure and dynamics was essential as background to the fluent nervousness with which Filippino treated his late narrative paintings. It is very unlikely, however, that the sketches on these sheets were made as studies for paintings, or were ever used as such; this was certainly not their primary purpose.

The two draped figures to the right of the upper sheet (recto), and perhaps that at the left of the lower sheet (verso), were evidently made from a single pose of the model. They are fine examples of the draughtsman's swift, angular outlines, quick hatching of drapery folds and the typical impressionistic thatch of hair. Filippino's keen eye responded swiftly to the fall of light, catching the highlights with a few brushstrokes of heightening. Likewise, in a series of continuous records of the nude model, he captured with a vigorous contour the muscular build, the proportions, and the urgent, tensed movements (particularly on the upper verso) with an ease and clarity which are the results of conscientious training of both eye and hand. Similar techniques of rapid recording of a model's changing pose were also used in other late fifteenth-century workshops. The draughtsman of 38a, probably from Botticelli's workshop, worked like Filippino Lippi across his sheet, turning it sideways on to fill up a horizontal space with his third swift study.

BIBLIOGRAPHY:
Byam Shaw 33
Berenson 853A (versos, as Davide Ghirlandaio) 1355B (rectos, as Filippino Lippi)
Ragghianti and Dalli Regoli 110, pls.163–164 (versos only)

39 ANTONIO POLLAIUOLO
Hercules and the Hydra (recto) *[colour plate 13]*
Two Dogs (verso)

London, British Museum, 5210–8
Pen and ink on paper (recto)
Black chalk (verso)
235 × 165 mm.

This is one of the finest examples of Pollaiuolo's highly accomplished pen technique. Because of its malleability, the pen requires greater dexterity and sureness of touch than any other drawing instrument. For the same reasons, it is also far more responsive to individual handling, directness of expression of personal styles, and calligraphic idiosyncracies. It is this immediacy of response which appealed to Stefano da Verona (26), to Parri Spinelli (27), and to Pisanello (2); but it was Pollaiuolo who exploited this quality with a vigour and a truth to human form unmatched before the drawings of the mature Leonardo da Vinci.

This is not to say that, in his swift representation of the nude in violent action, Pollaiuolo does not distort the anatomy: there is clearly something very wrong with Hercules' left shoulder, and the definition of the torso leaves much to be desired. But the draughtsman here was not concerned with a pedestrian definition and clarification of anatomical structure.

39a Antonio Pollaiuolo,
Hercules and the Hydra.
Florence, Uffizi, 8268.
Oil on panel; 175 × 120 mm.

39 (recto) ▷

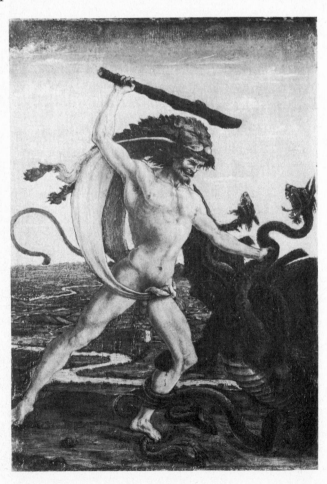

◁ 39(verso) Rather, he sought to capture a spontaneous, energetic movement, and to imply the source of that energy within a credible, if not wholly accurate, anatomy. This he achieved by moving his pen with great agility and grace, varying the strength and thickness of the line as he followed the movements and muscular strains of the limbs. The right, balancing leg is lightly drawn: a quick contour implies the structure, and a few thin lines add enough information about the shin and kneecap to convince the observer of its reality. The left leg, bearing both the weight and strain of movement, is more fully defined: an exaggerated angle in the light, springy line suggests the bulging tension of the calf muscles, a few rapid jabs with the pen show the grip of the toes on the ground, and the straining force of the thigh is demonstrated by the thicker, broken line along the top of the leg. It is a masterly description of violent energy. Hercules is bounding forcefully forward and grasping the Hydra. Against the apparently deft, but actually deeply considered and controlled drawing of Hercules, Pollaiuolo contrasted the sinuous curves of his lion-skin and the writhing form of the Hydra. This is only briefly sketched in to justify Hercules' urgent movements, its tail curled round his ankle, its body and neck twisting in supple, elegant linear rhythms.

As if to demonstrate Pollaiuolo's position as the leading Florentine draughtsman of the 1460s, the sketch of two dogs on the verso is in black chalk. In few, if any, earlier drawings is chalk used with such freedom as a sketching medium, yet with such subtlety for both internal modelling and expressiveness. The vignette of the right-hand dog stretching in a completely natural manner is emphasised in its naturalism by the parallel hatching lines which follow the direction of the strained muscles of the forelegs. This is the only surviving example of Pollaiuolo's use of chalk, although he must have used it occasionally, if only in the preparation of cartoons; but despite its uniqueness, it suggests a full awareness of the medium's potential.

The Hercules drawing is normally associated with the three lost canvases of *Labours of Hercules* which Pollaiuolo painted in 1460 for the Sala Grande of the Palazzo Medici. A scaled-down version on panel in the Uffizi (39a), in Pollaiuolo's own hand, reflects this composition.

BIBLIOGRAPHY:
Popham and Pouncey 225
Berenson 1905
H.S. Ede, *Florentine Drawings of the Quattrocento*, London 1926, pls. 24 and 25
L.D. Ettlinger, *Antonio and Piero Pollaiuolo*, Oxford 1978, 32

40 LORENZO DI CREDI
David [colour plate 14]

Oxford, Christ Church, 0057
Silverpoint, with white heightening and some flesh-coloured bodycolour, on
an off-white prepared paper (much deteriorated)
280 × 126 mm.

The artist was here as concerned with the investigation of the internal
rhythms and balance of the figure in its selected pose, as he was with the
study of the anatomical structure. The treatment of the upper half of the
figure is particularly successful. Unlike the graceful, even florid, character of
Credi's later silverpoint drawings, the handling is quite vigorous, the knotty
contours and rippling chiaroscuro of the musculature combining to create a
keen and confident response to the subject. The rhythms are balanced and
counter-balanced against one another so that, for example, the outline of the
right arm moves in a harmonious echo of the contour of the torso and hip,
which swing outwards to bear the figure's weight. Credi's real knowledge of
muscle structure is shown to marvellous advantage as he controlled the
subtle tonal transition, keeping it as smoothly continuous as the silverpoint
would allow. This pays dividends in the fluent effect of light playing on the
plastic, glistening surface of the torso. In its reflections of the two famous
bronze *David*s of Donatello (40a) and Verrocchio (40b), the pose gives the
figure a strongly sculptural quality.

The robust strength of the torso is belied by the much more schematic
treatment of the lower half of the body. The left leg seems to float weight-
lessly above the ground and, largely because the tonal range is less extensive
here, the forms seem flattened and the right leg lacks the strength to bear
David's weight. The draughtsman chose to lay particular stress on the head
and torso. He relished the opportunity to study the subtleties of the anatomy,
the twist of the alert head against the neck, the rhythmic energy of the
contours, and the structure of the virile torso as light flits across its rippling
surface. In fact he may have chosen the subject specifically to bring the pose
into focus. This is not however a study in preparation for a painting of
David, but is rather the study of a nude figure posed as the youthful hero,
with a view to training the eye and to improving the understanding of
anatomy.

BIBLIOGRAPHY:
Byam Shaw 29
Berenson 995 (as Granacci)
G. Dalli Regoli, *Lorenzo di Credi*, Pisa 1966, 23, p.109

40a Donatello, *David*.
Florence, Bargello.
Bronze; height 159 cm.

40b Andrea del Verrocchio,
David. Florence, Bargello.
Bronze; height 126 cm.

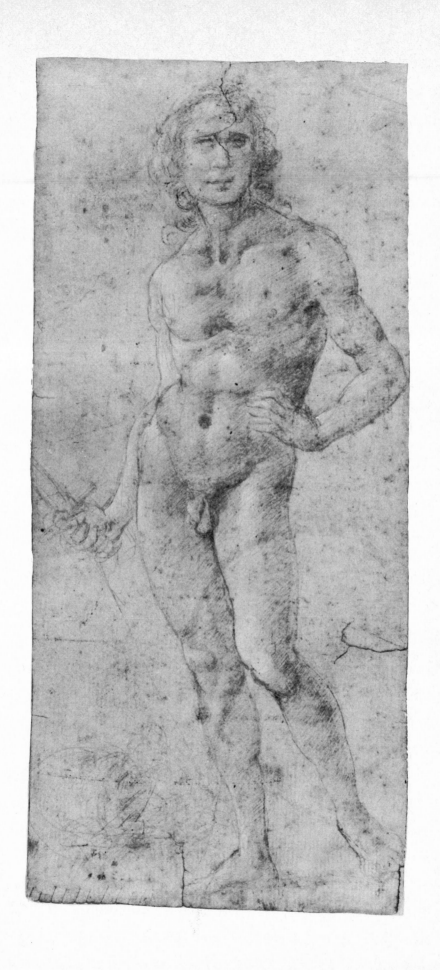

41 LUCA SIGNORELLI
Nude Man Seen from Behind

London, British Museum, 1946–7–13–11
Black chalk on paper
270 × 136 mm.

In this study Signorelli demonstrated his mastery of the chalk medium to wonderful effect. The modelling of the figure is achieved by broad, entirely smooth areas of chalk, so imperceptibly blended from shade into light (for example across the right leg and buttock) that the very soft, palpable quality of the skin is suggested. On the left side of the body, stronger shadow is indicated by a more vigorous, yet just as soft hatching added in long, smooth lines which flow from the hip to the knee. In the torso Signorelli used both hatched and entirely tonal areas of modelling to suggest both the suppleness and the volume of the musculature, along with freely drawn lines which indicate the bone structure in the curving sweep of the spine, and in the echoing form of the shoulder blades and upper edge of the pelvis. He used shorter hatched lines running at right angles to the spine and shoulder blades to describe the tension and tautness of the skin at these least fleshy points of the anatomical structure. The outline is as springy and supple as the internal form. With great confidence and spontaneity the line swings naturally with the body's curves. Signorelli strengthened it at points of accent, for example along the muscular curve of the upper torso, and reduced it to a mere wisp for such details as the hair.

Since Signorelli's chief interest in this study was clearly in the stance of the figure, he concentrated his attention on the torso and legs. Consequently, his description of details of the head is very brief; no part of the left arm is shown, and the right arm is cut off below the elbow. The 'ghost' of a second

LEFT 41a Luca Signorelli,
Pan and the Fates.
London, British Museum,
1946–7–13–12. Pen and ink,
with wash and white
heightening, on paper;
290 × 370 mm.

RIGHT 41b Luca Signorelli,
St Benedict Receiving Totila,
detail of figures.
Monte Oliveto Maggiore,
Cloister. Fresco on wall.

41 ▷

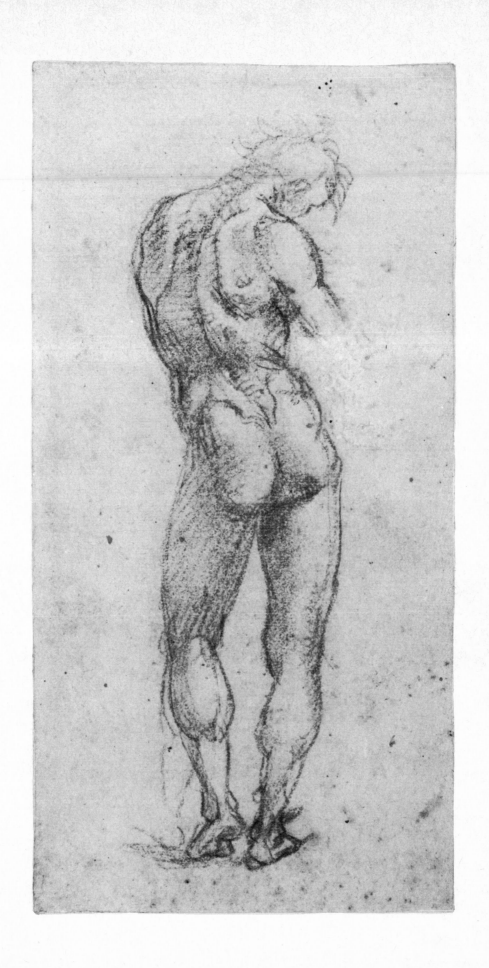

left leg, in a position suggesting a more upright stance and a more even distribution of weight, is probably the artist's guide to proportion before he drew in the present limb, bent at the knee and with the sole of the foot visible.

This study has been associated both with a figure in the fresco of *St Benedict receiving Totila* at Monte Oliveto Maggiore (41b), and with a piping figure on the right hand side of a fresco depicting *Pan and the Fates* from the cycle in the Palazzo Magnifico, Siena, known through a drawing of the composition in the British Museum (41a). It is, however, identical with neither, and was probably made without reference to a specific composition as a straightforward piece of studio study, upon which the artist may later have drawn for either or both of the above-mentioned compositions.

BIBLIOGRAPHY:
Popham and Pouncey 238
Berenson 2509B–4

42 LUCA SIGNORELLI
Hercules and Antaeus [colour plate 15]

Windsor, Royal Library, 12805
Black chalk on paper
283 × 163 mm

The spontaneity and directness of chalk as a drawing material is harnessed to an increased vitality of subject matter in this masterful study of two nude figures in combat. The climax of the struggle is represented, and Signorelli focused his attention on the torsos bulging with flexed muscle, and on Hercules' vice-like grip, from which the pain-wracked Antaeus vainly battles to free himself. The breadth and full tonal range of the chalk is exploited to describe the movement of the muscles beneath the skin. The artist used the broad side of his chalk stick in order to achieve continuity in tonal gradations, then hatched and cross-hatched over this to intensify the shadows, and at the same time to inject into the modelling the vigour demanded by the subject-matter itself. The contours are equally vital, the immediacy and fluency of the chalk expressing a vigour and tension equivalent to Pollaiuolo's penline as it describes dynamically the rippling musculature. The bold sweep of Antaeus' straining, curved torso, and the angular spread of his limbs against the springy form of Hercules, further heighten the dramatic impact. How the models managed to hold so strenuous a pose is hard to imagine, but that the artist was working from life is surely indisputable. Perhaps Antaeus was balanced on a low plinth or box which was removed only to finish off Hercules' legs.

The brisker modelling of Hercules' legs and Antaeus' right calf economically describes the powerful muscles which are almost exaggeratedly angular under the strain of their exertions. Both modelling and contours throughout the drawing are sketched with speed and assurance. The heads are even less highly finished than the legs. But again the wonderful economy of handling is informed by a power of expression which intensifies the drama. The swift, light touch of a truly confident draughtsman describes the anguish of Antaeus, his head thrown back in agony, his nostrils and open mouth two small, dark patches which add focus to the dramatic profile.

BIBLIOGRAPHY:
Popham and Wilde 29
Berenson 2509J

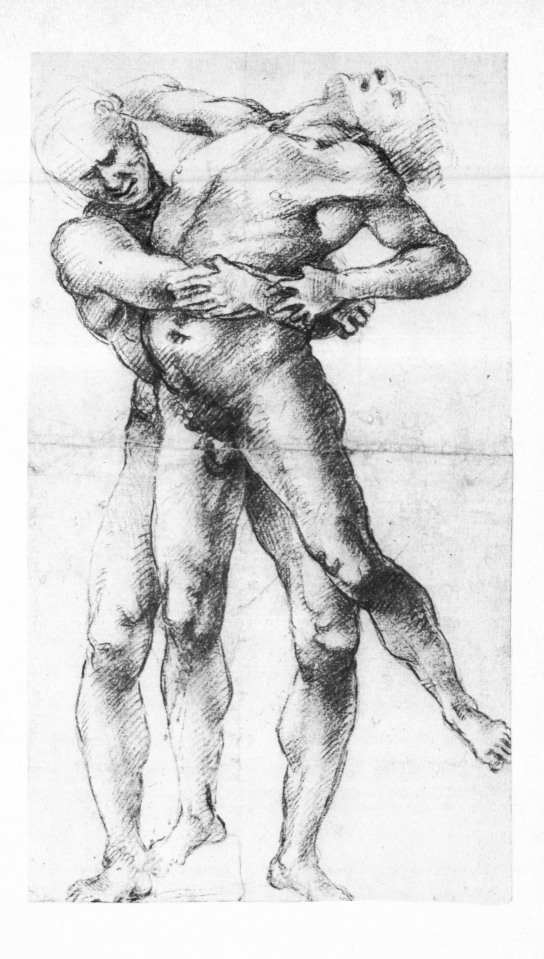

43 SCHOOL OF ANDREA MANTEGNA
Hercules and Antaeus

Windsor, Royal Library, 12802
Pen and ink on paper, the outlines picked through; squared with a stylus
347 × 232 mm.

This very different interpretation of the subject of Signorelli's drawing (42) is due, at least in part, to the fact that it is a study in reverse after an antique carving, and not made from the life. The model is preserved today in the Pitti Palace, Florence, in a much restored state, which may account for some of the differences in detail (43a). The pose in this drawing is much more 'studied' and less spontaneous than in Signorelli's version and the sense of a real physical struggle is diminished. It is difficult to understand how Hercules manages to lift Antaeus even momentarily into the position maintained here.

But it is in handling and technique that this study loses the energy and vitality so apparent in Signorelli's. Whereas chalk is capable of a very sophisticated continuity of modelling, the use of the pen demands an essentially linear chiaroscuro, which inhibits the fluency and mobility of the form. The draughtsman has, however, tried to vary the quality and density of the hatched line, in order to discriminate between pure shadow (for example under the thigh and buttock) and modelling within the muscle area (for example around the pectoral muscles and in the legs), where the hatching is brisker and conveys more of a sense of energy and tension. The most natural results are achieved where calligraphic freedom is most fully exploited. As Antaeus throws his head backwards in agony, the loose curls of the hair are suggested in a few swiftly twisting pen lines, and hatching alone describes the planes which determine the structure of his neck and face.

Yet another impediment to the directness of the image is the series of prick marks which isolate the areas of light and shade, and thus convey the impression that each muscle has been examined separately. The outlines, too, have been pricked through, and in some areas (notably Antaeus' right arm and hand) were reinforced with a darker brown ink. The sheet has also been squared with a stylus. This occurred before the drawing with the pen, for the figure study was clearly superimposed onto the grid. The purpose of the squaring was, therefore, to scale up a smaller sketch to this size for transfer, indicated by the pricking, onto a panel. The drawing cannot, however, be associated with any known work and its authorship remains elusive.

BIBLIOGRAPHY:
Popham and Wilde 17
Parker and Byam Shaw 12
Popham 1931, 157

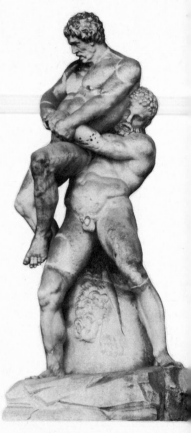

43a Classical sculpture,
Hercules and Antaeus.
Florence, Palazzo Pitti,
Cortile dell'Ammannati.
Marble.

43 ▷

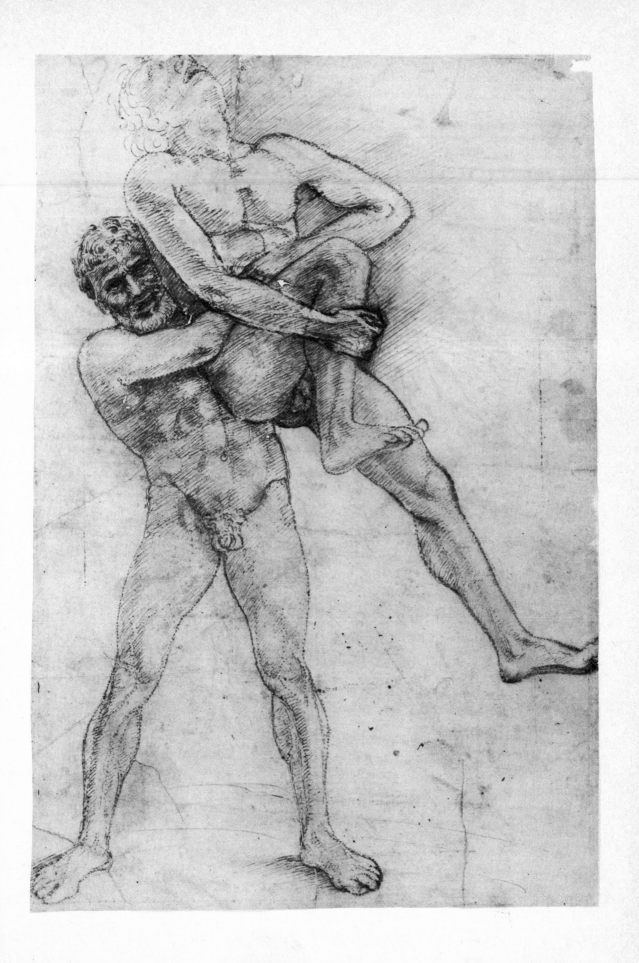

44 FRA BARTOLOMMEO DELLA PORTA (?)
Study of an Antique Statue of a Goddess

Oxford, Christ Church, 0125
Pen and ink on paper
245 × 100 mm.

This drawing is a virtuoso display of the use of cross-hatching with the pen to model the forms and, as far as is possible within the limitations of a linear technique, to imitate the fine undulations of the surface of the classical carved prototype. The range within the hatching and cross-hatching is remarkable: varying strength of pen-line, varying distance between parallel strokes, and varying directions and curvatures of the lines develop a satisfying mesh through which the relief of the form emerges. The close and varied cross-hatching with pen and ink reflects the technique much used in Domenico Ghirlandaio's workshop by such assistants as the young Michelangelo (44a). This drawing shares with the pages of the *Codex Escurialensis*, a modelbook of drawings after the antique made by members of Ghirlandaio's workshop (44b), the impersonality often seen in modelbook drawing. This suggests that it was intended as a detached observation, as faithful as possible to the original, which left no room for individual mannerisms or idiosyncracies.

In some respects, however, the drawing is incompetent: the proportions are strange for a classical figure and do not seem very close to the nearest

LEFT 44a Michelangelo, *Study of a Male Nude*. Paris, Louvre, 712 recto. Pen and ink over black chalk sketch on paper; 248 × 95 mm.

CENTRE 44b Workshop of Ghirlandaio, *Study after an Antique Female Figure*. Madrid, Escorial, *Codex Escurialensis*, f.54 verso. Pen and ink on paper; 330 × 230 mm.

RIGHT 44c Classical sculpture, *Venus*. Madrid, Museo del Prado. Marble.

44 ▷

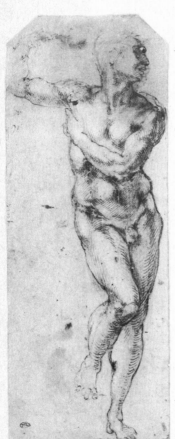

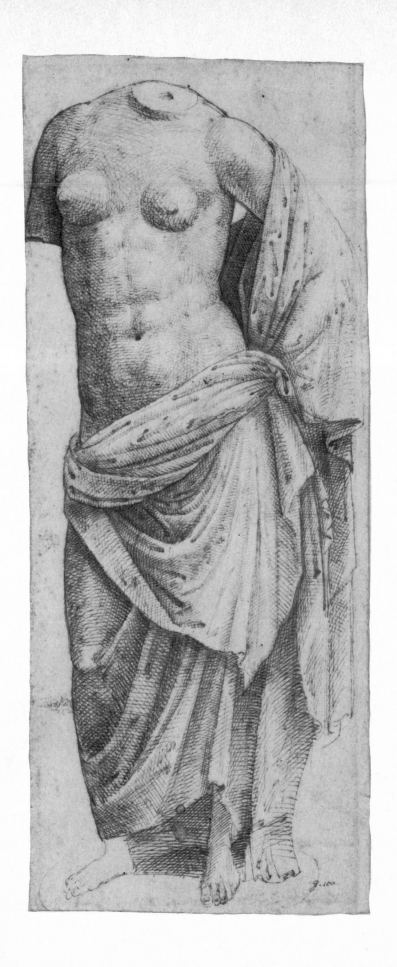

prototype which has been suggested (44c), and the relationship of neck to shoulders is disconcerting. However, it is interesting to find a late-quattrocento draughtsman studying so assiduously from classical sculpture and, when it comes to reflecting the sculptor's concern with nude form, producing such subtle internal modelling with the relatively intractable technique he used.

BIBLIOGRAPHY:
Byam Shaw 56

45 LEONARDO DA VINCI
Leda and the Swan [colour plate 16]

Chatsworth, Devonshire Collection, 717
Pen and ink with wash over a black chalk sketch, on paper
160 × 139 mm.

Leonardo produced this remarkable study in the early years of the sixteenth
century, when he was most concerned with depicting fully rounded form in
his drawings. The figure is based on a classical pose (45c and d), but Leonardo's
handling is quite different from that of 44. Rather than using parallel
hatching and cross-hatching to follow the tonal strength of the shadows, his
hatching moves with the rounded shapes of the forms, following their
structure. The curvilinear flow of the hatching generates forms of uncom-
promising volume and fullness. On Leda's left leg, for example, the passage
from light to shade across her thigh creates a particularly powerful sense of
the plump, yielding fleshiness of her anatomy. Leonardo's method was
rapid but rhythmic and controlled as he worked with the pen over his
preliminary jottings in black chalk. In startling contrast to this almost
obsessive striving for fullness of form in imitation of antique statuary, the
landscape background is sketched in with extreme calligraphic economy,
and the foreground vegetation shows the characteristic free perceptiveness
of Leonardo's studies of plant forms and growth.

LEFT 45c Classical
sculpture, *Venus and a
Tortoise.*
Madrid, Museo del Prado.
Marble.

RIGHT 45d Classical
sculpture, *Crouching Venus.*
London, British Museum.
Marble.

45 ▷

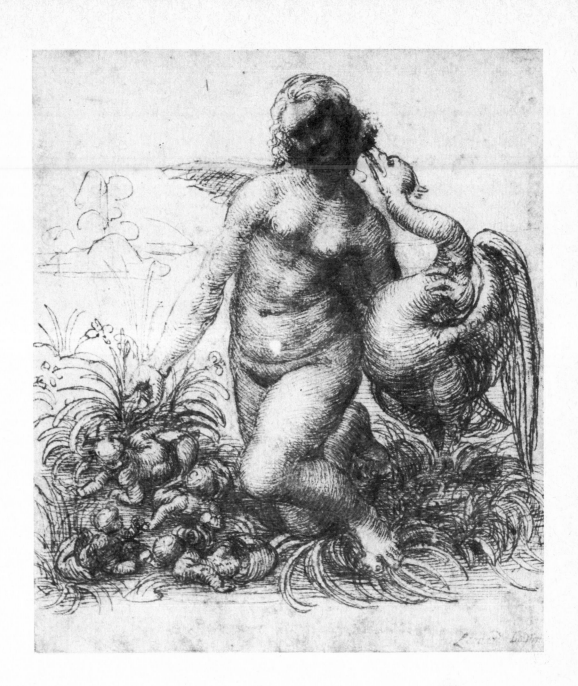

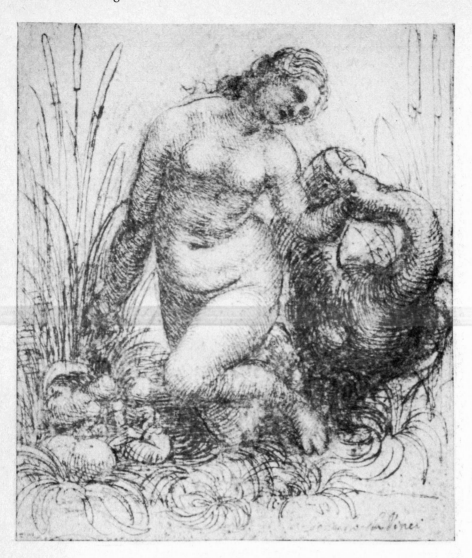

This drawing and another of the same subject in Rotterdam (45a) appear to show a preliminary stage of Leonardo's ideas for the lost painting of *Leda and the Swan*. In the technique of curvilinear hatching they are analogous to, and perhaps directly dependent on, Dürer's pen and ink drawing style of *c.*1495 (45b) which, in turn, is related to the printmaker's method of hatching. In Leonardo's drawing it is, however, used more extensively and applied in a softer manner, which allowed him to achieve with the pen the kind of tonal variation and power of modelling of three-dimensional form more usually associated with black chalk.

BIBLIOGRAPHY:
Chatsworth Exhibition I, 32
Berenson 1013A
M. Kemp, *Leonardo da Vinci. The Marvellous Works of Nature and Man*, London 1981, pp.270–273

LEFT 45a Leonardo da Vinci, *Leda and the Swan*. Rotterdam, Museum Boymans-van Beuningen, I–466. Pen and ink with black chalk on paper; 126 × 109 mm.

RIGHT 45b Albrecht Dürer, *Female Nude Seen from Behind*. Paris, Louvre, 19058. Pen and ink with wash on paper; 320 × 210 mm.

v Compositional Drawings

At the beginning of the fifteenth century, paper and parchment were seldom used for drawings in which pictorial compositions were considered. Experimental sketching as a stimulus for creative thought was, generally speaking, an activity which evolved as the century progressed in response to the new habits of mind of the Renaissance artist. Compositional sketches were doubtless made early on, but, since their usefulness would have been specific and short-term, they were almost certainly drawn on a reusable surface like the prepared wooden tablet that the *garzone* in 3 seems to be using. When paper was used, it was normally for formal purposes rather than for the swift, creative design-sketches which were commonplace by about 1500. Compositional drawing evolved from the traditions of under-drawing for wall-painting and for manuscript illumination. Drawing in manuscripts, the form most similar in surface and scale to drawing on paper, was intended as a preliminary to painting, for illuminating was rather like 'colouring in' in children's drawing today: the painter provided himself with a clear and orderly pattern of lines within which he laid his colours (V A). The compositional scheme was drawn in uniform, closed outlines, and was thus inevitably impersonal in graphic character. These earlier conventions exerted some control, if only subconscious, over the draughts-man's freedom in compositional drawing on paper. So it is not surprising that most of the compositional drawings which survive from the early quattrocento have a specifically formal purpose. The informal, experi-mental compositional sketch, the equivalent of such spontaneously drawn figure-studies as Stefano da Verona's *Prophets* (26), is very rarely to be found before about 1460.

Many early compositional drawings were made as contract drawings, or as detailed designs submitted to a patron for his approval. Often legal contracts of commission for fifteenth-century paintings record the existence of a drawing which had been agreed between patron and painter as the basis for the work. To be useful, both for the painter to demonstrate his ideas as to exactly how the painting would turn out, and for the patron to be sure that the agreed design had finally been carried through, a legal contract drawing had to be highly detailed. Since it would normally be on a much smaller scale than the final work, a contract drawing tended to be almost miniaturist in technical finish: in this connection the controls of earlier drawing conventions perhaps operated most strongly. Early in the century, when the durability of paper was still called into question, a contract draw-ing would often be made on parchment (46). Being much more expensive than paper, the parchment tended to exert further pressure on the draughts-man towards the impersonal exactness of handling found both in drawings

for manuscript illumination and in modelbook drawings. The patron's demand for clarity of detail also tended to produce a stereotyped quality more akin to architectural elevation drawings than to free, creative compositional designs. Later in the fifteenth century a growing freedom of handling is found in contract drawings like Ghirlandaio's *Annunciation to Zacharias* (V B). Such drawings are still recorded in contracts as final drafts to be approved or amended by the patron, and as exemplars to be followed exactly in the execution of the painting. But the controls on the draughtsman's freedom, so closely observed by patron and artist around 1400, had relaxed as a result of his greater independence and of the growing respect for his creative individuality.

In North Italian workshops, stocks of formal compositional drawings were preserved in bound volumes alongside modelbooks. In the two classic surviving examples, Jacopo Bellini made a large number of elaborate compositional designs which are, however, experimental in the sense that they record his explorations in the field of pictorial design (V C). On the other hand, these drawings are formal in their careful finish and completeness of detail. This suggests that one of their functions was to serve as paradigms of the workshop's style and traditions, preserved for the benefit of future generations of apprentices. Such 'patterns' of compositional drawing may, like modelbooks, have been used in workshop training in North Italy: overfinished compositional drawings often look like apprentices' copies of masters' designs (V D). Another kind of compositional 'pattern' drawing probably lies behind the *Battle of Naked Men* (51), which is analogous to

BELOW VB Domenico Ghirlandaio, *Annunciation to Zacharias*. Vienna, Albertina, 4860. Pen and ink, with wash, on paper; 259 × 374 mm.

ABOVE RIGHT VC Jacopo Bellini, *Adoration of the Magi*. London, British Museum, 1855–8–11–17v to 18r. Metalpoint on (prepared?) paper; 415 × 672 mm.

BELOW RIGHT VD Workshop of Gentile Bellini, *Pope Alexander III Handing a Consecrated Sword to Doge Ziani*. London, British Museum, 1891–7–17–23. Pen and ink, with wash, on parchment; 225 × 335 mm.

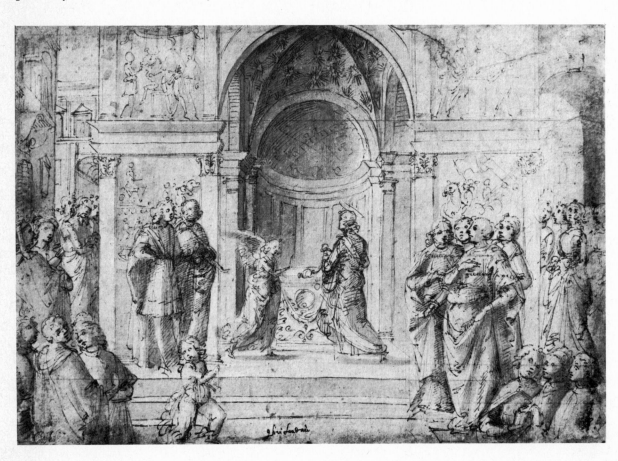

engravings from Antonio Pollaiuolo's workshop. These works were intended, however, more as patterns of the nude form in movement than as demonstrations of skilful compositional organisation.

Other drawings made in connection with prints and printmaking show a similar precise clarity of outline. A number of detailed compositional drawings stress the closed, uniform outlines characteristic of Florentine engraving techniques in the 1460s (VE), and several grand, well-worked drawings, such as 52, are either preparatory drawings for, or more probably elaborate copies after, prints made in Mantegna's workshop. Drawings of this type may have been produced as 'presentation' drawings, a form which emerged late in the fifteenth century when the status of drawing had risen to such a height that finely finished drawings could stand in lieu of panel paintings. A Central Italian example of the same practice is the group of highly polished derivations made by Signorelli around 1500 from figures in his Orvieto frescoes (VF).

A final category of formal compositional drawings are cartoons for small paintings (61), or for works in other mediums, such as embroidery (VG). These come at the end of the design process, and show the composition fully evolved and elaborated. Clarity and continuity of outline were essential at this stage, so that pricking would transfer the design exactly, line for line, onto the surface to be painted or embroidered. The transfer function of these drawings explains their rather static, routine handling, which contrasts with the freedom of most late quattrocento compositional drawings.

In all these types of formal drawings, individual graphic style and handling gives way to functional considerations. Most fifteenth-century compositional drawings, however, were experimental in nature, and were vital steps in the genesis and elaboration of a pictorial design. This was already becoming apparent at the beginning of the century (48), and is manifestly so in the swift designs, sometimes scarcely intelligible in places, of the decades immediately before the High Renaissance (56,57). Early in the century, preliminary compositional studies tended to be fairly uniformly detailed, and may often have been drawn so that designs for a series of scenes could be compared to achieve continuity in figure-scale, setting, or narrative treatment. Later on they became more like rough layout-sketches, stimuli to further creative thought (often recorded directly on the same sheet), or indications of the poses and grouping of figures to be reconsidered in more detail on another sheet. During the century the balance shifted from the compositional drawing which generally had a formal purpose to the freely sketched design which occupied a crucial place in the draughtsman's creative process. The spontaneous vigour of the majority of late quattrocento compositional drawings demonstrates vividly the change in the role of drawing, which by 1500 had become essentially a creative activity. This is perhaps both the outcome of, and the stimulus for, the early Renaissance artist's growing consciousness of the need for greater unification of figures and setting, and of greater expressive clarity in communicating the narrative and its meaning to the observer. These changes culminate triumphantly in the High Renaissance narrative designs of Michelangelo, Raphael and Titian.

ABOVE VE Maso Finiguerra?, *Scenes from Genesis*. Frankfurt, Städel Institut, 415. Pen and ink, with wash, over charcoal sketch, on parchment; 285 × 410 mm.

BELOW LEFT VF Luca Signorelli, *Two Nude Figures*. Paris, Louvre, 1801. Watercolour and white heightening on greenish-grey paper; 355 × 255 mm.

BELOW RIGHT VG Raffaellino del Garbo, *The Virgin Appearing to St Bernard*. London, British Museum, 1860–6–16–114. Pen and ink, with wash and white heightening, over black chalk sketch, on two joined sheets of paper, pricked for transfer; 270 × 363 mm.

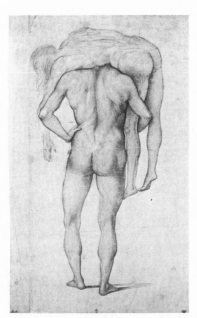

46 JACOPO DELLA QUERCIA
Fragment of a Design for the Fonte Gaia, Siena

London, Victoria and Albert Museum, Dyce 181
Pen and ink on parchment
151 × 228 mm.

Vasari wrote of some drawings by Quercia in his collection that they 'rather resemble the work of an illuminator than that of a sculptor' (Vasari/Hinds I, p.214). Painstaking, small-scale exactness is certainly one of the foremost characteristics of this drawing. This is due partly to its purpose, and partly to the use of a sheet of parchment which is very small compared with the size of the Fonte Gaia itself (46b). Using a very finely cut quill, Quercia described the architectural forms with great precision: the lines were carefully ruled and the detail to be carved was monotonously repeated. The style of the figures is freer, for the linear rhythms of the drapery folds are drawn with swinging, form-generating outlines, but the carefully hatched and cross-hatched modelling leaves little to the imagination. The most individual passages are the figures' neatly-rendered features and the texturing of hair, especially sensitive on the guard-dog on top of the wall. Slight touches of reinforcement with the pen enliven the free-standing group of *Rea Silvia* which thus has a smooth lyricism denied to the figures confined awkwardly to their niches.

Although Vasari's criticism of Quercia's drawing style may in general have been fair, the precise handling of the pen here is best explained by the purpose of the drawing and its pendant, showing the left-hand side of the Fonte Gaia (46a). These two sheets are almost certainly parts of the documented drawing which Quercia made for a new public fountain in the Campo in Siena, and which was filed with the contract drawn up in January/February 1409. This explains both the use of costly but durable parchment, which would be sure to survive in the archive for future reference, and the clarity of detail with which Quercia drew all the forms to be carved. To have this agreed design available to keep check on Quercia's progress may have been considered important both because the Fonte Gaia was the major civic monument of its time in Siena, and because Quercia was notoriously unreliable. Changes were subsequently made to the design by the civic authorities, and to the sculpture by Quercia, but the wisdom of preserving the contract drawing was vindicated by the fact that the fountain was not completed until ten years after the contract had been signed.

BIBLIOGRAPHY:
Ward-Jackson 17 (as copy after Jacopo della Quercia)
L. Collobi Ragghianti, *Il Libro de' Disegni del Vasari*, Florence 1974, p.43, figs.52–53
Degenhart and Schmitt 113
A.C. Hanson, *Jacopo della Quercia's Fonte Gaia*, Oxford 1965, pp.11–13
R. Krautheimer, 'A Drawing for the Fonte Gaia in Siena', *Metropolitan Museum Bulletin* X, 1952, pp.265–74
Popham 1931, 7 (as Studio of Jacopo della Quercia)

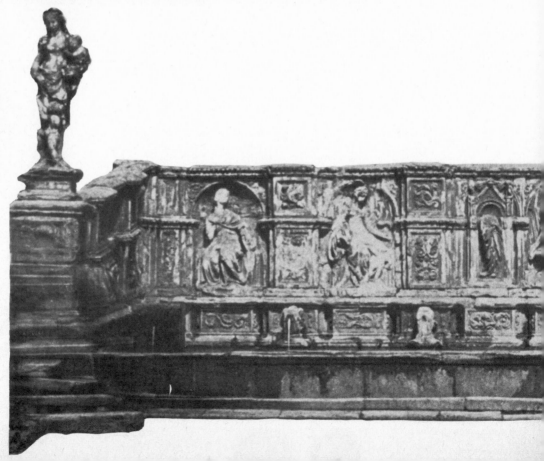

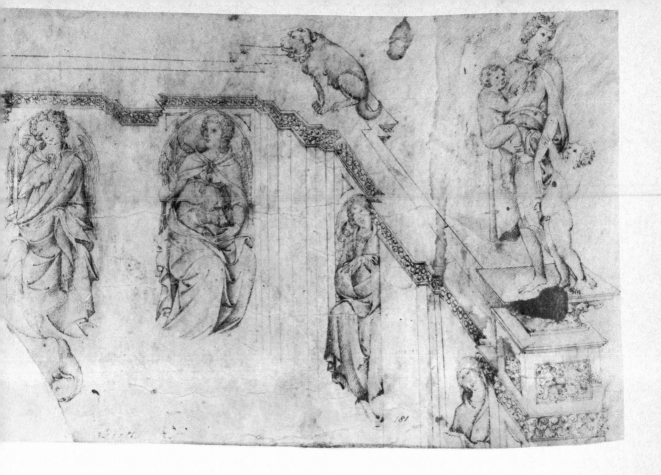

ABOVE LEFT 46a Jacopo
della Quercia, *Design for the
Fonte Gaia, Siena*, left side.
New York, Metropolitan
Museum, Harris Brisbane
Dick Fund, 49.141.
Pen and ink on parchment;
202 × 218 mm.

ABOVE RIGHT 46

BELOW 46b Jacopo della
Quercia, *Fonte Gaia* (before
removal in 1858).
Siena, Campo.

47 LORENZO SALIMBENI
The Massacre of the Innocents

Oxford, Ashmolean Museum, KP 43
Pen and ink on paper
282 × 434 mm.

In scale and handling this drawing has all the appearance of a contract drawing, or at least one sufficiently detailed and finished to give the patron a clear sense of the artist's approach to his subject. Attention is focused on the figure-groups, on the complex interweave of foreshortened figures and dramatic movements in the narrative, and on the range of expressive and emotional facial-types involved. With the exception of the gateway through which Herod has ridden, the architectural setting is scarcely indicated. In drawing the figures, however, the draughtsman used his pen with great finesse and exactness, building up the forms and the draperies in a careful, almost stippled technique. Feathery parallel hatching, so fine as to be almost imperceptible, was the principal means for indicating drapery folds, and there is some cross-hatching in the deepest shadows. Expressive accents which clarify the figures' features and emotions, and the decorative detail on dress and architectural forms, were touched in with a thicker pen and darker ink.

The composition is abruptly cut off, evidently uncompleted, at the right-hand edge, and may originally have been continued on a further sheet. This sheet alone, however, is large for a date early in the fifteenth century, and the handling is unusually neat and studied. A great deal of labour and attention was lavished on producing a clear and convincing sample of the composition, and of the draughtsman's figure-style and narrative interpretation.

BIBLIOGRAPHY:
Parker 43
Degenhart and Schmitt 123

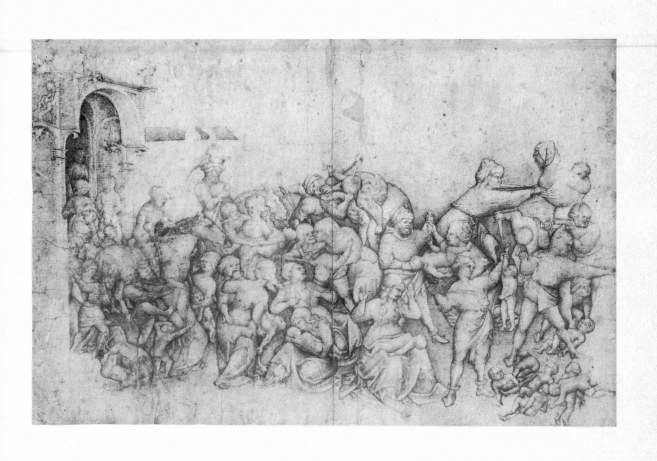

48 SIENESE DRAUGHTSMAN, c.1410
The Betrayal of Christ (recto)
Christ before Caiaphas (verso)

Chatsworth, Devonshire Collection, 716
Pen and ink, over brief sketch in charcoal (or black chalk), on red tinted paper
225 × 186 mm.

The draughtsman first made a slight sketch, probably in charcoal, of the broad layout of the figures, a procedure recommended by Cennini (writing not long before these drawings were made) for underdrawing on panel in preparation for painting. He then drew loosely and fluently with lithe twists of the pen, which create a pattern of interlocking curving movements, to capture the excited, urgent drama of the Betrayal. He experimented on the paper, working out the position of St Peter's legs for instance, and superimposing the soldier's hand over Christ's left arm. The drapery folds are only weakly defined, with minimal pen hatching and faint wash. But the draughtsman shows spirited freedom in the use of firm pressure on the pen to touch in the figures' expressive features, and a spontaneity of handling in the dynamic lines which imply the movement of the Apostles at the right, the flames in the torches, and the pennants on the soldiers' spears. The drawing on the verso has a less passionate subject and is thus less vigorous: there are few forceful accents and the handling of figures is somewhat limp. As lively as certain passages on the recto, however, is the architectural cresting of the throne and the characterisation of Caiaphas about to rend his garments.

Very few drawings survive from the early fifteenth century to document this early stage in compositional design, since most sketches of this type were probably made on reusable surfaces for reasons of economy. These two drawings and their companions (48a, 48b) probably therefore had some special purpose which necessitated the use of paper. The draughtsman may for example particularly have wished to explore the designs in pen and ink, which cannot satisfactorily be used on a prepared surface; or more probably he may have needed to line up a series of designs, perhaps for a predella (or a fresco-cycle) of scenes from Christ's Passion, to ensure compositional conformity or to be shown together to his patron. A sixteenth-century inscription on the verso reads 'di maestro Simone Memmi da Siena', and it is indeed within the Sienese tradition of Simone Martini that this designer belonged.

BIBLIOGRAPHY:
Chatsworth Exhibition I, 1
L. Collobi Ragghianti, *Il Libro de' Disegni del Vasari*, Florence 1974, p.32, figs.21–22
Degenhart and Schmitt 108
P. Pouncey, 'Two Simonesque Drawings', *Burlington Magazine* LXXXVIII, 1946, pp. 168–172 (and *cf.* Popham and Pouncey 269)

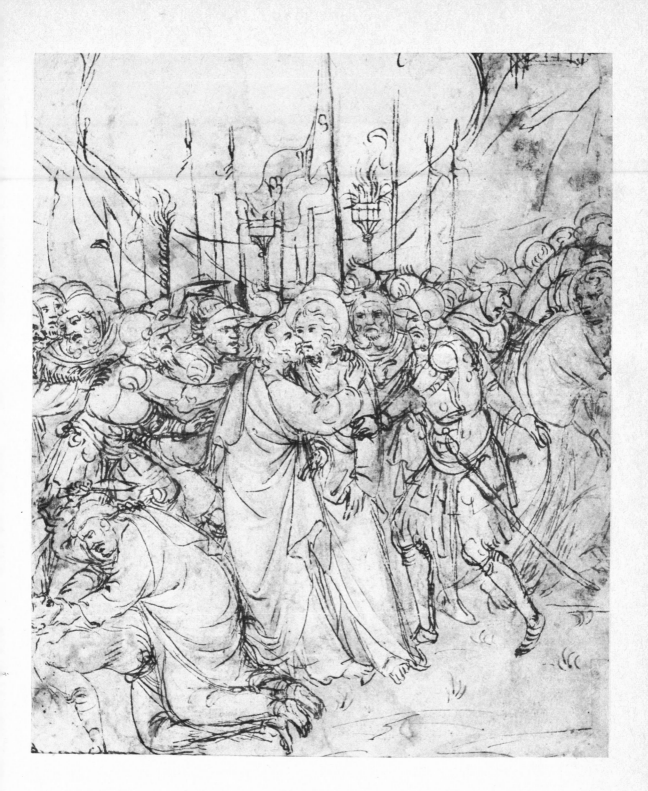

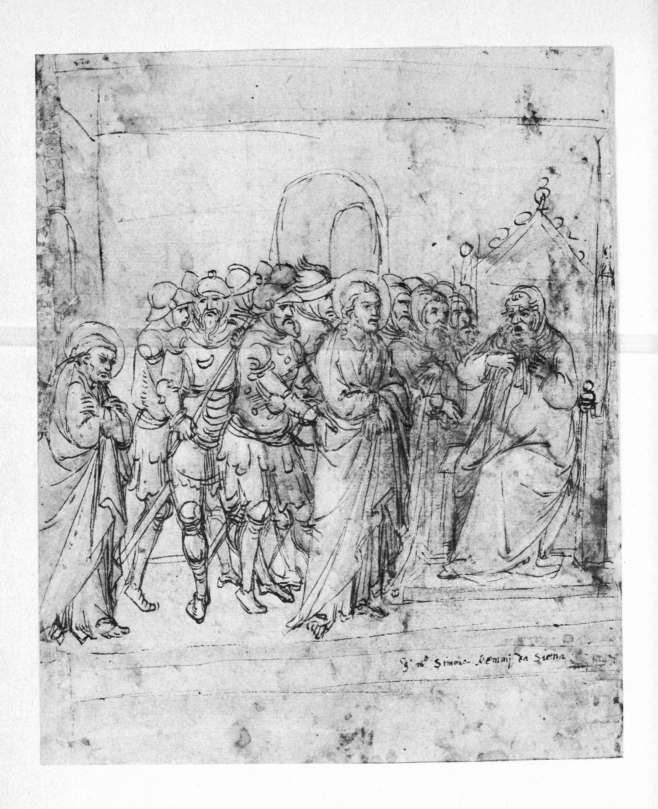

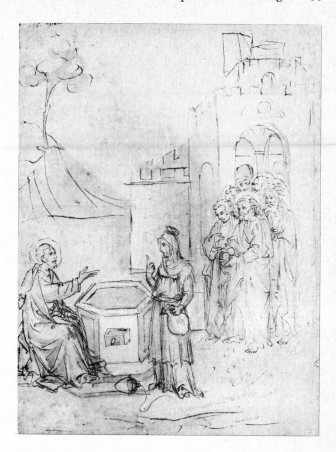

ABOVE 48a Sienese
Draughtsman, *c.*1410, *Christ
and the Woman of Samaria.*
London, British Museum,
1895–9–15–680 recto.
Pen and ink, with wash and
white heightening, over
black chalk sketch on pink
tinted paper; 275 × 210 mm.

BELOW 48b Sienese
Draughtsman, *c.*1410. *Christ
Healing the Blind Man.*
London, British Museum.
1895–9–15–680 verso.
Pen and ink, with wash and
white heightening, over
black chalk sketch on pink
tinted paper; 275 × 210 mm.

◁ 48 (verso)

49 PARRI SPINELLI
Christ and the Adulteress (recto)
Pilgrims Praying Before an Altar (verso)

Chatsworth, Devonshire Collection, 703
Pen and ink over slight metalpoint sketch on paper
288 × 208 mm.

Although the architectural setting for Christ and the Adulteress is only briefly suggested, the figures on both sides of the sheet are well worked up. They show Parri Spinelli's inimitable handling of the pen (compare 27). Long fluent lines indicate the curvilinear drapery folds which swathe the attenuated figures and are rhythmically played off against the wave-patterns of flowing fabrics. Spinelli built up tone by cross-hatching and additional strengthening, in a darker ink, in the deep shadows. In this way, he generated a wider range of tone-values than perhaps any contemporary pen draughts-man, and was thereby able to construct convincing three-dimensional forms in many passages, such as the unbending vertical of Christ's right side, or the drapery stretched across St Peter's right arm. The contrast between these areas and the insubstantiality of others, on which curvilinear patterns of lines seem to be superimposed, is characteristic of Spinelli's contradictory style. The verso of the sheet, of apparently inexplicable subject-matter, shows the same stylistic features handled with less polish and perhaps less imagination: the figures seem cramped and monotonously drawn in comparison with the fluid narrative presentation on the recto.

BELOW LEFT 49a Parri Spinelli, *Group of Pharisees*. Florence, Uffizi, 23E. Pen and ink on paper; 274 × 196 mm.

BELOW RIGHT AND OPPOSITE 49 (recto)

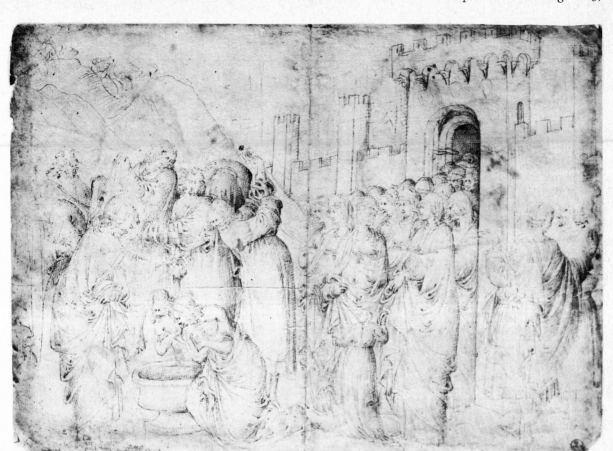

ABOVE 49b Parri Spinelli,
Baptismal Scene.
Florence, Uffizi, 8E. Pen and
ink on paper; 291 × 408 mm.

◁ 49 (verso)

Compositional drawings are seldom found in sketchbooks. They were normally made in relation to specific projects, and were thought out as individual studies, rather than being included in the more general context of the sketchbook. Surviving from Parri Spinelli's book, however, are two large compositional drawings, each originally spread across a double page, and the recto of 49 is the right hand half of a larger drawing. At the left, the composition was extended to complete the group of the Apostles (49a), and to include a group of Pharisees who leave the scene in dismay, balancing the figures at the right of 49. A comparable but intact double page spread, showing a *Baptismal Scene* (49b), may have been the central opening of one section of Spinelli's sketchbook. These drawings are perhaps essentially experiments in figure-grouping for expressive narrative effect, rather than studies for particular narrative compositions. Like those in Jacopo Bellini's books of drawings (VC), they are probably exemplars of Spinelli's style and compositional technique for the general benefit of the workshop and its apprentices.

BIBLIOGRAPHY:
Chatsworth Exhibition II, 65
Berenson 1837D
Degenhart and Schmitt 212
Parker and Byam Shaw 1

50 A: NANNI DI BANCO (?)
Pilate Washing His Hands (recto)
Christ Carrying the Cross (verso)

Pen and ink over metalpoint sketch on paper
288 × 378 mm.

B: FLORENTINE DRAUGHTSMAN,
early fifteenth century (?)
Four Dogs

Pen and ink on paper
111 × 179 mm.

Chatsworth, Devonshire Collection, 963
Mounted by Vasari for his *Libro de' Disegni*

On both sides of the larger sheet are compositional drawings of Passion scenes drawn with a simple, angular pen stroke. The draughtsman tended to stress relief contours with his line, drawing along forms which lie parallel to the picture-surface, rather than investigating the three-dimensional structure of the forms delineated. As a result both drawings, and especially that on the verso, have a disconcerting stark, flat character. Hatching is severely restricted to small areas, and, because it is tonally low-key and invariable, it seldom effectively suggests volume. The crisp, angular treatment of cipher-like features, reflected later in the drawing style of Ghirlandaio (56), has an effective punchiness but provides little range of expression. The *pentimenti* are evidently original: on the verso the draughtsman worked directly on the sheet in reconsidering the articulation of the soldier's left leg.

Although the style can neither be associated with any other surviving drawings nor be precisely localised, there is some reason for thinking that the drawings were made by a sculptor. The general analogy with the speed and directness of handling of pen on paper in drawings a century later by Baccio Bandinelli (1493–1560) and other sculptors, combined with the emphasis on low relief and surface contour, lends some credence to Vasari's attribution to Nanni di Banco, who was one of the leading Florentine sculptors of the second decade of the quattrocento. The compositional solutions reached, however, are so gauche that one hesitates to attribute these sketches to so accomplished a master of design and form. Even if they were early ideas for relief sculpture, perhaps in preparation for *bozzetti*, it seems surprising that the draughtsman should have used such a large sheet for such broad drawings.

The rapid studies of dogs on B have a similar immediacy of touch: in taking much detail for granted they do not strictly belong to the painters' modelbook tradition, although they possibly derive from such a source. They cannot clearly be associated with any identifiable draughtsman, and they appear to be significantly different in style from A, but Vasari may have had good reasons, unknown to us today, for grouping the two sheets together.

BIBLIOGRAPHY:
Chatsworth Exhibition II, 8 (as Anonymous Florentine School)
L. Collobi Ragghianti, *Il Libro de' Disegni del Vasari*, Florence 1974, p.45, figs.59–60
Degenhart and Schmitt 264 (A, as Nanni di Banco or Donatello) and 267 (B, as Circle of Donatello)
O. Kurz, 'Giorgio Vasari's "Libro de' Disegni"', *Old Master Drawings* XII, 1937–38, p.9, pls.2–3

Nanni di Antonio di Banco Scultore Fiorentino

NANNI D'ANTONIO
SCVLTORE.

50B

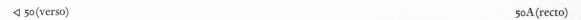

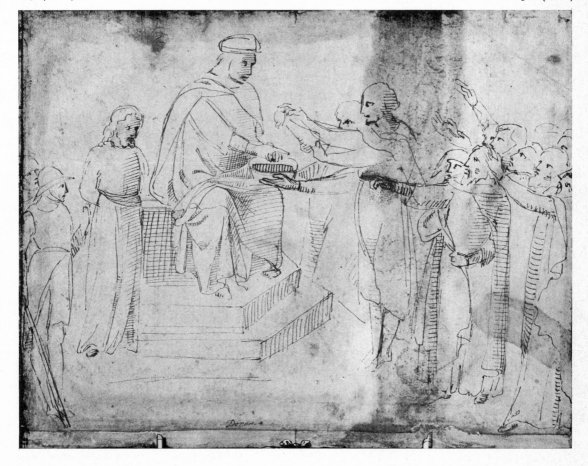

51 ANTONIO POLLAIUOLO (?)
Battle of Naked Men

Windsor, Royal Library, 059
Pen and ink, over some stylus underdrawing, with wash on paper
205 × 435 mm.

The 'patterns' produced in Pollaiuolo's workshop as exemplars of anatomical drawing came not only in the form of studies of the nude model (37), but also as complex compositions of interlocking figures in energetic movement. The most celebrated example, in Pollaiuolo's day as in ours, is the engraved *Battle of the Ten Nude Men* (51a). This drawing is less transparently pedagogic than the *Battle* engraving, and is more conspicuously a Renaissance version of a Classical battle sarcophagus composition, reconsidered in the light of new attitudes to nude anatomical form and of available exemplars for its representation. Like the *Battle* engraving it has no ostensible subject, and should be seen as an exercise in nude drawing, and in the design of a complex figure-group made up of a number of studies of nudes in violent action.

The question mark against Pollaiuolo's name implies uncertainty, however, about the status of this drawing. Is it an original, or is it a pastiche of just that high quality that Pollaiuolo sought to inspire by encouraging his apprentices to copy his 'patterns'? The energetic, rhythmic contours of the main foreground combatants and the soft, confidently placed areas of wash indicating briefly the internal modelling, seem characteristic of the master at

BELOW 51a Antonio Pollaiuolo, *Battle of the Ten Nude Men*. Engraving; 383 × 595 mm.

51 ▷

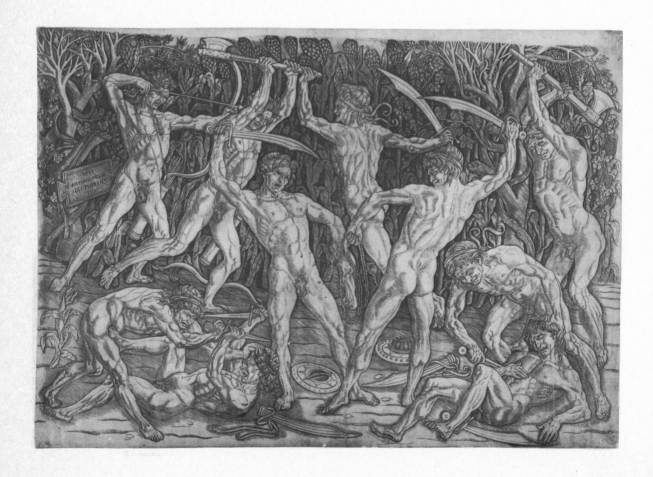

his best; but several of these figures are drawn over stylus outlines, which suggests that they were transcribed from other drawings. The groups of figures at the sides, and the spear-bearers behind the main figures, have neither the firmness of articulation nor the wiry force of movement of Pollaiuolo's nudes. Anatomically, indeed, they are relatively feeble: their limbs, drawn in behind the foreground figures, fail to hang together; and their faces too are different in character, lacking the bellicose strength and fierce concentration of the main warriors. The whole may therefore be an excellent but later assemblage, in which a ten-man battle composition derived from a Pollaiuolo prototype has been elaborated by the addition of several extra figures of lesser quality. The deceptive similarity of the style and handling to the master's is, however, a tribute both to the skills of the copyist and to the effectiveness of the teaching of Pollaiuolo's 'patterns'.

BIBLIOGRAPHY:
Popham and Wilde 27

52 ANDREA MANTEGNA
Battle of the Sea-Gods [*colour plate 17*]

Chatsworth, Devonshire Collection, 897
Pen and ink on paper
257 × 380 mm.

Mantegna's handling of the pen in this magnificent compositional drawing closely resembles his printmaking technique. The contours round many forms are prominently thickened to develop stronger tones, and diagonal hatching is, within the limitations of this technique, applied in a masterful manner to build up the internal modelling. On passages such as the necks of the sea-horses the hatching lines are very carefully clipped off, and the distance between each line is precisely and evenly regulated. Paradoxically, the single-minded regularity of spacing of these lines gives a curiously unrealistic, faceted appearance to forms which in nature are smoothly rounded. The sense produced of a harsh light reflecting from surfaces which have apparently been cut from a hard, unmalleable material, justifies Vasari's criticism that Mantegna's style was 'somewhat sharp, more closely resembling stone than living flesh' (Vasari/Hinds II, p.104). If in this respect Mantegna's graphic treatment seems contrived, the pen, however, is used with easy freedom in the hair of the grotesque figure of *Invidia* (Envy) and on the horses' manes, for example, or in the rapidly sketched buildings of the distant townscape. In passages of expressive tension like the figures' open mouths or the sea-horses'

BELOW 52a
Andrea Mantegna,
Battle of the Sea-Gods.
Engraving; 307 × 415 mm.

52 ▷

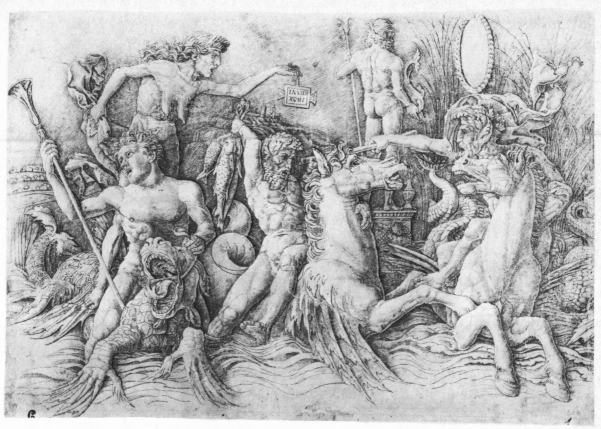

52b Workshop of
Andrea Mantegna,
Battle of the Sea-Gods. London,
Victoria and Albert
Museum, Ionides 406. Pen
and ink on paper;
283 × 420 mm.

staring eyes, spontaneous touches of reinforcement with the pen stress the emotions generated by battle.

It might appear that in this drawing Mantegna was preparing for the engraving of the same subject (52a), probably made in the late 1480s. It is unlikely, however, to be the final preparatory design for the print, both because there are passages of great freedom, and because it is in the same direction as the engraving: one would expect the direction of the narrative to be retained in the process of transcription from drawing to plate, and therefore reversed in printing. An equally good explanation is that it is an autograph copy after the print, differing in many small details and of much higher quality than another copy (52b), more fully finished but also more pedestrian in style, made by a workshop assistant of relatively limited ability. Both 52 and 52b may be examples of the procedure by which Mantegna and his assistants made 'presentation' drawings and paintings after prints produced in his workshop.

BIBLIOGRAPHY:
Chatsworth Exhibition I, 37
A.M. Hind, *Early Italian Engraving* V, London 1938–48, p.15
P. Kristeller, *Andrea Mantegna*, London 1901, p.404
E. Tietze-Conrat, *Mantegna*, London 1959, p.204

53 WORKSHOP OF ANDREA MANTEGNA
The Three Maries

Chatsworth, Devonshire Collection, 4
Pen and ink on paper
130 × 171 mm.

This drawing is a copy, by a relatively able assistant in Mantegna's workshop, of the group of the three Maries in the *Entombment* (53a), itself engraved by an assistant of Mantegna around 1475. The prints produced in Mantegna's workshop may, it appears, have had a training function, serving as exemplars for apprentices to copy in order to become familiar with workshop styles and techniques. The carefully drawn and redrawn parallel hatching here is rather academic, the heavy reinforcement around the profile and features of the left-hand figure is unaccomplished, and there is also something rather naïve about the heavy-handed curls of hair trailing down the Magdalene's back.

This is, then, an exercise in workshop graphic handling: the way that the shadows are built up of varied parallel hatching over the thick contours of the drapery folds, is characteristic of the drawings and engravings of Mantegna's followers. But it is also an exercise in compositional grouping: the closely integrated group of the Virgin and the Magdalene might well have been considered a valuable theme to stimulate assistants' later variations, for the problem of composing a figure-group in which physical compactness would both reflect and express emotional unification, was one which became a growing preoccupation for Italian artists at the end of the quattrocento.

BIBLIOGRAPHY:
A.M. Hind, *Early Italian Engraving* V, London 1938–48, pp.20–21

BELOW 53a Workshop of Andrea Mantegna, *Entombment*. Engraving; 458 × 350 mm.

53 ▷

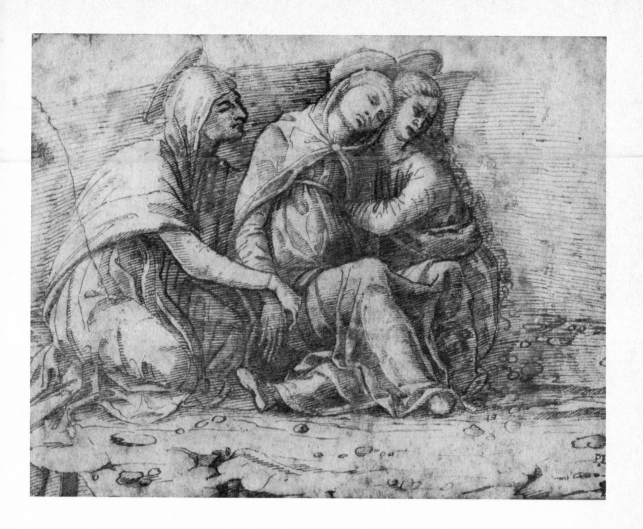

54 ERCOLE DE' ROBERTI (?)
The Pietà (recto) [colour plate 18]
Fragment of a Crucifixion (verso)

London, British Museum, 1946–7–13–9
Red chalk on paper
140 × 155 mm. (cut down on all sides)

This sheet shows two vigorous compositional sketches for Passion subjects, in which red chalk is exploited for its spontaneous fluency of application. The sheet has been cut down to the size of the more compact and finished of the two, the *Pietà* on the recto. The chalk is more gently handled here than on the verso, and the mood developed is more passive, although no less tortured. The principal aims of the draughtsman were to block out the forms of the figures, to investigate their physical and emotional interrelationships and then, finally, to examine in more detail the stiff, emaciated body of Christ. Below His body the forms are sketched with the utmost brevity, merely to indicate the outlines: only the Virgin's left foot provides a point of stabilisation for the group above. The powerfully expressive heads and torsos of the Virgin and St John were briskly laid in, using a blunt chalk in swift, flowing lines, with occasional points of expressive emphasis on the grief-stricken features. More attention was paid to Christ's torso and to His pose on the Virgin's lap: the backward-tilted head and strongly foreshortened chin seem to have given the draughtsman some trouble, for this passage is more heavily worked than any other. Form is built not through careful blending of tones, but through rapid hatching: like Signorelli (42), the draughtsman takes advantage of the immediacy of chalk to suggest here a fleeting moment of grief, and captures dramatically the figure's passionate movements and emotions.

In the fragmentary figure-group drawing for a *Crucifixion* on the verso, red chalk is handled even more vigorously. Great play is again made of the emotional and dynamic contrasts in the scene, and again the draughtsman concentrates on the passages most salient to the narrative. Emphasis is placed on the violent contrast between the Virgin's bowed head and the fierce onward movement of the soldier who strides forward brandishing hammer and nails. The vigour of the slashing diagonals of red chalk across the soldier's waist and left leg in turn contrasts with the softer, fuller modelling of the Virgin's face, in a remarkable demonstration of the potential of red chalk for characterising widely differing emotional states.

The composition on the recto is broadly similar to Ercole de'Roberti's Liverpool *Pietà*, but neither drawing can be directly related to any surviving work by Roberti or by any other Ferrarese artist. Indeed, the vivacity of handling compares better with chalk drawing in the early sixteenth century than with that which survives from Roberti's lifetime.

BIBLIOGRAPHY:

Popham and Pouncey 229
A.E. Popham, in *Old Master Drawings* VIII, 1933–34, pp.23–25, fig.4 (verso)

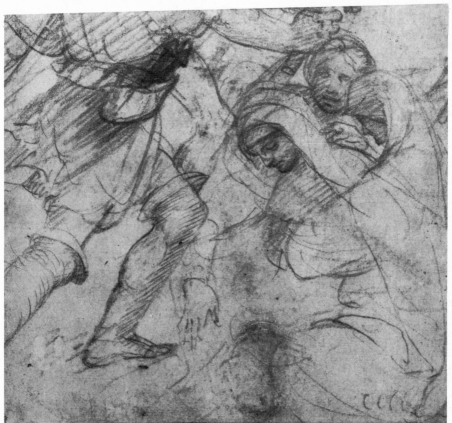

55 FILIPPINO LIPPI
The Death of Meleager

Oxford, Ashmolean Museum, KP 21
Pen and ink over stylus sketch, with wash and white heightening, on paper;
 the brazier and vessel pricked for transfer
226 × 230 mm.

This is the earliest of a group of drawings in which Filippino Lippi worked out
a composition for a complex Classical legend. Filippino drew with a vigorous
pen over the broad compositional lines laid out with a stylus, which made
slight indentations in the paper (clearly visible in the upper right corner), but
left no colour on the surface. Firm lines were drawn to build the setting and
to define the contours of the figures: over these the pen played with an
almost tremulous, flickering vivacity. Light hatching, cross-hatched in the
deepest shadows, was drawn in all directions on draperies and background.
The textures of the fine, loose fabrics worn by the main figures were charac-
terised sensitively by Filippino's nervous pen, especially as he followed and
reinforced the principal figure's forward movement with a series of dis-
connected lines to indicate the fluttering drapery of her dress. Touches of
wash deepen the pools of shadow and white heightening adds occasional
expressive accents to strengthen the narrative.

LEFT 55a Filippino Lippi,
The Death of Meleager.
London, British Museum,
1946–7–13–6.
Pen and ink with wash
and white heightening,
on paper; 297 × 284 mm.

55 ▷

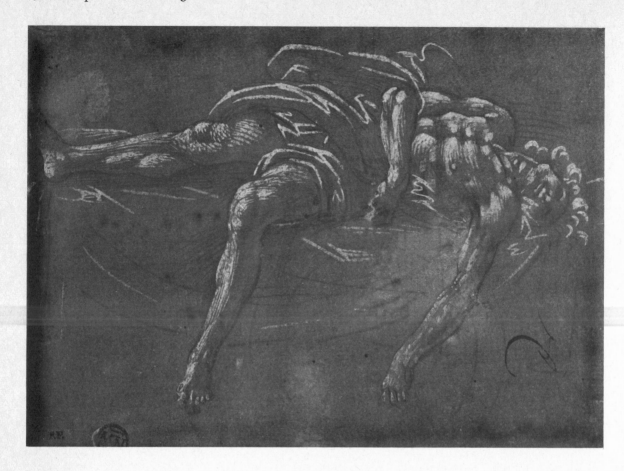

The larger, more detailed compositional drawing of the same subject in the British Museum (55a) lacks some of the spontaneity of this sketch. This suggests that it is a later attempt at the composition, moving closer to the final design. The composition is much changed and the penmanship is generally less excited, the wash and white heightening giving the drawing a more pictorial appearance. Another drawing (55b), which may lie between the two designs (or which may be a workshop copy of Filippino's figure-study), is a reconsideration of the two main female figures. The brazier between them was transferred directly from 55, which served as a cartoon for this detail. This may suggest that Filippino developed a method of working his design up through a number of stages, while retaining specific details which could be transferred by pricking to later drawings to preserve continuity. Although the brazier in the British Museum drawing (55a) is not the same, the figure of Althaea is identical in reverse to that in 55b. Both figures could have been transferred from a single, reversible cartoon; as could the recumbent Meleager in 55a and in another sheet in Paris (55c). This last drawing is, however, more spontaneous, and seems to be a *garzone* study for the figure of Meleager.

BIBLIOGRAPHY:
Parker 21
Popham and Pouncey 133 (for 55a)

ABOVE 55c Filippino Lippi?, *Study for Figure of Meleager*. Paris, Louvre, 9862. Silverpoint, with white heightening, on brown prepared paper; 125 × 175 mm.

RIGHT 55b Filippino Lippi, *Two Figures in the Death of Meleager*. Florence, Uffizi, 203E. Pen and ink, with wash and white heightening, on paper; 255 × 155 mm.

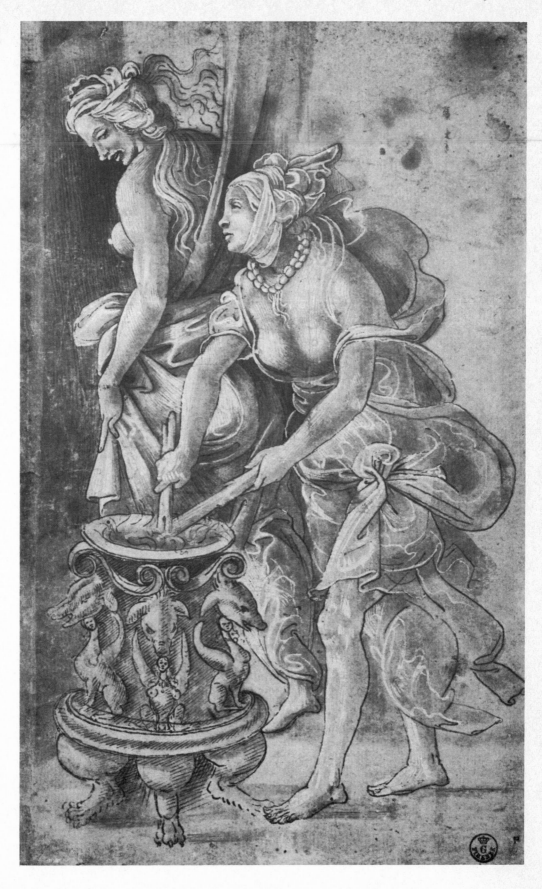

56 DOMENICO GHIRLANDAIO
The Birth of the Virgin

London, British Museum, 1866–7–14–9
Pen and ink on paper
215 × 285 mm.

Ghirlandaio treated the earliest stage in compositional design with great freedom. In this sheet, made in preparation for the fresco of the *Birth of the Virgin* in Santa Maria Novella, Florence (56a), he used the process of drawing to stimulate further work on details of the composition. This can be sensed from the varying clarity with which the figures are drawn, and from the differences between drawing and final composition. In the first stage of evolving the design, the interior setting was laid out, and the perspective of the complex architecture of the left-hand side of the scene and of the form of St Anne's bed was defined. The orthogonals of the barrel-vaulted passage leading out of the space were evidently drawn before the figures, and the group of midwives was likewise added over the schematic indication of the bed. Ghirlandaio had trouble with the perspective at the upper left-hand side, resulting in some rather ungainly lines which contrast with the light fluency of the sketching elsewhere. The figure-style varies too, from the breezy step of the visitors on the left, whose drapery almost entirely lacks definition by hatching, to the more considered group of midwives: here, the poses are more complex and needed more careful definition in preparation for further study. Throughout, however, a rapid shorthand was used for heads, hands and feet. Ghirlandaio's purpose was to set out the context of the scene and the interplay of figures and groups within it.

BELOW 56a Domenico Ghirlandaio, *The Birth of the Virgin*. Florence, Santa Maria Novella, Tornabuoni Chapel. Fresco on wall.

56 ▷

After further work had been done on the figures, and the patron had introduced modifications which, under the terms of the contract, he was entitled to require, the result as shown in the final fresco (56a) was significantly different. Ghirlandaio himself developed much further the idea of the water-pouring figure who enters at the right: the figure in the compositional design, which may perhaps have been sketched from a lay-model, has been replaced by a more complex running figure which was the subject of a separate study (56b). It was probably, however, at the patron's demand, on seeing a more finished compositional drawing, equivalent to that for the *Annunciation to Zacharias* (VB), that the group of visitors was increased to five. Two later stages in the preparation of these figures are shown in 71. In their dignified but rather static bearing, these visitors create a disconcerting contrast to the rhythms of the figure-group at the right. Partly for this reason, the final fresco lacks the spontaneous freshness of the compositional design, which is one of the finest and most dynamic of its type to survive from the late quattrocento.

56b Domenico Ghirlandaio, *Girl Pouring Water*. Florence, Uffizi, 289E. Pen and ink on paper; 219 × 168 mm.

BIBLIOGRAPHY:
Popham and Pouncey 69
Berenson 878
G.S. Davies, *Domenico Ghirlandaio*, London 1908, p.142
H.S. Ede, *Florentine Drawings of the Quattrocento*, London 1926, p.21 pl.34

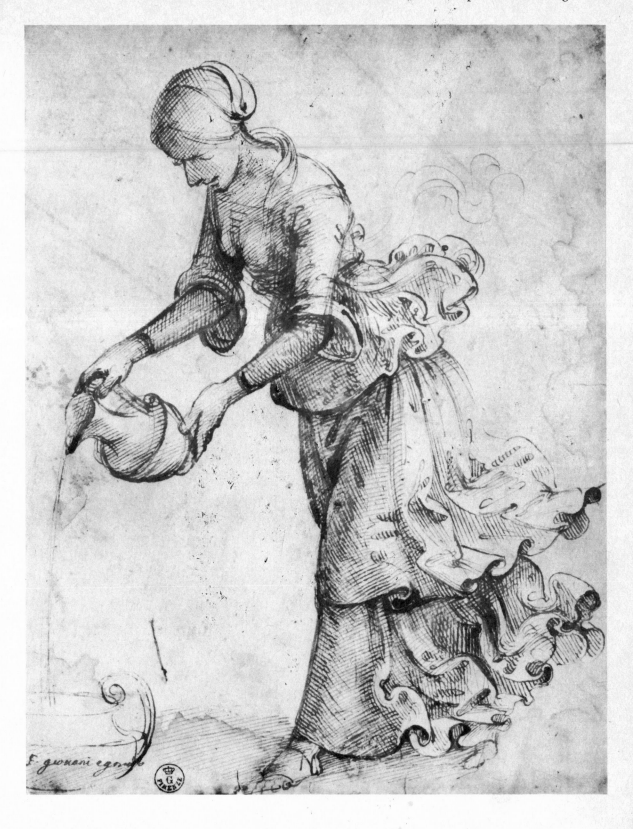

57 GENTILE BELLINI
Processional Scene [*colour plate 19*]

Chatsworth, Devonshire Collection, 738
Pen and ink over slight sketch in red chalk, on paper
145 × 209 mm.

This Venetian equivalent of Ghirlandaio's *Birth of the Virgin* sketch (56) also represents the first stage of compositional design, and is treated with similar freedom. The basic lines of the setting were rapidly drawn in red chalk, a technique of underdrawing which seems to have been characteristically Venetian. Over this brief sketch the principal architectural forms were drawn freehand without concern for precision of perspective or proportion. Architectural detail, however, is plentiful enough to show that the narrative was to have a specifically Venetian setting. The rounded pediments over the cornice and doorway of the main building, and the domed, two-storeyed loggia are typical of late quattrocento Venetian architecture. The figures are less clearly defined: all we can see is that they are taking part in a procession which winds towards the portico at the right. Gentile Bellini wished to show that his painting was to be well-filled with figures, but few of them are clarified in status or function. A simplified figure-type was repeated innumerable times to create a sense of the crowd on the piazza: an elongated loop served to indicate the body, a quick circle the head. The pen was nervously jabbed down onto the paper in some places, producing a thickened, darker line; in others, it was pulled across so quickly that the grain of the paper shows through the pallid line. An even swifter cipher was used, with a quick dart of the pen, for the background figures and for the details of the buildings receding beyond the piazza. A rapid, brusque hatching suggests the shadows cast at the right-hand side, and within the open doorway.

A later stage in Gentile Bellini's compositional design process is shown by a drawing in the Uffizi (57a), in which a rather similar external setting is treated very much more precisely. Many of the figures in the final painting would have been based on *simile* drawings analogous to Carpaccio's workshop figure-studies (34; and see also III G), which explains why no definition of different figure-types was necessary here. Portraits derived from drawings like Carpaccio's (70) or Bonsignori's (VI E), would then have been added to some of the processional figures at the behest of the patrons. Unified in conception and consistent in the degree of finish, this sheet represents the first consideration on paper of the design for a large-scale narrative painting. It has with reason been associated with one of the canvases painted by Gentile and Giovanni Bellini for the Sala del Maggior Consiglio in the Doge's Palace, representing a scene from the life of Pope Alexander III.

BIBLIOGRAPHY:

D. von Hadeln, *Venezianische Zeichnungen des Quattrocento*, Berlin 1925, pp.44–45, pl.8
Popham 1931, 169 (as Carpaccio)
Tietzes 263

OVERLEAF 57a Gentile Bellini, *Processional Scene*. Florence, Uffizi, 1293E. Pen and ink, with wash, on paper; 442 × 591 mm.

57 ▷

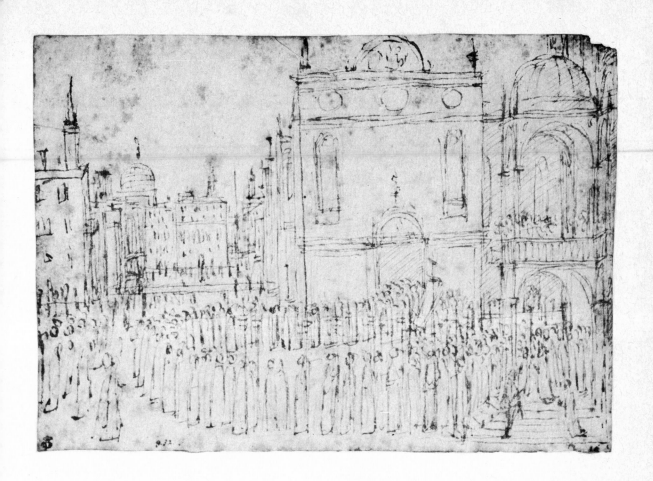

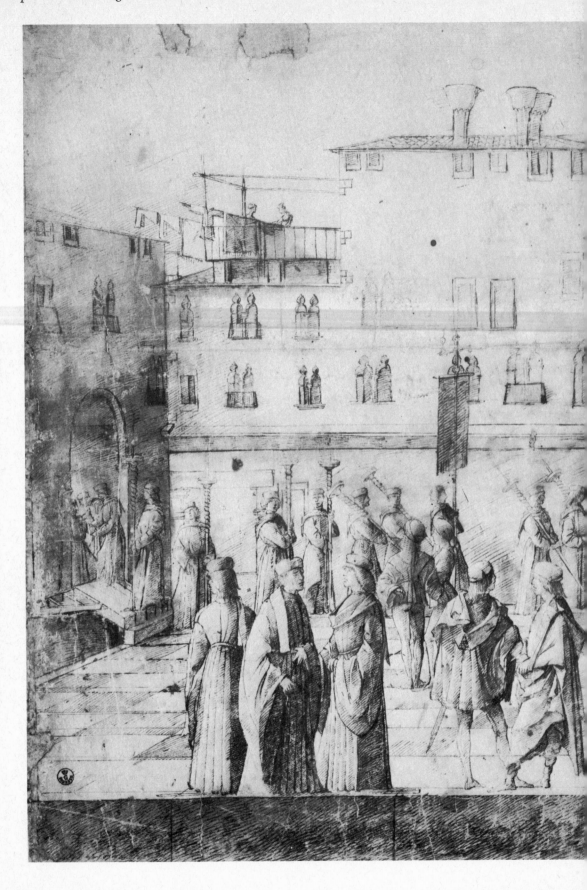

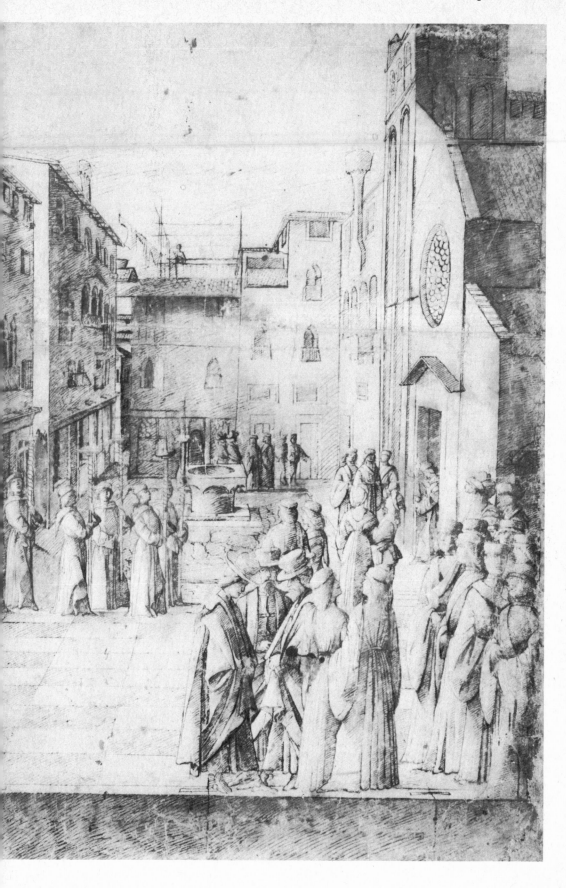

58 VITTORE CARPACCIO
Prince Conon Taking Leave of His Father (recto)
Studies for Figures and Compositions (verso)

Chatsworth, Devonshire Collection, 740
Pen and ink, over black chalk sketch, on paper (recto)
Pen and ink (verso)
129 × 271 mm.

The principal drawing on the recto shows the second stage of Carpaccio's design procedure, after the composition had been established in a sketch analogous to Gentile Bellini's (57). The main figure-group was considered more closely here: the simplified ciphers of the preliminary drawing were enlarged and reworked in fuller detail. To this end, Carpaccio worked for the most part with a light pen, which he stroked swiftly over the paper surface to leave pale, angular lines. Curiously reminiscent of brushstrokes, these lines happily convey the silky textures of the fabrics worn by king and courtiers. In other details of the foreground figures, a correcting pen was handled more heavily, leaving much darker lines, as Carpaccio experimented with the pose or drapery directly on the paper. The two figures at the left foreground, drawn in simpler, more angular strokes, may be outline copies of workshop *simile* drawings, such as the figures in 34. Those in the background, sketched in to indicate the change of scale as the composition recedes towards the landscape, preserve the rapid simplifications of a preliminary compositional design.

58a Vittore Carpaccio,
Prince Conon Taking Leave of His Father.
Venice, Accademia, inv. 369.
Oil on canvas;
280 × 611 cm. (complete).

58 (recto) ▷

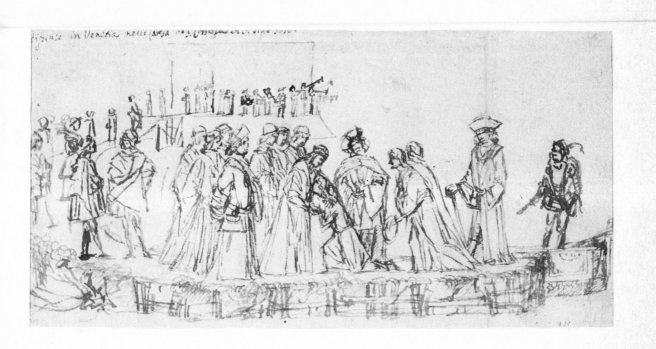

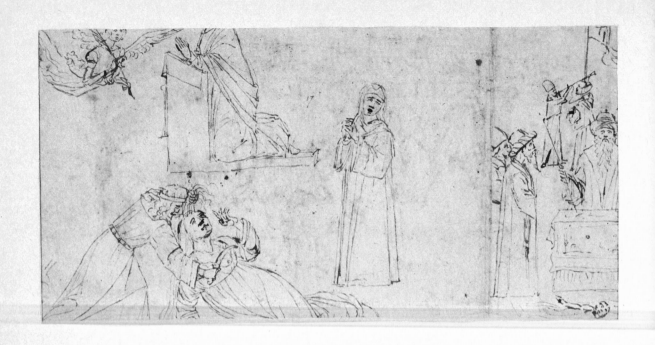

58b Vittore Carpaccio,
*Fortified Harbour with
Shipping.*
London, British Museum,
1897–4–10–1. Pen and ink,
over red chalk sketch, on
paper; 172 × 192 mm.

◁ 58 (verso)

The drawing is the main figure-group study for the painting of *Prince
Conon Taking Leave of His Father*, dated 1495, in the St Ursula cycle (58a). The
major change in the finished painting is the introduction of a large and
obtrusive group of spectators in the left foreground. A portrait-drawing,
now at Princeton, N.J., made from life for one of these heads, suggests that
these figures are all portraits of members of the Scuola di Sant' Orsola. They
had presumably to be interpolated into Carpaccio's composition at the
request of the Scuola, after Carpaccio had produced a finished drawing for
their approval. The townscape and landscape elements in another drawing,
in the British Museum (58b), were reconstituted and used for the background
behind the figure-group here studied.

On the verso are several sketches of figures and groups. The technique is
similar but the handling is relatively mediocre and may be due to an assistant
in Carpaccio's workshop, perhaps his son Benedetto. A fold in the sheet,
coinciding with the edge of a compositional study, suggests that the sheet
was originally bound into a sketchbook. The heterogeneous collection of
ideas on the verso certainly has the character of sketchbook jottings; but the
recto clearly had a very specific function in compositional preparation.

BIBLIOGRAPHY:
D. von Hadeln, *Venezianische Zeichnungen des Quattrocento*, Berlin 1925, p.53, pl.13
Lauts 6, p.266
Muraro pp.32–33
Tietzes 592

59 VITTORE CARPACCIO
Group of Bystanders

Oxford, Christ Church, 1882
Pen and ink, with wash, on paper
66 × 112 mm.

A brilliant little sheet of natural observations, this is a compositional drawing only in the sense that a number of figures were drawn on a single sheet and were later transferred, more-or-less unaltered, onto one of the canvases of Carpaccio's St Ursula cycle. The draughtsman's aim here was to capture a glimpse of a group of figures, and to characterise those figures with a few lines, swiftly changing the strength and direction of the pen. The two gentlemen, apparently in close conversation, are constructed in rapid, angular lines with the speed of a brief caricature; the five females are clearly distinguished in age and status by subtle variations of spacing and of pen-movements. A light wash was dabbed briskly on, to fill out the figures and to suggest the platform-like space on which they are set. This is a spontaneous observation, akin to the figure-sketches made by Leonardo da Vinci when following his own recommendations about poses and gestures: 'observe and sketch briefly, with few lines, the actions of men as they occur accidentally, without their being aware of it. . . briefly note the movements and actions of bystanders and their grouping' (Leonardo/McMahon I, pp.104–5).

Although Carpaccio probably had no particular objective in mind beyond an interest in recording types and movements, he later worked up these figures and integrated them, with only slight rearrangement, into the background of his *Reception of the English Ambassadors* in the St Ursula cycle (59a). After establishing his composition, the artist probably searched through his stock of *simile* drawings and idle figure-sketches to find material suitable for the staffage of incidental areas of his paintings. Thus these lightly and vividly sketched figures were brought into play to add a further naturalistic vignette of Venetian life to the rich contemporary detail of the painting.

BIBLIOGRAPHY:
Byam Shaw 711
Muraro p.68

59a Vittore Carpaccio, *The Reception of the English Ambassadors*, detail: background figures. Venice, Accademia, inv. 366. Oil on canvas; 275 × 589 cm. (complete).

59 ▷

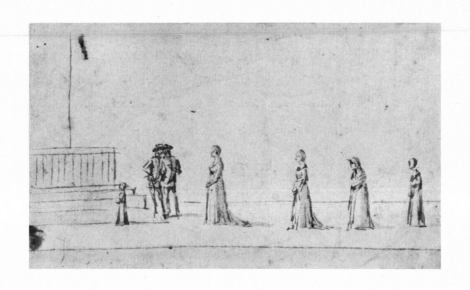

60 VITTORE CARPACCIO
A Monk and Three Musicians (recto)
A Scholar in His Study (verso)

London, British Museum, 1895–9–15–806
Pen and ink, with wash (recto only), on faded blue paper
189 × 277 mm.

Carpaccio investigated different aspects of an interior space on the two sides of this sheet. The recto is more fully worked up, despite curious inconsistencies which suggest that this may be an early stage in the exploration of a design. The monk is significantly smaller than the musicians, perhaps to suggest his position further back in the space, and the rebec-player at the right is larger than her companions. She is cut uncomfortably by the parapet which marks the front of the picture space. Nonetheless the figures have been drawn with much care: the pen lines are characteristically firm and generate various ingenious impressionistic effects. The quivering zig-zag lines on the seated musician's hair, for example, give a strong sense of texture; and the rippling folds of the central musician's full sleeves are conveyed with easy, rhythmic touches of the pen. The elaborate grandeur of the compositional drawing is increased by the application of a tonally-varied wash, which suggests that the light entering from the left is strong, reflecting brightly from the seated musician's hair, and generating deep shadows beneath the lute to emphasise the roundness of the instrument's body.

On the verso, attention is focused on the instruments of the scholar's study: set-square and dividers hang from the shelf and books lie on the desk before him. Here figure, interior and objects are rendered by line alone, without the assistance of wash to lay in the shadows. The space is, however, absolutely clear, and the rapid, darting movements of Carpaccio's pen define the details of setting and figure with admirable economy.

The purpose of these two compositional designs is obscure: they cannot convincingly be associated with known projects, and they may have been no more than experiments in compositional drawing. The seated musician on the recto reappears in full as a musician-angel in a *Madonna and Child Enthroned* altarpiece of 1518 in San Francesco, Pirano; but this drawing is in no sense preparatory for that painting. It may well be that both figures derive from a workshop *simile* drawing of the motif.

BIBLIOGRAPHY:
Popham and Pouncey 38
D. von Hadeln, *Venezianische Zeichnungen des Quattrocento*, Berlin 1925, p.57 pls.32–33
Lauts 28, p.272
Muraro pp.50–51
Tietzes 614

61 BERNARDINO PINTURICCHIO
Adoration of the Shepherds

Oxford, Ashmolean Museum, KP 40
Pen and ink on paper, pricked for transfer
183 × 262 mm.

The neat handling of the pen in this finished compositional cartoon is conditioned principally by its purpose. Pinturicchio drew the contours with a pen so unvaryingly handled that it might almost have been a stylus. The result is static, which suits the contemplative interpretation of the subject but also produces a routine, rather impersonal result. The only details drawn with any freedom are the trees in the landscape behind; and the pricking of these forms is loose and arbitrary, indicating that they were to be more freely invented in paint than the figures. The exactness and inflexibility of the figures' contours is necessary to provide a clear guide for pricking, in preparation for the transfer of the design to a small panel prepared for tempera painting. The cross-hatching in the shadows suggests that this sheet may have served not only as a cartoon, but also as a finished design to be approved by the patron. Its interest lies not so much in the style, which in the nature of so finished a drawing is rather characterless, as in its rarity as a compositional cartoon; and that it was used for transfer to a panel is further suggested by some discoloration, probably caused when the design was pounced through with charcoal dust.

In contrast to the use of chalk for the cartoons of heads (71, 72), this cartoon is in pen and ink. This is because on the small scale of a predella panel, (analogous to the piece of embroidery for which V G was the cartoon), the fine, precise lines of the pen are needed to produce the detail which had to be transferred. Several cartoons of this type survive from the years around 1500, suggesting that by the end of the fifteenth century the practice of making cartoons for important forms and figure-groups (68) had been extended to the production of cartoons for entire small compositions.

BIBLIOGRAPHY:
Parker 40
Fischel 78

62 ALVISE VIVARINI
Design for an Altarpiece

Windsor, Royal Library, 069
Pen and ink, over ruled stylus lines, with faint touches of white heightening, on paper
347 × 249 mm.

This sheet demonstrates the care taken by late quattrocento Venetian painters in the design of the architectural setting of their large altarpieces. There is a clear contrast between Vivarini's treatment of the architectural forms and decorations, on the one hand, and of the figures on the other. That the bias of his concern was towards the setting is evident from the relative brevity of the figure-treatment, whereas the study of the architectural forms is detailed and conscientious. The principal verticals and horizontals of the architecture, and the compass-swung semicircles of the arches, were first drawn with a stylus, and the figures were presumably roughly drawn over the stylus lines so that the architecture could be built up around them. The architectural forms (pilasters, capitals, cornices) were then defined very precisely, and, as though to emphasise the crispness of detail, some of the outlines were reinforced in a darker ink. The decorative patterns to be applied in the final painting to the panelled pilasters, the mouldings and the figurated spandrels, are all neatly incorporated on the left: the right-hand side was evidently to be a mirror-image and therefore did not require full detailing. The freer treatment of the forms of the Madonna's throne shows up by contrast the fine, clear lines of the architectural articulation. Touches of white heightening were finally added on the inside of the arches at the right-hand side, and on the receding cornices, to support the soft hatching in the shadows in demonstrating the fall of a gentle light from the left.

The figures alone have a sense of liveliness. The two angels were sketched freely with a thinly-cut quill and a light ink; by contrast, the outlines of the main figures were boldly thickened, their features were generated from firm, angular thrusts of the pen, not unlike Carpaccio's in 58, and heavy hatching built up a deep tone in the shadows. Boldly though the figures were treated, Vivarini was principally concerned to produce a set of variations on the architectural theme, and the devotional significance of the altarpiece is overpowered in this preliminary drawing by an intense concentration on the details of the setting.

BIBLIOGRAPHY:
Popham and Wilde 31
J. Steer, *Alvise Vivarini: His Art and Influence*, Cambridge 1982, 44, pp.170–171

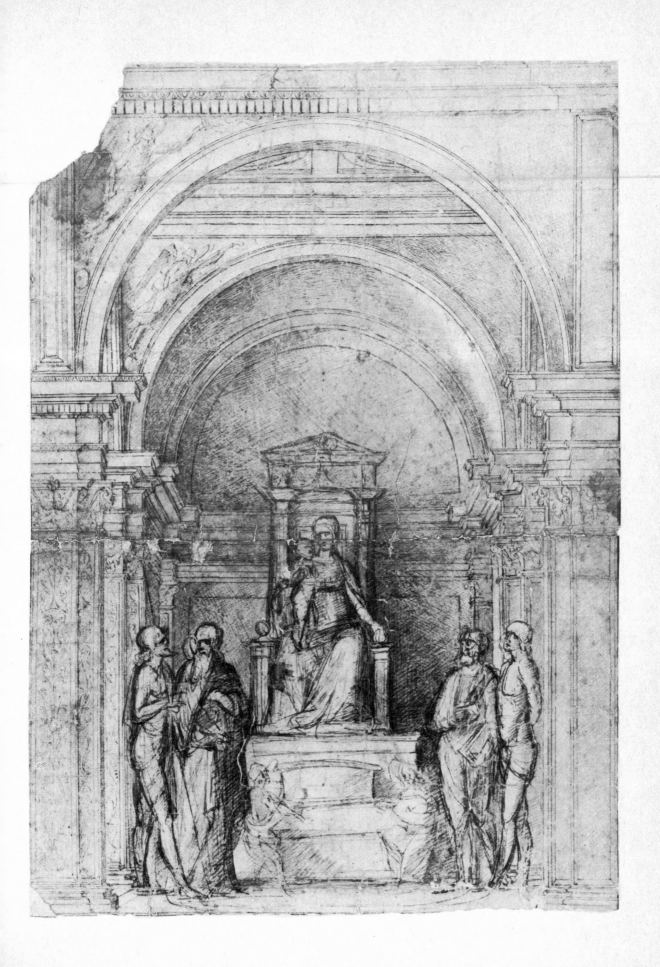

63 FRA BARTOLOMMEO DELLA PORTA
Sketch for an Altarpiece for San Marco, Florence (recto)
Two Figures (verso)

Birmingham, Barber Institute of Fine Arts
Black chalk, with touches of white heightening, on paper
260 × 197 mm.

In contrast to Alvise Vivarini's altarpiece design (62), Fra Bartolommeo's shows the draughtsman's exploitation of the freedom of black chalk as he sought to evolve a unified composition. The rhythmic flow of the chalk generates the solid forms with enviable ease, to produce a group of relaxed, graceful figures, who develop around them an atmosphere of harmonised devotion. Rapid parallel hatching creates much of the tonal modelling, but Fra Bartolommeo also exploited the soft, friable quality of a blunt stick of chalk to lay in areas of tone in the drapery and in the Madonna's Cloth of Honour. He also used his chalk in an energetic, purely linear manner, in the fluent lines of the drapery of the angel in the upper left-hand corner, who draws the composition together at the top.

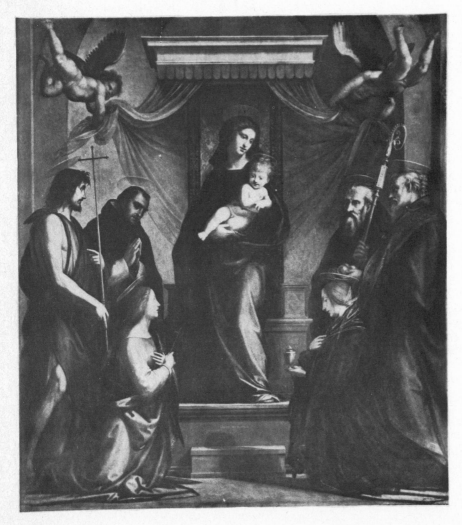

63a Fra Bartolommeo della Porta, *Madonna and Child with Saints and Angels*. Florence, S. Marco. Oil on panel; 240 × 215 cm.

63 (recto) ▷

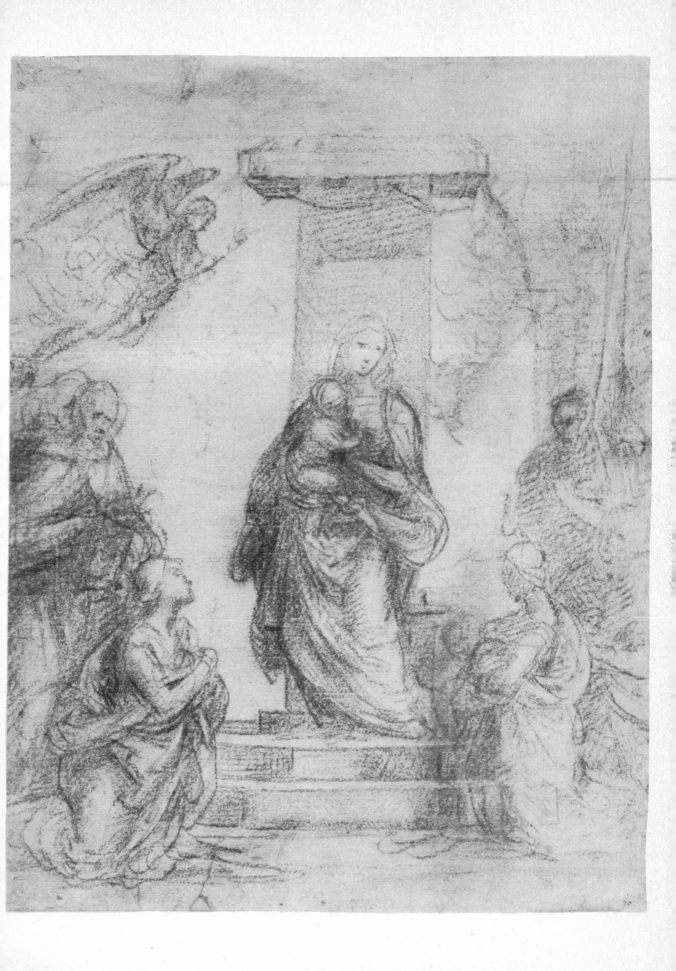

◁ 63 (verso) As in Vivarini's design (62), the left-hand side is more fully worked up than the right: the steps of the throne were drawn after the kneeling saint to the left, but before the one on the right, who seems little more than an after-thought to balance the drawing and to add another dimension to the con-templative mood. On the right-hand side, Fra Bartolommeo's handling is much broader: the tonality is lighter but the figures, though less compactly formed, are still intelligible within the context of the whole. This is a work-ing sketch for a *Madonna and Child with Saints* altarpiece (63a), painted in 1509 for San Marco in Florence, in which the devotional temper of the altarpiece evolved alongside the formulation of the individual figures, unified by the enveloping tones of the black chalk.

On the verso is a brief yet virtuoso black chalk sketch of two nearly full-length figures who bear no relationship with the altarpiece but demon-strate the confident spontaneity of Fra Bartolommeo's handling of chalk for sketching.

BIBLIOGRAPHY:
Berenson 210B
H. von der Gabelentz, *Fra Bartolommeo und die Florentiner Renaissance* II, Leipzig 1922, 304, pp. 131–132
Parker and Byam Shaw 53

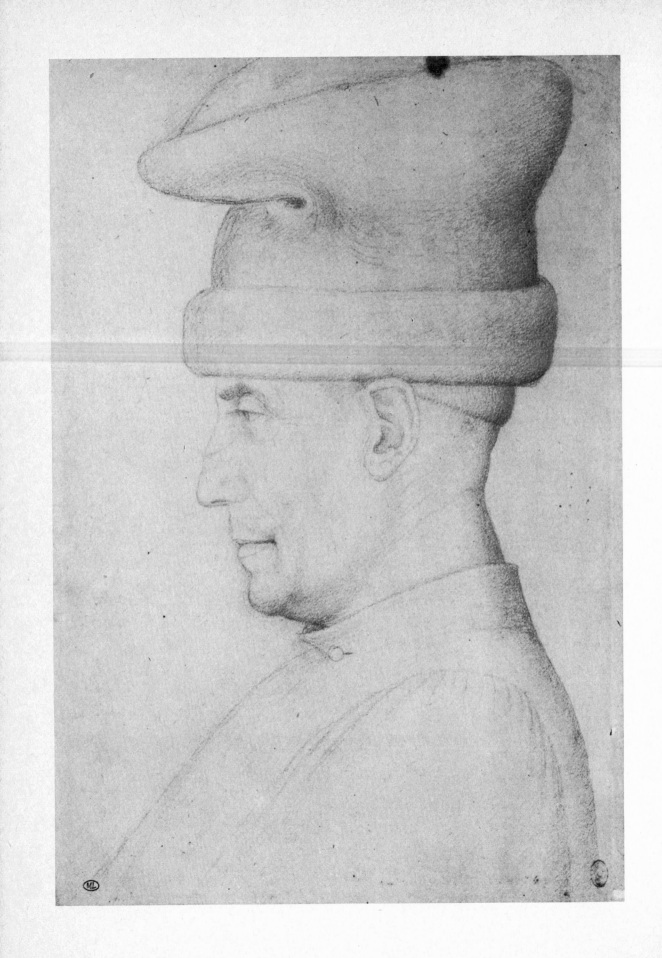

Another major preoccupation of the Italian artist towards the end of the fifteenth century was with facial expression, with reflecting what Alberti called the 'movements of the mind' in the outward portrayal of the face. Before the mid-fifteenth century, facial types had been painted essentially by formula: conventions existed for representing the types of the major biblical figures, and individualisation was not considered important. Around 1400, Cennino Cennini, in his *Libro dell'Arte*, instructed the painter on 'The method for painting an aged face'; and the section 'On painting and doing flesh for a youthful face' is a series of practical steps for depicting a young type, using the Virgin Mary as an example worthy of special attention. Cennini did not apparently consider the possibility, or sense the potential, of varying facial types to stress individual emotional states.

The early Renaissance painter's growing concern with facial characterisation was reflected in Alberti's theory of narrative, set out in *Della Pittura* (1436). Central to this theory was the concept of 'appropriateness': each figure, in movement and expression, must suit its role within the meaning and the mood of the narrative. Alberti's plea to artists to consider each facial type individually was later taken up by Leonardo da Vinci. Writing some one hundred years after Cennini, Leonardo discussed in detail how the draughtsman could gain practice in observing movements, gestures and expressions by making informal sketches, so that he could apply his experience in depicting the 'mental state' of any figure he had to paint. Filippino Lippi's brisk handling of silverpoint and white heightening (67) was well suited for rapidly noting down an expressive type, either for future reference or, more probably, as an exercise in the momentary perception and recording of his model's emotional mood.

In practice, this led draughtsmen to study the head, the expressive focus of each figure, in greater detail than before. Early examples of studies of heads can be found from Pisanello's workshop (VIA): such drawings are, in a loose sense, portrait-studies, since they were drawn from models and, by their very nature, seek to encapsulate the model's individuality. But their objective was to explore how drawing and drawing techniques could best be exploited in the study of form and expression, rather than to produce independent portraits. The portrait-drawing as an independent form developed in North Italy towards the end of the century. Before this, of course, drawn portraits were made of particular individuals, but they were not made on commission, or for presentation to the sitter: they were made either in preparation for (or copied from) a painting (VIA), or to record for posterity an individual's features (VIB). Any painted portrait, of a donor in an altarpiece, of an important bystander in a narrative fresco, or of the sitter

VIA Antonio Pisanello, *Portrait of Niccolo Piccininò*. Paris, Louvre, 2482. Black chalk on paper; 308 × 208 mm.

in a portrait-painting, is likely to have been based on a drawing. There is no known drawing for an extant Italian portrait of the first half of the fifteenth century, but two surviving examples from Northern Europe may parallel Italian practice. A fine silverpoint drawing in preparation for Jan van Eyck's so-called *Portrait of Cardinal Albergati* (Vienna) is provided with colour-notes in Jan's hand, and the French painter Jean Fouquet made a masterly drawing in black and coloured chalks of *Guillaume Jouvenel des Ursins* (VIC) for the painted portrait in the Louvre. There is, however, no indication that portrait-drawings were acceptable to patrons in lieu of painted portraits before the late fifteenth century.

By this time the independent portrait-drawing had become acceptable for several reasons. Isabella d'Este's difficulties in obtaining paintings from Giovanni Bellini and especially from Leonardo da Vinci may exemplify a general tendency which led patrons to change their attitudes towards draw-ings. Lacking time to produce more, as he passed through Mantua on his way from Milan to Venice in 1500, Leonardo made a portrait-drawing of Isabella d'Este which, at her request, he seems to have coloured in pastels (VI D). Leonardo's portrait conformed with the strong tradition in North Italy that finished drawings ranked as works of art in their own right, or were con-sidered to be such at least within the artist's workshop. The independent genre of the commissioned portrait-drawing followed naturally, and became more popular as the North Italian draughtsman's technical skill in chalk-drawing increased. The earliest datable black chalk portrait-study is the preliminary drawing for Francesco Bonsignori's *Portrait of a Man* of 1487

LEFT VIB Florentine Draughtsman, *c*.1400. *Portrait of Manuel Crysoloras.* Paris, Louvre, 9849b. Pen and ink, with wash, on paper; 136 × 94 mm.

RIGHT VIC Jean Fouquet, *Study for Portrait of Guillaume Jouvenel des Ursins.* Berlin, Kupferstichkabinett, 4367. Black and coloured chalks on grey paper; 267 × 195 mm.

OPPOSITE VID Leonardo da Vinci, *Portrait of Isabella d'Este.* Paris, Louvre, M.I.753. Black chalk and pastel colours on paper, pricked for transfer; 630 × 460 mm.

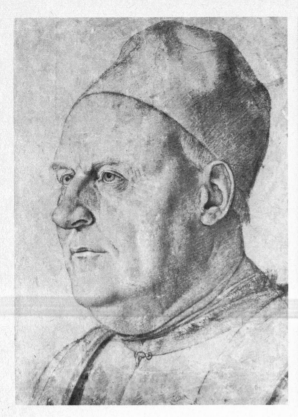 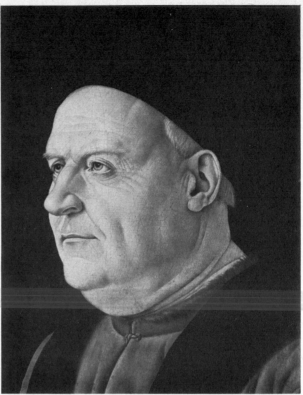

(VIE, VIF), which already shows a highly accomplished, if somewhat pedestrian, technique of modelling, using the full tonal range of the black chalk. It is but a short step from such proficiency to a virtuoso drawing like Giovanni Bellini's (69), which was in all probability made as an independent portrait. Here Bellini admirably exploited the painterly qualities of black chalk to develop tonal effects which are directly analogous to his mature oil-painting technique.

In Central Italy the drawing held no such high status before the early sixteenth century. Portrait-studies (64,65) were functional: they were probably produced in connection with finished paintings, as were other studies of heads (67,72) drawn from workshop models. One of these functions, which led the way towards a more intensive examination of individual types, was in the production of cartoons for the transfer of portrait-types into narrative or commemorative frescoes (71). Formulae for the depiction of specific types were evolved in the fourteenth century, partly because the fresco-painter needed a simple system which he could memorise and reproduce rapidly. It was not until about 1450 that the Central Italian painter began to realise the value of a full-scale drawing, which could serve both to transfer the outlines to the wet plaster and to guide him as he laid in the internal modelling of his heads. Henceforth, painters were prepared to use the larger amounts of paper needed for cartoons, so that they could reproduce accurately on the picture-surface the finest details of their studies of character and expression. The large scale of drawing demanded by cartoons encouraged draughtsmen to exploit the broad medium of charcoal and, with increasing frequency, of black chalk (68). This, in turn, gave them more practice in using chalk to explore tonal gradients; whereas in Venice (69) it was the technical parallel

LEFT VIE Francesco Bonsignori, *Study for Portrait of a Man.* Vienna, Albertina, 17.6.672. Black chalk on paper; 360 × 262 mm.

RIGHT VIF Francesco Bonsignori, *Portrait of a Man.* London, National Gallery, 736. Oil on panel; 420 × 295 mm.

VIG Leonardo da Vinci, *Study for Head of Judas*. Windsor, Royal Library, 12547. Red chalk on reddened paper; 180 × 150 mm.

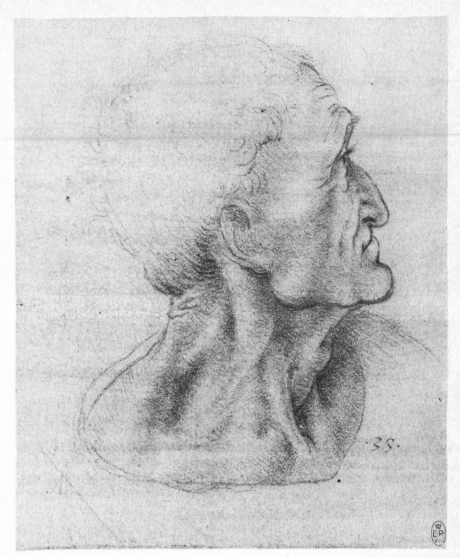

with oil-painting which led to increasing exploitation of chalk for portrait study. However, despite the stimulus to the use of chalk provided in Central Italy by cartoon drawing, small-scale studies of heads were almost invariably made in silverpoint (64,65,73). On his return to Florence in 1500, however, Leonardo da Vinci revealed to his contemporaries, such as Fra Bartolommeo (14), the potential of small-scale study and sketching in red chalk which he had exploited in the preliminary work for his *Last Supper* in 1497 (VIG). Ultimately it was Leonardo's efforts to perceive and reproduce the emotional and psychological response of each figure to the drama in which he was involved which established these techniques, which had only occasionally been used in quattrocento workshops, as fundamental to the sixteenth-century painter's thought and practice.

64 BENOZZO GOZZOLI
Head of a Curly-haired Youth (recto)
Four Seated Saints (verso)

Windsor, Royal Library, 12811
Silverpoint, with white heightening, on brown prepared paper (recto)
Pen and ink on paper (verso)
232 × 169 mm.

Benozzo Gozzoli's careful handling of the silverpoint clearly defines the individual hairs in the mass of curls around the boy's right ear. This seems to be the focus of the draughtsman's attention, at the expense of a firm sense of anatomical form: the relationship between head and neck, for instance, is weakly articulated. This is partly due to Gozzoli's use of an unusually dark-toned preparation on the paper, so that the colours of the silverpoint lines and of the ground differ little. In contrast, the white heightening shows up very clearly, and as a result the lighted left side of the face has a rather schematic appearance, since the fine white hatching does not blend smoothly with the generally dark tonality. The boy's features are described by white lines, but the areas of white across the forehead, round the mouth, and especially under the right eye, do not adequately describe the fall of the strong light over the relief of the face. The highlights are most successful where a linear brushstroke is most appropriate, for example in the curls of the hair, which delicately complement the soft grey silverpoint curls. On the boy's coat, where a thicker brush and more diluted pigment was used, a clearer control of anatomical definition can be sensed.

Although probably a study from life of a workshop *garzone*, this drawing has the somewhat lifeless character which may result from the lengthy process of working with a stylus. It is thus a good example of the limitations of the silverpoint in portrait study, especially in the hands of a draughtsman who, relatively early in the fifteenth century, did not yet seek for the spontaneity of perception and technique of a Filippino Lippi (66,67).

The four weakly drawn saints on the verso may indicate that this sheet was originally part of a workshop sketchbook or portfolio. The draughtsman seems to have been a Gozzoli workshop assistant, whose handling of the pen was dull and automatic, and whose sense of form and expression was relatively primitive. These four figures may be apprentice copies of established patterns, perhaps for the four Evangelists. Another sheet, from a Gozzoli workshop sketchbook in Rotterdam, has versions of the two lower figures (64a), perhaps copied from this drawing or sharing a common prototype; and a third sheet (64b) in the British Museum includes two more very similar figures.

BIBLIOGRAPHY:
Popham and Wilde 11
Berenson 546
Degenhard and Schmitt 401
Parker and Byam Shaw 27
Popham 1931, 23

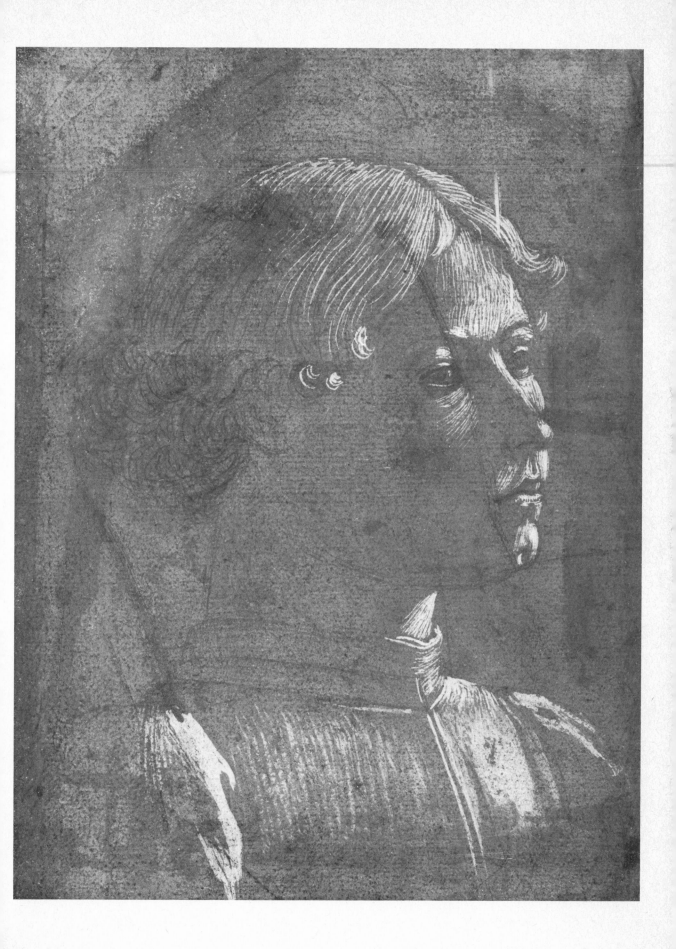

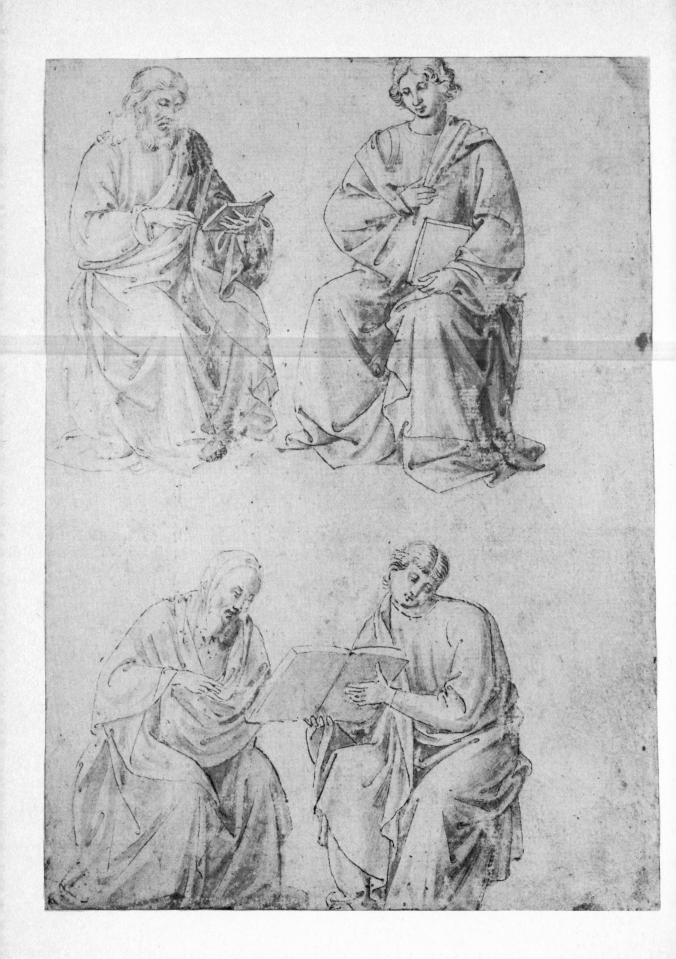

LEFT 64a Workshop of
Benozzo Gozzoli,
Sheet of Studies. Rotterdam,
Museum Boymans-van
Beuningen, Gozzoli
sketchbook f.45r.
Silverpoint and pen and ink,
with wash and white
heightening, on prepared
paper; 229 × 160 mm.

RIGHT 64b Workshop of
Benozzo Gozzoli, *Sheet of
Studies*.
London, British Museum,
Pp.1–7 verso. Pen and ink
on paper; 220 × 148 mm.

◁ 64(verso)

65 LORENZO DI CREDI
Head of a Man

Chatsworth, Devonshire Collection, 704
Silverpoint, with white heightening (blackened), on buff-coloured prepared paper
215 × 185 mm.

As is characteristic of the finesse of execution of Lorenzo di Credi, the handling of the silverpoint here is delicate and precise. The tonal range is built up with subtle accomplishment, for the most part using the low-key sequence from the surface-preparation through to the deepest shadow that the stylus could produce. It is far from easy, using the essentially linear technique of silverpoint, to achieve the soft play of light and shade across the cheek and neck with which Credi characterises the forms of the side of the sitter's face. His conscientious handling succeeds in producing a clear impression of the relief of the features, but the sense of a firm, solid head is lacking. The structure of the invisible side of the man's head is implied by the swinging curves of the hat, but less clearly so by the face itself: the facial contours appear to define the edge where form meets surrounding space, rather than the point at which the three-dimensional solid is lost from sight.

White heightening is sparingly used to emphasise a few salient lights, rather than to light whole planes in contrast to the silverpoint shadows. Although the technique is simpler than Filippino Lippi's (66), Credi's drawing paradoxically lacks the lifelike warmth of Lippi's portrait-study, probably because of the laborious care that he took in building up the fine gradients of tone. The effect is therefore static: the sitter's crooked glance is awkward and rather unconvincing, because it appears to be rigidly fixed and not the result of a transitory movement.

BIBLIOGRAPHY:
Chatsworth Exhibition I, 34 (as Filippino Lippi)
Berenson 1277 (as Filippino Lippi)
Parker and Byam Shaw 43
Popham, 1931 44 (as Filippino Lippi)
Scharf 293 (as Filippino Lippi)

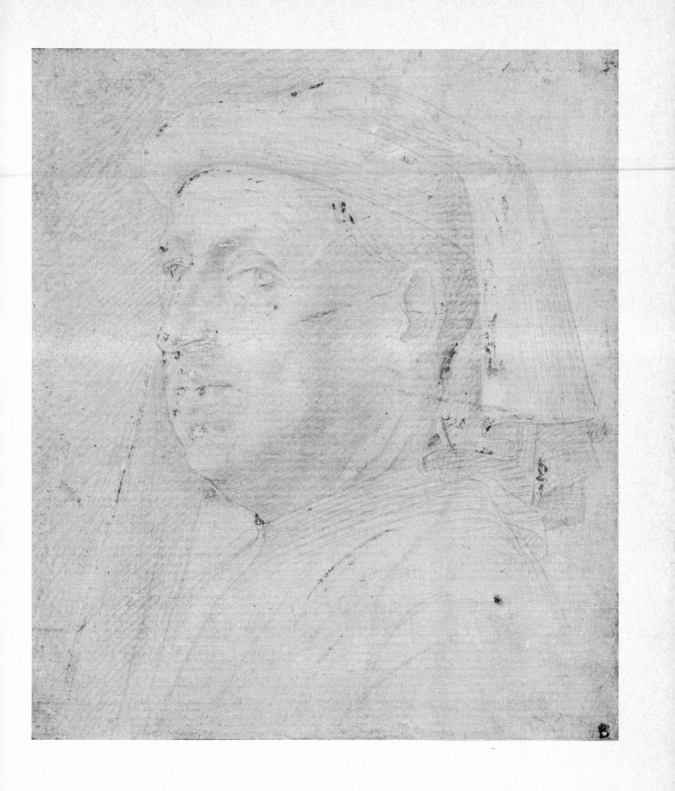

66 FILIPPINO LIPPI
Head of an Old Man [colour plate 20]

Chatsworth, Devonshire Collection, 705
Silverpoint, with white heightening, on bluish-grey prepared paper
190 × 140 mm.

The vitality of Filippino Lippi's handling of the silverpoint is here evident. As in the sketch of a *Litter-bearer* (7), the draughtsman's sensitive feeling for the value of freely drawn lines enabled him to create an immediate and expressive portrait-study. The rhythmic flow of the lines defining the sagging flesh over the sitter's right cheek and left jowl, and the rapidly sketched whisks of hair behind his ear, show the complete confidence of Filippino's drawing. The three-dimensional solid of the head is firmly implied by the concentric curves of the man's hat, and Filippino's innate sense of anatomical structure produces a juxtaposition of head on neck as secure as Gozzoli's (64) is unconvincing.

Variable silverpoint hatching adds modelling to the linear definition of the forms, often cutting across the fluent contours and strengthening them in shadow. White heightening brings up the lights: the brushwork is for the most part smooth, and gives a consistent sense of a gentle light flowing from the sitter's right across the varying relief of his face. Only occasionally, as on the lower lip, do the brush-strokes result in a slightly artificial impression. At certain points the white heightening has blackened through oxidisation, adding unintentional emphases as, for example, on the wisps of formerly white hair growing from the model's temples.

The clear sense of structure, and the spontaneity of application of silverpoint lines and swift dabs and strokes of white heightening, result in a more lifelike, more believable portrait than Benozzo Gozzoli's (64), or Lorenzo di Credi's (65). Filippino Lippi appears to have been highly sensitive to his sitter's personality, and was able to translate his perceptions with unusual immediacy of touch. He thus produced a fine, expressive study, which contrasts with the conscientious polish of most fifteenth-century silverpoint drawings. This drawing seems to have been used for the portrait of the sculptor Mino da Fiesole in the 1568 edition of Vasari's *Lives*, and was therefore probably in Vasari's own collection.

BIBLIOGRAPHY:
Chatsworth Exhibition I, 35
Berenson 1274B
Popham 1931, 58 (as Lorenzo di Credi)

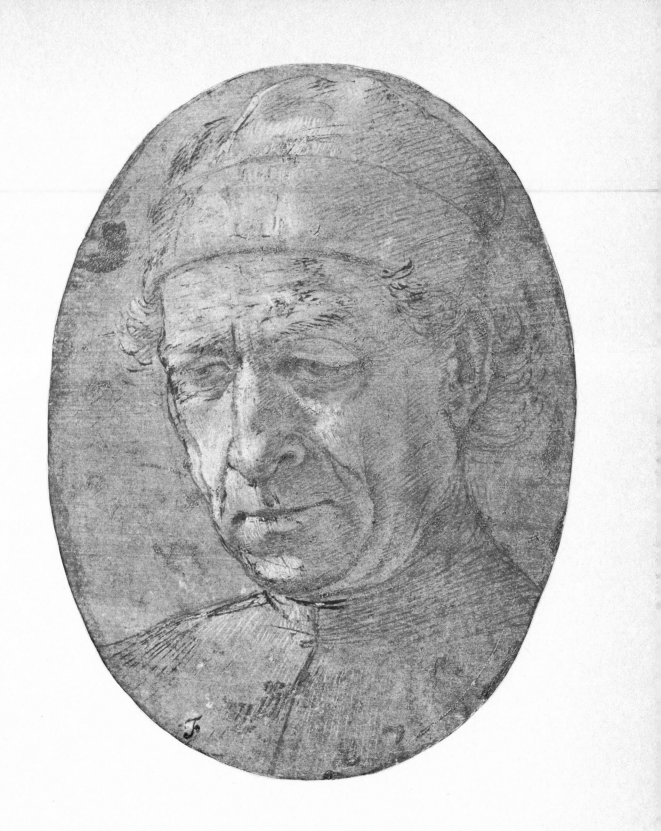

67 FILIPPINO LIPPI
Head of an Elderly Man (recto)
Study of Praying Hands (verso)

Windsor, Royal Library, 12822
Silverpoint, with white heightening, on light blue-grey prepared paper
241 × 185 mm.

Thin, fluent silverpoint lines give a brief indication of the model's collar and shoulders, and brisk touches of the stylus imply the wiry curls of his hair in this vigorous sketch. A thicker stylus was used with varying lengths of stroke to build up the shadow on throat and chin; and at the back of the neck the stylus is handled in Filippino Lippi's characteristically dashing, impetuous manner. The plastic surface of the ageing skin is effectively indicated by the length and direction of the silverpoint lines. The forms of the face were developed mainly by the addition of white heightening, using a very fine and delicately handled brush for hatching round the major features, and a thicker brush loaded with more dilute paint to reinforce the curls and waves of the model's hair. Finally, certain areas of the blue-grey ground were scraped away, perhaps with the end of a brush, to pick out the nostrils, the mouth, and the highlights beneath the chin and on the throat, in the lighter tone of the paper itself. Despite the number of different stages involved in the production of this study, the effect is strikingly spontaneous, the free-flowing hair indicating the violent forward thrust of the model's head, which in turn causes a powerful tensing of the neck muscles.

In no sense a portrait, this drawing is a rapidly perceived and executed study of old age, analogous in freedom of treatment to Filippino Lippi's studies from the model for pose and drapery (7,30). It therefore contrasts, both in purpose and character, with the more formal and finished silverpoint portrait-studies elsewhere in this section (64,65,73), and vividly demonstrates Filippino's interest in exploring the scope of his very individual silverpoint style for representing the surface, and even to some degree the texture, of elderly skin. On the verso of the sheet is an equally swift study of praying hands, in which the silverpoint hatching is scribbled on between the rapidly drawn contours, and the heightening was brusquely drawn over the forms with a thick brush and dryish paint, which in places leaves a discontinuous stroke. The two sketches taken together may suggest that the sheet of studies was made in preparation for a shepherd adoring the infant Christ, or for some such devout figure.

BIBLIOGRAPHY:
Popham and Wilde 13
Berenson 1369
Parker and Byam Shaw 11
Scharf 305

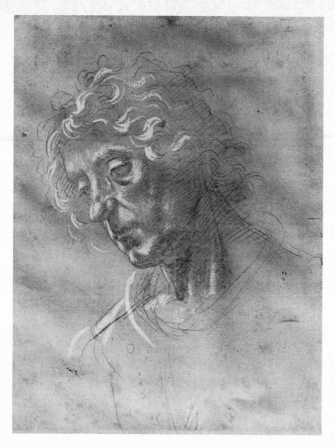

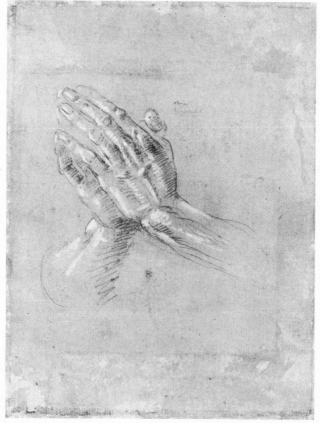

68 PIETRO PERUGINO
Head of a Bearded Man

Oxford, Christ Church, 0122
Black chalk on paper, squared and pricked for transfer
270 × 250 mm. (maximum dimensions)

Seizing with relish the opportunity to draw on a large scale in preparing the cartoon for a figure group, Perugino used his black chalk with great freedom in this fragment. In generating a vigorous movement and expression, he made full play of the tonal range of the chalk, from fine shading across the brow through to the dramatic blackness of the wiry strands of hair flowing from the left side of the model's head. Between these extremes he developed many different qualities of line and tone. Long, easy contours define the drapery folds over shoulder and across torso, and forceful hatching in bold, thick strokes of chalk builds up the shadows over the figure's left shoulder. The whole drawing has a dramatic directness of handling, which contrasts strikingly with the delicate finesse of Perugino's silverpoint drawings (73), or with the careful study in black chalk of the relief of facial surface by Verrocchio (72), Perugino's one-time master.

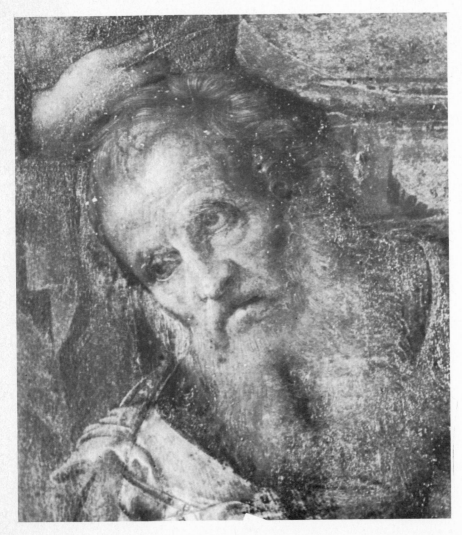

LEFT 68b Pietro Perugino, *Lamentation*, detail: head of Joseph of Arimathea.

68 ▷

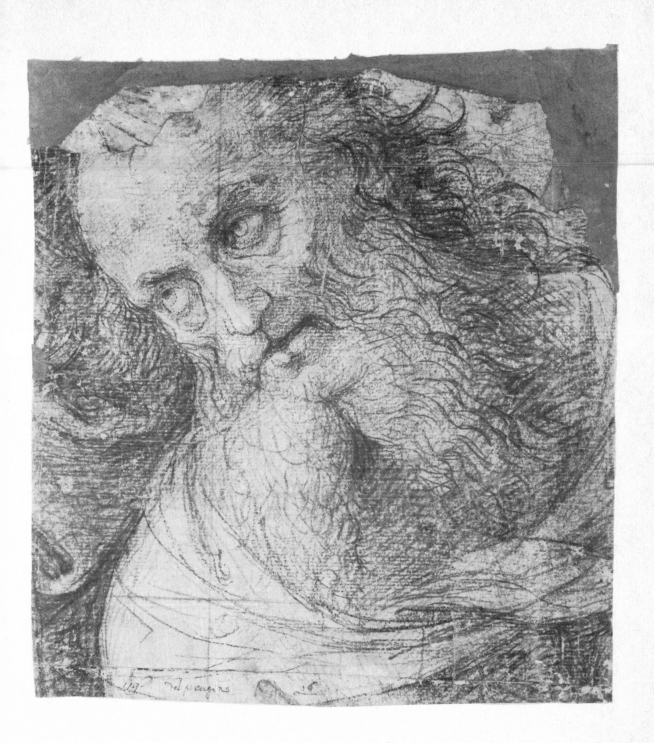

The energy of Perugino's handling may be explained, on the one hand, by the subject of this drawing (it was made for the head of Joseph of Arimathea in the *Lamentation* of 1495 for Santa Chiara, Florence, now in the Palazzo Pitti: 68a, 68b), and on the other, by its function. That it is a cartoon, like the Verrocchio and Ghirlandaio sheets (72,71), is demonstrated by the pin-pricks which reinforce many of the lines. The squaring beneath the bearded head helped in the process of scaling up from a small compositional drawing. The use of fine preliminary studies, perhaps in silverpoint like Perugino's *Head of the Virgin* (73), as guides to the execution of individual details, might explain the relative freedom and imprecision of this cartoon compared with those of Verrocchio (72) and Ghirlandaio (71). That this cartoon fragment was used in the production of the Pitti *Lamentation* can be seen, not only from the close similarity with Joseph of Arimathea's head (68b), but also from its fragmentary condition. The folds of drapery at the lower left hand side, and the fact that this fragment consists of two sheets of paper stuck together, show that it came from a larger cartoon, which probably included the whole of the figure-group of the *Lamentation*. It was evidently badly damaged during transfer, yet was retained and has survived in surprisingly good condition, considering the rough treatment it received.

BIBLIOGRAPHY:
Byam Shaw 8
Fischel 42
Parker and Byam Shaw 37

68a Pietro Perugino,
Lamentation.
Florence, Palazzo Pitti
Oil on panel; 214 × 195 cm.

69 GIOVANNI BELLINI
Portrait of a Man [*colour plate 21*]

Oxford, Christ Church, 0263
Black chalk on paper, with some wash
391 × 280 mm.

The great advantages of black chalk, realised in Italy during the last quarter of the fifteenth century, are exploited here more fully than in any other drawing in the exhibition: this portrait is a magnificent display of the full potential of the medium's tonal range. The rich blackish brown of the man's hat sets off the deeper tones in the shadows beneath the hair at the left, and brings out the dynamic flow of the contour of the left side of his face. In contrast to these dense shades, the fine, wavy lines of light hair to the right produce a soft texture; on the left, darker tones again create a natural-looking silhouette of random strands of hair punctuating the background. The drawing of the decorative pattern on the brocade likewise appears free and almost accidental in details. The greatest attention is reserved for the face and neck: the lively twisting movement of the head against the axis of the neck increases the expression of alertness, which is partially achieved through the subtle handling of the chalk to describe transitions of tone. The texture and character of the ageing man's flesh is perceptively captured in the folds beneath the chin and in the hard lines running from nose to mouth. The shadow cast by the hair across the right temple is keenly observed; and the play of light and shade across the eyes is rendered with the finest of tonal modulations, which reproduce an ever-varying relief. This is a masterpiece of chalk drawing, a manifesto of the quattrocento handling of the technique.

It is also a portrait-drawing *par excellence*: it stands by itself as a completed work of art, a paradigm of the North Italian practice of making highly finished drawings as commissioned portraits. The problem of attribution of this sheet is, and will continue to be, a bone of much contention. It may, however, be argued that only a painter completely confident in his experience and skill in the use of oil-glazes for describing tonal gradations, was capable of exploiting black chalk, for the same reasons, with the impeccable subtlety shown here. It has, with some justice, been proposed that this drawing is a portrait of Gentile Bellini; and it might further be suggested that only his brother Giovanni could have depicted in such a masterly fashion the outward appearance of his face, and could intuitively have perceived the personality which manifests itself through the drawing with such forceful presence.

BIBLIOGRAPHY:
Byam Shaw 702
K.T. Parker, *Disegni Veneti di Oxford*, Venice 1958, 2 (as Mantegna or Giovanni Bellini)
Parker and Byam Shaw 40 (as attributed to Giovanni Bellini)
Popham 1931, 177 (as perhaps by F. Bonsignori)
Splendours of the Gonzaga: Exhibition Catalogue, London 1981, 64, p.141 (as attributed to
 Francesco Bonsignori)
Tietzes A318 (as Mantegna)

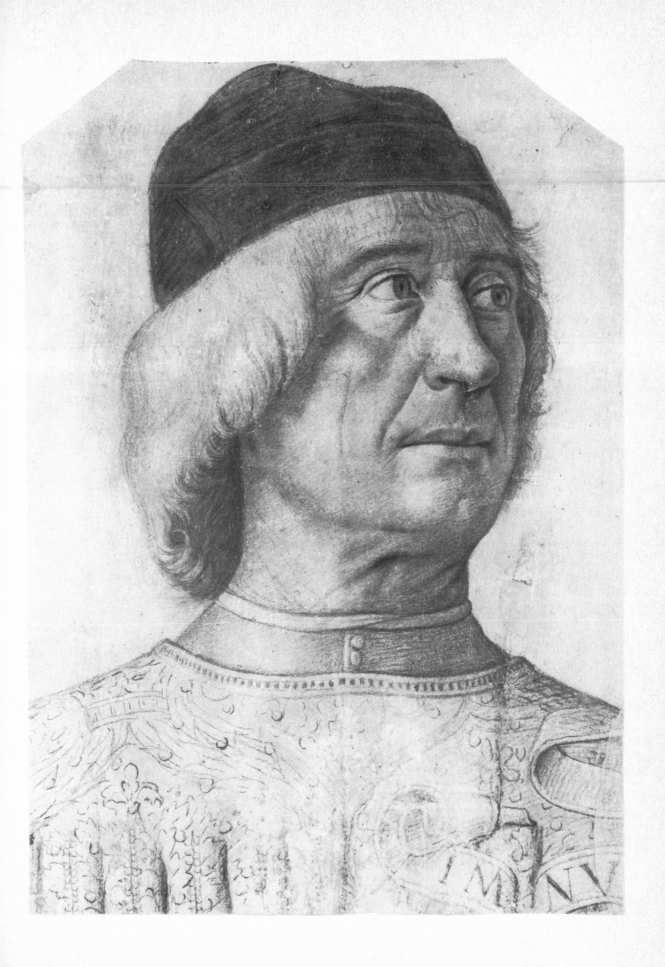

70 VITTORE CARPACCIO
Head of a Young Man

Oxford, Christ Church, 0282
Black chalk, wash and white heightening on blue paper
265 × 187 mm.

This drawing is an excellent example of the characteristic Venetian technique of drawing on blue paper (*carta azzurra*), a surface particularly popular in Carpaccio's workshop (34,60). The outlines were drawn, and the shadows hatched, in black chalk, using a fairly blunt, soft stick of chalk to produce a feathery effect in the hair, and gentle hatching in the shadowed side of hat and robe. The highlights were then added with white pigment applied with a fine brush. As in Benozzo Gozzoli's study (64), some passages of the white heightening look artificial, but others add precisely the necessary pinpoints of light to bring up the features. Perceptively touched with highlights, the silhouette of the youth's profile, against the soft shadow of his hair, is finely calculated. The striated appearance of the drapery, created by long parallel brushstrokes of white, ingeniously suggests the texture of the cloth. The brief touches of reflected light, on the forward strands of hair, reinforce the sense of texture produced by the black chalk. The only awkward passages are the fine white lights under the left eye and on the forehead: heightening of this sort is not flexible enough to demonstrate successfully the play of light on the surface of facial skin, stretched over the relief of the bone structure.

Although now faded, the blue paper (which is analogous to, but distinct from, the pigmented grounds used in Central Italian silverpoint drawing) provides a gentle atmospheric middle-tone from which both shaded and highlighted areas emerge. This delicate play with the tones at Carpaccio's command emphasises his perceptiveness of the type and personality of his sitter. This sheet may have been an independent portrait-drawing, but more probably was a portrait-study, perhaps of one of the patrons entitled to have his likeness included in a large narrative painting, of the type commissioned by the members of the Venetian *Scuole* late in the fifteenth century. It cannot, however, be associated with any figure in Carpaccio's surviving paintings, although stylistically it appears to date from the period of the *St Ursula Cycle, c.*1495–1500.

BIBLIOGRAPHY:
Byam Shaw 710
D. von Hadeln, *Venezianische Zeichnungen des Quattrocento*, Berlin 1925, p.60 pl.15
Lauts 1962, 41
Muraro pp.67–68
K.T. Parker, *Disegni Veneti di Oxford*, Venice 1958, 5
Popham 1931, 171
Tietzes 629

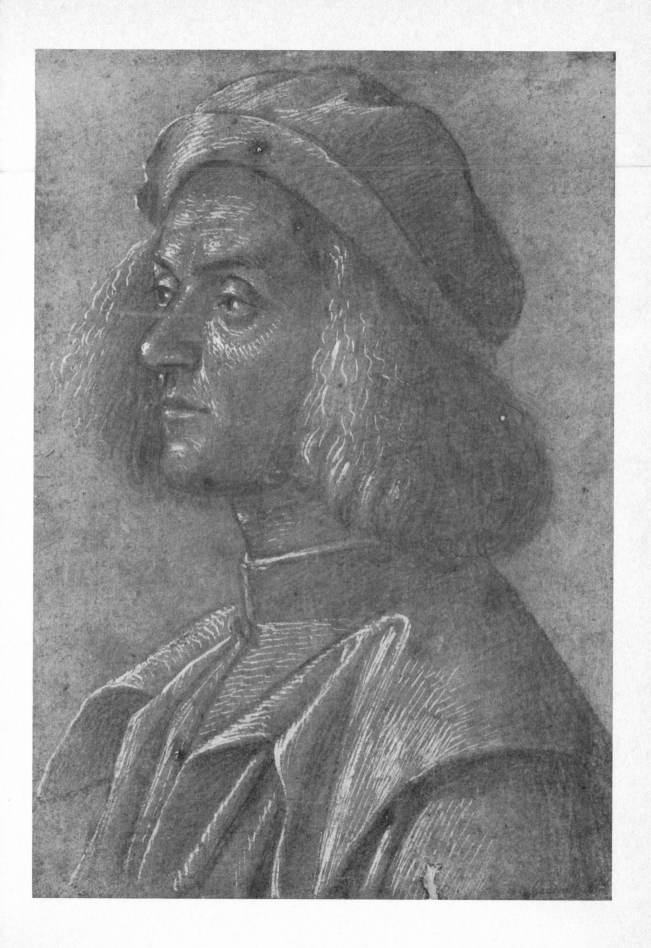

71 DOMENICO GHIRLANDAIO
Head of a Woman (recto) [*colour plate 22*]
Drapery Study, and Faint Sketch of a Face (verso)

Chatsworth, Devonshire Collection, 885
Black chalk on paper, recto pricked for transfer
345 × 220 mm.

In this large cartoon, the most important to survive from late quattrocento Florence, Ghirlandaio handled chalk with great skill, using careful hatching to demonstrate on the large scale the variations of tone values. Within the heavy contours the modelling is subtly varied, serving as a guide to the tonality that the painter sought to achieve in the finished fresco. Particularly perceptive is the contrast between the softened shadow on the woman's right cheek and the lighter effect of the skin seen through the thin veil. The texture of the veil, too, is sensitively defined by the supple contour and by the delicate chalk hatching within the trough of its wave-like form. Ghirlandaio's greatest attention was reserved, not surprisingly, for the features: the fine cast of the nose, the exact curve of the eyebrows, and the small, tight mouth, are neatly defined with careful, close hatching, which produces a convincing three-dimensional form.

This sheet was the cartoon for the head of the fifth and last of the group of ladies visiting St Anne in the *Birth of the Virgin* fresco in the Tornabuoni Chapel, Santa Maria Novella, Florence, (56a, 71a, 71b), commissioned in 1485 and completed in 1490. The type is refined and austere, in contrast with the vivid expressive warmth of Giovanni Bellini's chalk portrait-drawing (69).

RIGHT 71b Domenico Ghirlandaio, *The Birth of the Virgin*, detail: head of a lady. Florence, Santa Maria Novella, Tornabuoni Chapel. Fresco on wall.

LEFT 71c Domenico Ghirlandaio, *Study for Portrait of an Old Woman*. Windsor, Royal Library 12804. Silverpoint, with white heightening, on orange prepared paper; 232 × 185 mm.

71 (recto) ▷

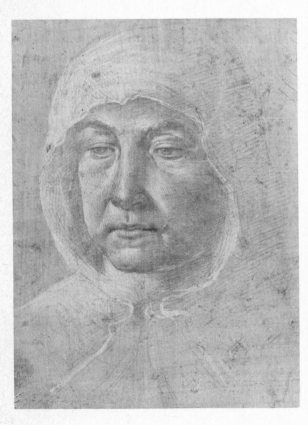

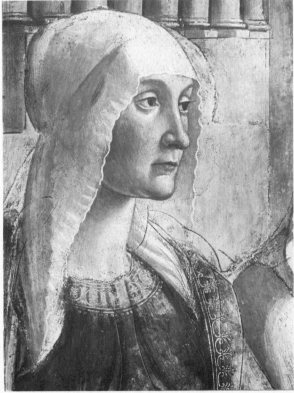

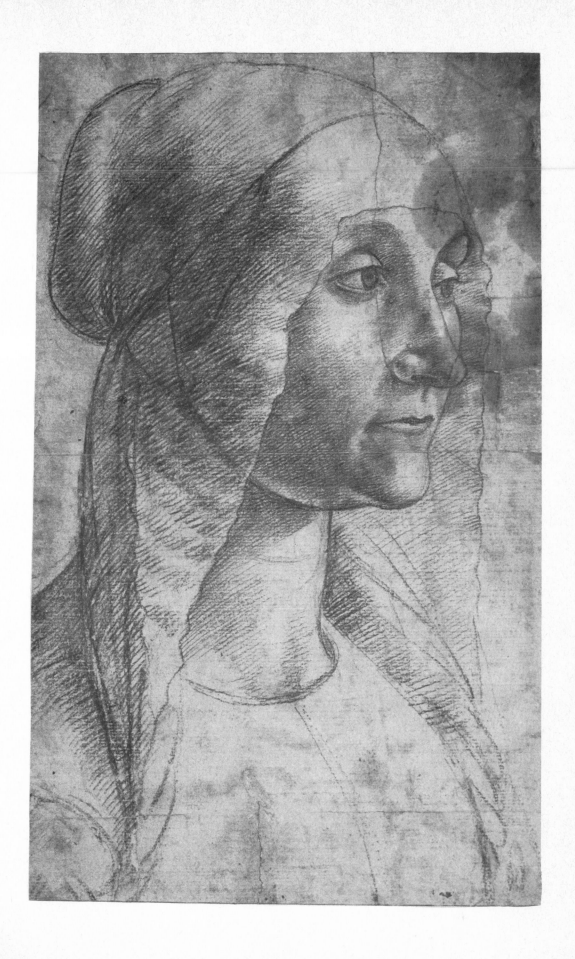

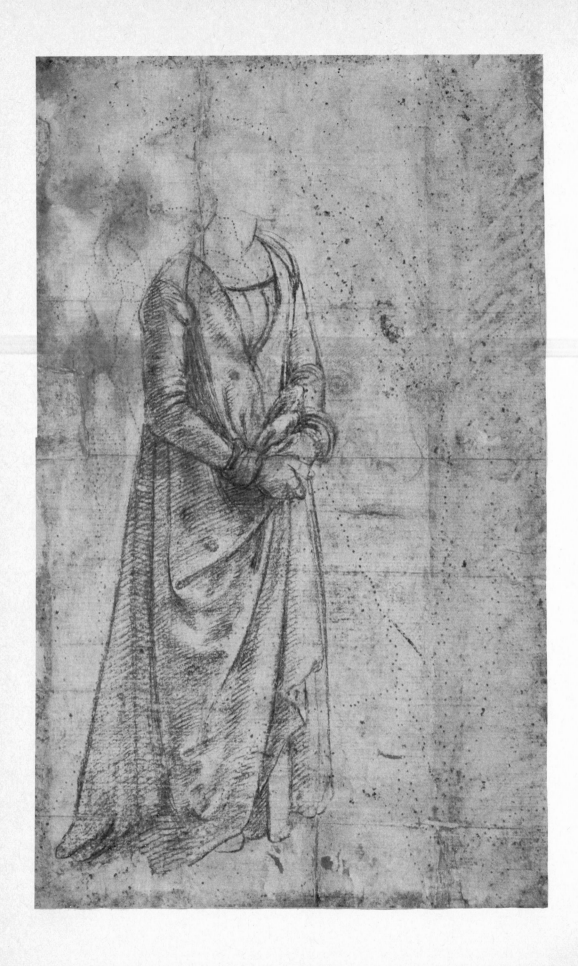

RIGHT 71a Domenico
Ghirlandaio, *The Birth of the
Virgin*, detail: group of
ladies. Florence, Santa
Maria Novella, Tornabuoni
Chapel. Fresco on wall.

◁ 71 (verso)

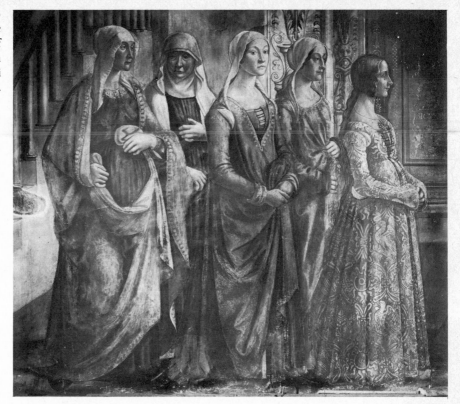

It was probably worked up from a silverpoint portrait-study, like that for
another of the heads in the same group of visitors (71c), a technique which
seldom lent itself to freedom of expression; and furthermore the purpose of
the Tornabuoni portraits in the frescoes was to emphasise the dignified
position of the family in Florentine society. But the practical function of the
cartoon was perhaps the major influence on Ghirlandaio's style and hand-
ling. If the outlines of the forms appear somewhat harsh, it may be due both
to the need for clear contours for pricking, and to the effect of the pinpricks
themselves. The purpose of the drawing and the speed of execution neces-
sary in fresco-painting meant that it was unnecessary for Ghirlandaio to
strive for the softer, more smoothly graded handling of chalk achieved by
Verrocchio (72).

The verso of the sheet shows a slight, rather freer, drapery study, again in
black chalk, for the third figure in the same group (71a), and a delicate, light
sketch of a face, which was perhaps a preliminary trial for a portrait-study
of the head of the same figure. Given these drawings on the verso, it seems
very unlikely that the main drawing was ever part of a large cartoon: the
rest of the figure must have been painted on the basis of a *sinopia* drawing,
with the help of small sketches akin to the drapery study on the verso of
this sheet. Only the type and character of the face was considered suffici-
ently important to warrant the detailed attention of a cartoon.

BIBLIOGRAPHY:
Chatsworth Exhibition I, 24
Berenson 866
J. Lauts, *Domenico Ghirlandaio*, Vienna 1943, p.53
Parker and Byam Shaw 23
Popham 1931, 37

72 ANDREA DEL VERROCCHIO
Head of a Woman [colour plate 23]

Oxford, Christ Church, 0005
Black chalk, rubbed in places, with touches of grey wash and pen and ink
strengthening, on paper, pricked for transfer
408 × 327 mm.

Despite the pen and ink strengthening on the contours of the nose, lips,
chin and elsewhere (which are presumably later retouchings, since they do
not always follow the line of the pinpricks), this sheet is one of the finest
surviving Florentine quattrocento chalk drawings. The smooth flow of the
chalk contours is somewhat distorted by the pricking, but elsewhere the two
principal advantages of chalk are exploited with great versatility. The rapid,
sketchy movements of chalk, its speed and flexibility of application, easily

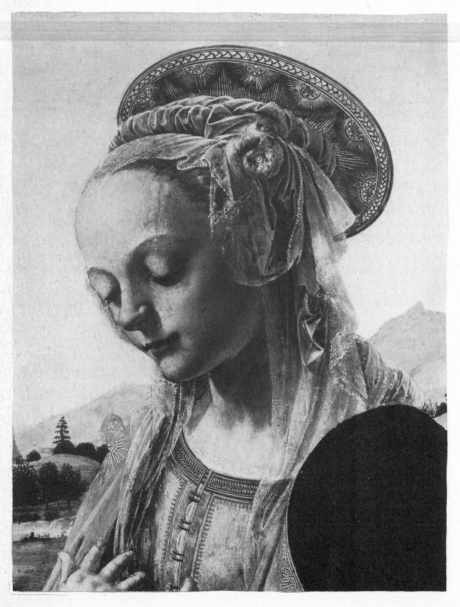

LEFT 72a Andrea del
Verrocchio, *Madonna and
Child*, detail: head of the
Madonna.
Berlin, Gemäldegalerie,
104A. Oil on panel;
720 × 530 mm. (complete).

72 ▷

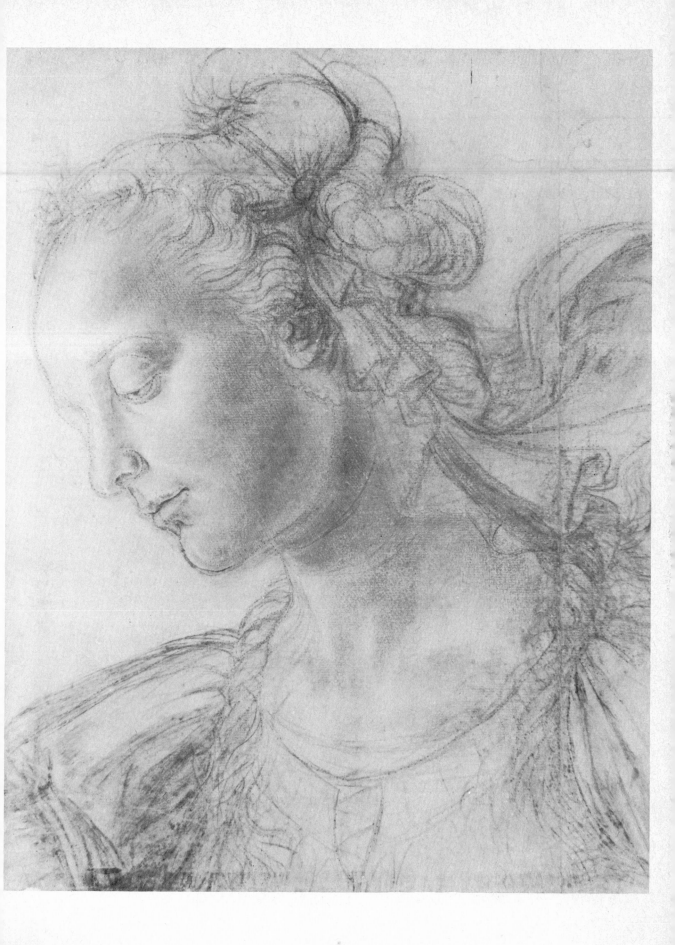

generate the swift twists of hair around the temple and the decorative, curvi-linear plaits at the back of the model's head and over her right shoulder. More significant, in terms both of Verrocchio's primary concern here and of the drawing's function, is the unusually fine modulation of tone in the chalk hatching, assisted by judicious rubbing, on the brow, cheek and throat. The effect of rubbing together the lines produced by a blunted stick of chalk, to merge the tones imperceptibly, and to represent the play of gentle light across the skin stretched tautly over muscle and tendon, can be seen parti-cularly well on the throat. In this way Verrocchio produced a strong sense of the textural contrast between the smooth, fine skin and both the crisply curving strands of hair and the silky quality of the fabric covering the model's shoulders, which is rendered by a series of rapid, light lines of sharper chalk.

This is one of a group of Verrocchio black chalk cartoons which (like two others, 72b and 72c), were made for transfer of the form directly to the surface of a panel for painting. The elaborately careful tonal modelling in black chalk was probably intended to serve as a direct guide for the mono-chrome underpainting of the Virgin's face. Unfortunately, the painting for which this sheet was the cartoon has not been identified, but comparison can be made with the head of the Virgin in Verrocchio's *Madonna and Child* in Berlin (72a). Like the Uffizi drawing (72b), this sheet has been slightly reworked, by the application of a faint light-grey wash hatching on the shadows of temple, cheek and neck. This hatching runs downwards from left to right, indicating that it was added by a left-handed artist, perhaps Leonardo da Vinci, in Verrocchio's workshop. The reworking unfortu-nately rather distorts the immaculate smoothness of the tonal transitions of Verrocchio's black chalk modelling.

BIBLIOGRAPHY:
Byam Shaw 15
Berenson 2782A
Parker and Byam Shaw 42, pl.9
G. Passavant, *Verrocchio*, London 1969, D8, p.193
Popham 1930, 51

ABOVE 72b Andrea del Verrocchio, *Head of an Angel*. Florence, Uffizi, 130E. Black chalk, reinforced with ink, on paper, pricked for transfer; 210 × 180 mm.

BELOW 72c Andrea del Verrocchio, *Head of an Angel*. Berlin, Kupferstichkabinett, 5093. Black chalk on paper, pricked for transfer; 185 × 157 mm.

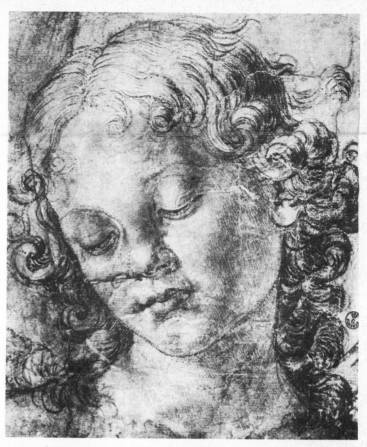

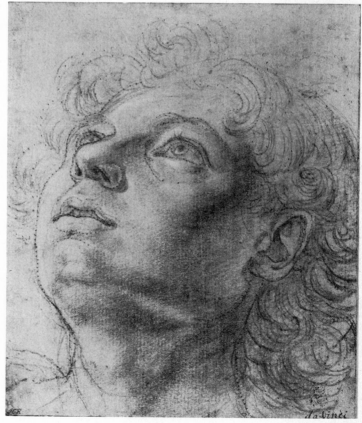

73 PIETRO PERUGINO
Head of the Virgin [colour plate 24]

Windsor, Royal Library, 12744
Silverpoint, with white heightening, on pink prepared paper
234 × 224 mm.

This finished study shows the heights of fluent delicacy reached by Perugino in his silverpoint technique. The contours around the face, simple curves which lack vigour to imply form, but merely define the limits of the model's face, are drawn in thickened, almost harsh lines. Simplified though they may be, they have a calm, fluid sweep, which establishes at once the essential atmosphere and character of the drawing. Within the contours, shading is carefully applied, not to generate a rich tonal range, but rather to indicate the forms by long, sweeping, but impeccably light-toned lines. Sometimes the hatching appears to follow the shapes of the forms, with the result that

LEFT 73b Pietro Perugino, *Madonna and Child with Ss. John the Baptist and Sebastian*, detail: head of the Madonna.

73 ▷

in areas, like the jaw and chin, pale lines cut across each other to form apparently accidental cross-hatched areas. The quiet mood is reinforced by the delicate curves of the Virgin's hair over her right ear, and of the veil falling away beside her left cheek.

Equally lyrical and controlled is the application of white heightening. Using a more diluted, less starkly white pigment than Benozzo Gozzoli (64) or Carpaccio (70), Perugino followed with his brush the easy curves of the hair, to add shimmering reflections of light. He brought up the lights across the eyebrows, on the nose, and around the eyes, with a tone which differs only very little from the light tone of the pink ground. This is a refined, contemplated drawing, entirely characteristic of the serene and somewhat withdrawn mood of Perugino's female types. It gives a clear indication of the care taken by Perugino in the preliminary work on his paintings, for it is the fully considered preparatory drawing for the head of the Virgin in the *Madonna and Child with Ss. John the Baptist and Sebastian* altarpiece of 1493, painted for San Domenico, Fiesole, and now in the Uffizi, Florence (73a,73b). Neither squared nor pricked, its role in the transfer of the design to the panel is not clear, though probably a full-scale cartoon would have been drawn up on the basis of this drawing. It could certainly have served as a detailed guide to the painter, when laying in the tones of the underpainting and the highlights on the top surface of the forms.

BIBLIOGRAPHY:
Popham and Wilde 22
Fischel 44
Popham 1931, 104

73a Pietro Perugino,
*Madonna and Child with Ss.
John the Baptist and
Sebastian.*
Florence, Uffizi, 1435.
Oil on panel; 178 × 164 cm.

74 BARTOLOMMEO MONTAGNA
Head of the Virgin

Oxford, Christ Church, 0283
Black chalk, rubbed in places, heightened with white chalk, on paper
290 × 199 mm.

This drawing is a virtuoso demonstration of the atmospheric *sfumato* which can be achieved by the delicate handling of black chalk. Due to wear, the overall tonality may be less strong than it originally was, and the clarity of the white chalk heightening may particularly be somewhat diminished. Nonetheless the late quattrocento Vicentine draughtsman's subtle use of chalk to build form, which is probably a result of his training in Venice, is still clear. The contours, a series of almost geometrical interlocking curves, are drawn freely to indicate the separate forms of head, neck, bust and head-dress. The texture of the fabrics is distinguished by rough, near-parallel strokes of chalk, which create a halo-like effect around the Virgin's luminous face. On the face itself the general tonality is lighter and more softened: Montagna has achieved remarkably full modelling within his limited tonal range, by rubbing the black chalk and by adding an almost veil-like surface of white chalk. This may partly be explained by his relative lack of interest in

BELOW 74a Bartolommeo Montagna, *Madonna and Child with Saints*, detail of Madonna.
East Berlin, Gemäldegalerie, 44, Oil on panel;
203 × 157 cm.
(complete).

74 ▷

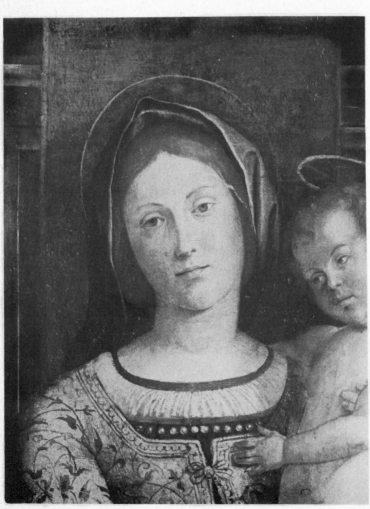

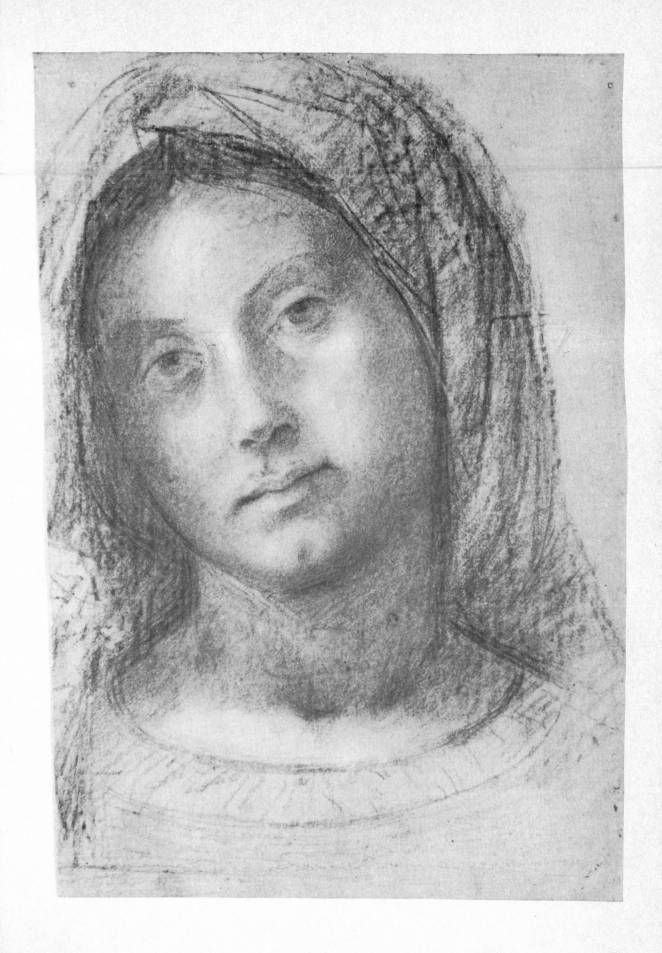

the finer details of anatomical form and surface: the aim appears to have been to generate a solid, ovoid structure, rather than to investigate through the play of light and shade the varying relief of the facial surface. As a result, Montagna developed an almost hazy atmosphere around the face, analogous to the effects achieved in oil-paintings from the Bellini circle at the turn of the century, which may help to explain both the rather undefined forms and the Virgin's somewhat abstracted expression.

Paradoxically, Montagna's paintings are generally characterised by a much sharper definition of planes, and of the angles at which they meet, than is shown in this drawing. This may be seen, for example, in the *Madonna and Child with Ss. John the Baptist and Jerome* altarpiece of 1499, in which the Virgin's head (74a) bears a close resemblance to this drawing, and also to a related, but not identical, drawing at Windsor (74b). In this second drawing, the forms of the draperies are less convincingly distinguished, and the rather heavier modelling on the face creates a harder, less impressionistic atmosphere. The existence of two similar drawings, and a series of paintings for which either might have been a study, suggests that Montagna may have made particularly conscientious efforts in his study of the Virgin's head, and may have produced a series of alternative solutions which could be used and reused in his workshop.

74b Bartolommeo Montagna,
Head of the Virgin,
Windsor, Royal Library, 12824.
Black chalk on paper; 349 × 251 mm.

BIBLIOGRAPHY:
Byam Shaw 709
T. Borenius, *The Painters of Vicenza*, London 1909, p.110
K.T. Parker, *Disegni Veneti di Oxford*, Venice 1958, 10
L. Puppi, *Bartolommeo Montagna*, Venice 1962, p.149

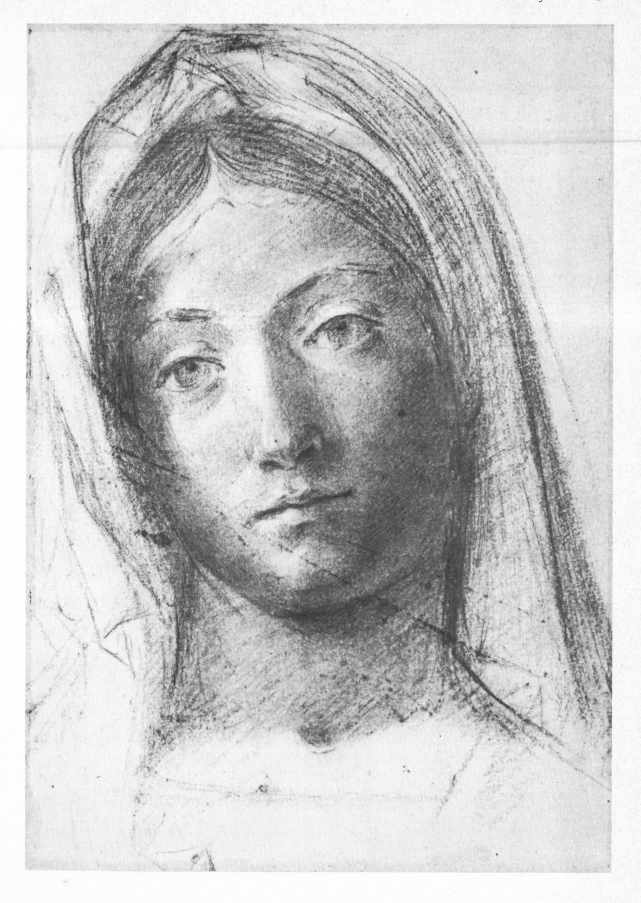

Glossary

(Numbers in brackets refer to some examples amongst the exhibits)

Black chalk: A natural carbonaceous shale quarried in North Italy or France and cut into sticks for drawing on paper. To be satisfactory it had to be both friable and fine-textured, yet cohesive enough for tonally-dense, indelible lines to be drawn (13, 42, 72).

Bodycolour: Opaque coloured paint, a mixture of a pigment, white lead and a binding medium, applied with a brush primarily to modelbook drawings (15).

Bozzetto: Wax or, more often, clay model made as a preparatory sketch for a sculptural work.

Brush drawing: A drawing made on paper with a fine brush carrying a water-soluble pigment and/or wash (9, 34).

Carta azzurra: Paper coloured blue, normally with cobalt or indigo, originally manufactured in Arabia and imported through Venetian trade with the Orient; in the fifteenth century used predominantly in Venetian workshops for brush drawing, the pigmentation supplying a middle tone between the brown wash and the white heightening generally used in such drawings (9, 34, 70).

Cartoon: A full-scale drawing, either of a small composition or of a form within a larger one, used to transfer the design directly to the surface to be painted. In the fifteenth century the cartoon was normally a *spolvero*: the design was transferred by pricking small holes through the paper along the contours of the forms. Charcoal dust was then 'pounced' through these holes from a muslin bag to leave dotted lines on the painting surface. A highly finished cartoon could also serve as an 'auxiliary cartoon' to guide the painter or his assistants while the underpainting was being executed (11, 61, 71).

Cast drapery study: A length of fabric dipped in plaster or wet clay was thrown over a support, such as a lay-model, and left to set. The resulting cast fold-pattern was used for carefully finished drapery studies (31).

Charcoal: A material made by heating small sticks of willow wood in an air-tight container, sometimes used for sketching underdrawings on panel, wall or paper. Such drawings rarely survive, because charcoal smudges and can easily be erased.

Contract drawing: A finished compositional drawing made for the patron to approve as the agreed, legally binding design for the commissioned work (46). Not to be confused with a presentation drawing.

Garzone **study:** A drawing made, normally for experimental or training purposes, using a posed workshop assistant or *garzone* as model. Such studies can often be recognised from the contemporary dress worn by the model (2, 3, 4, 10).

Heightening: A white pigment, usually white lead, added with a brush to a drawing to indicate the highlights.

Inks: In the fifteenth century two types of black pigment were used in the preparation of drawing inks, bound in a medium of gum and water: lamp-black (carbon particles from the smoke of burning oil) or, more frequently, ferrous sulphate boiled with galls such as oak-apples. The latter, iron-gall ink, can have slight corrosive effects on paper, and in time fades to the brown colour often found in Renaissance pen-drawings.

Lay-model: A three-dimensional model, probably of clay or jointed wood, used for figure-study (especially of difficult poses which could not be held for long by a *garzone*), and as the support for fabrics for cast drapery studies (56).

Modelbook: A book, usually of parchment pages bound together before use, in which highly finished, often coloured, studies of natural forms such as animals or birds were drawn. These studies were used primarily as models for apprenticeship copying and for direct transfer into paintings or manuscript decorations (15, 16).

Niello: A black sulphur compound for filling in engraved designs on silver plaques (3a). Impressions could be taken from these plaques to produce prints not dissimilar in appearance to pen and ink outline drawings.

Paper: The standard surface for surviving fifteenth-century drawings was made by pulping down cloth (usually waste rags, or linen for higher quality paper), and rolling the pulp out into a thin layer on a fine-mesh wire grill to dry.

Parchment: A more durable, but more expensive, surface for drawing than paper, parchment was prepared from sheep or goat skins; the higher-quality vellum was made from calf skin. It has a smooth texture, sometimes marred by hair follicles on one side, and absorbs much ink to allow deep-toned lines.

Pastels: Synthetic chalk sticks made by binding dry pigments in a medium such as gum arabic.

Pen: The best quill pens for drawing were made from feathers plucked from the leading edge of a goose wing. They could be trimmed to a variety of shapes and thicknesses, thus giving rise to a wide range of types of line.

Prepared paper: Paper and parchment had to be prepared for silverpoint drawing, by applying with a brush several coats of a ground made of white lead and powdered bone, tempered with glue and often coloured. In a more rudimentary preparation, much used on prepared wooden tablets, powdered bone was applied with spittle as the binding medium.

Prepared wooden tablets: Thin panels of close-grained, hard wood (normally box-wood or fig-wood), surfaced as was prepared paper, and used for workshop stylus sketching. The preparation was scraped off and re-applied for subsequent drawing, leading to the loss of innumerable experimental drawings (3).

Presentation drawing: A highly finished drawing, in status equivalent to a monochrome painting, presented as a gift to a friend or patron (69). Not to be confused with contract drawing.

Recto: The side of a double-sided sheet which has the more important drawing or drawings; or the right-hand side of an opening (the upper side of the page) in a bound book of drawings.

Red chalk: A red ochre variety of haematite, or iron oxide, diffused in clay, and quarried in the Alps. It had to be soft enough to be sawn into sticks and sharpened to a point for drawing with ease, yet hard enough not to crumble but to leave a strong, warm-coloured mark on paper (14,32).

Silverpoint: The favoured instrument for stylus drawing by early Renaissance draughtsmen, although it had to be used on a prepared paper or wooden tablet. It was generally made of a length of cast base-metal with a silver tip at each end, so that lines of two different widths could be drawn with a single stylus (5,6 etc.).

Simile drawing: A figure drawing used by a Venetian painter for background staffage figures in narrative painting, or for copying by apprentices in his workshop (34).

Sinopia: The underdrawing for a fresco, drawn with the brush and the red-earth pigment sinoper directly onto the wall. A fresh layer of plaster was laid over the *sinopia* before fresco-painting commenced.

Sketchbook: A bound book of sheets of paper used for rapidly sketched records of motifs, perhaps for later reconsideration, or for experimenting with problematical forms (22,23,24,25).

Squared drawing: A drawing was sometimes covered with an even mesh of horizontal and vertical lines, to assist in copying the subject onto the larger scale of a panel or wall surface, which itself was squared with a more widely spaced mesh of lines (13).

Stylus: A drawing instrument made of metal, often with a point at each end. As well as silver, metals such as gold, copper, lead, and tin were sometimes used, Colourless, indented lines were sometimes made with an iron stylus as an initial guide to drawing (14); and a leadpoint was sometimes used for underdrawing directly on unprepared paper, but lead is too soft to be used for fine stylus drawing.

Taccuino di viaggi: A book of drawings assembled by a travelling draughtsman or workshop over a period of time, often recording works of art in many different places (18).

Tinted paper: White paper brushed or sponged over with a translucent coloured wash, in the fifteenth century often pink or rose-red (20,21,48).

Underdrawing: A preliminary sketch, usually in charcoal, leadpoint, or chalk (red or black) on paper, of the contours of the forms to be studied or worked up subsequently by more detailed drawing in another technique (57).

Vellum: *cf.* parchment.

Verso: The side of a sheet which has the less important drawings (*cf.* recto); or the left-hand side of an opening (the underside of the page) in a bound book of drawings.

Wash: Diluted ink brushed onto a drawing (normally in pen and ink), as a rapid indication of lighting and internal modelling.

Watercolour: a pigment which dissolves in water to produce a translucent, coloured wash which could be brushed onto a drawing, in particular one in a modelbook (17,18 recto).

Biographies of Artists

LEON BATTISTA ALBERTI, 1401–1472. Architect and theorist. Probably born in Genoa, the illegitimate son of a Florentine exile. Educated at Padua and Bologna Universities, he visited Florence for the first time in 1428. Joined the Papal civil service, 1431. Wrote *De Pictura* (1435), translated into Italian as *Della Pittura* (1436). *De Re Aedificatoria* (1452) set out his ideas on architecture and town planning. His façade for Santa Maria Novella, Florence (1456–1470), and the churches of San Sebastiano (1460) and Sant' Andrea (1470), Mantua, give practical form to these theories.

ANTONELLO DA MESSINA, c.1430–1479. Sicilian painter. Trained first in Naples, probably by Colantonio, and then elsewhere, perhaps even in Flanders, by an artist acquainted with the Flemish technique of oil-glazing evolved by Van Eyck. His documented visit to Venice (1475–1476), where he painted the *San Cassiano Altarpiece*, introduced his virtuoso technique and Flemish-style portrait design to artists there. His influence on Giovanni Bellini is particularly important.

FRA BARTOLOMMEO DELLA PORTA, c.1474–1517(?). Florentine artist apprenticed to Cosimo Rosselli in 1484. In 1500 joined the Dominican order at San Marco, Florence, whose workshop he ran from 1504. Visited Venice in 1504 and Rome in 1514/15. His mature style, seen in such works as the *Mystic Marriage of St Catherine* (1511), characterises the early sixteenth-century movement towards grandeur of design and generalisation of setting.

GENTILE BELLINI, c.1429/30–1507. Venetian school. Usually accepted as the elder son of Jacopo Bellini, he was probably named after Gentile da Fabriano, his father's master. Knighted by the Emperor in 1469, he was sent to Constantinople as a painter/ambassador from 1479–1481. Worked on a major cycle of history pictures for the Doge's Palace, destroyed by fire in 1577. His most renowned surviving achievement is the series he painted for the *Scuole* (charitable institutions) of Venice, full of portraits and views of the city.

GIOVANNI BELLINI, c.1430–1516. Venetian school. Like Gentile he trained in the workshop of his father, whose style greatly influenced his early paintings. Other strong early influences were from his brother-in-law, Andrea Mantegna, and the work of the Flemish artist Rogier van der Weyden. After contact with Antonello da Messina (1475–1476), adopted oil painting which afforded him a new breadth and enhanced his natural ability to use tone atmospherically. Dürer described him in 1506 as 'very old, but still the best in painting'.

VITTORE CARPACCIO, c.1460/5–1523/6. Venetian school. Probably a pupil of Gentile Bellini and certainly influenced by him. He too is best known for his series paintings for the Venetian *Scuole*, in which the narrative cycle is embellished with rich details of contemporary domestic life.

CENNINO CENNINI. Florentine artist, pupil of Agnolo Gaddi. Wrote the earliest Italian treatise on painting, *Il Libro dell' Arte*, (c.1400). A practical manual for working painters, it is the source of our knowledge of workshop practices and techniques in the trecento and early quattrocento.

LORENZO DI CREDI, c.1458–1537. Florentine school. A pupil in Verrocchio's workshop at the same time as Leonardo da Vinci, he stayed on with his master and became more of a business partner, taking over the workshop when Verrocchio died in 1488. His conservative, technically accomplished style remained virtually unaffected by the developments of the early sixteenth century.

FRANCESCO DI SIMONE FERRUCCI, 1437/8–1493. Florentine sculptor. Worked in Verrocchio's studio alongside Lorenzo di Credi and Leonardo da Vinci. He is now generally held to have been responsible for the drawings which once belonged to the so-called *Verrocchio sketchbook*. The marble tomb of Alessandro Tartagni at San Domenico, Bologna, is by him.

MASO FINIGUERRA, 1426–1464. Florentine school. Goldsmith and niellist. Worked as an assistant to Ghiberti on the second set of doors for the Florentine Baptistry. Vasari accredited him with the invention of the method of engraving silver with lines which were then filled with sulphur compound, called *niello*.

RAFFAELLINO DEL GARBO, c.1466–1524(?). Florentine painter. According to Vasari, Raffaellino began his career as an assistant to Filippino Lippi, working in the Chapel of Cardinal Caraffa, in Santa Maria Sopra Minerva, Rome. Vasari also describes the decline in his talent and fortunes in later life, and tells of his money-spinning activities as a designer of embroidery.

GENTILE DA FABRIANO, before 1385–1427. Born in the Marches. First recorded working in Venice in 1408 where he painted a series of historical frescoes (destroyed) in the Palazzo Ducale, later completed by Pisanello. Probable master of Jacopo Bellini. Major exponent of the International Gothic style, the elegant and decorative qualities of which are well seen in his *Strozzi Altarpiece* (1423). Died in Rome in 1427, while work on a major cycle of frescoes in San Giovanni in Laterano was still in progress.

DAVIDE GHIRLANDAIO, 1452–1525. Florentine School. The younger brother of Domenico Ghirlandaio, he was a full partner in the family workshop which became one of the most popular studios in late quattrocento Florence. He also distinguished himself as a mosaicist.

DOMENICO GHIRLANDAIO, 1449–1494. Florentine school. With the help of his brothers Davide and Benedetto, he ran one of the most thriving workshops in late quattrocento Florence. Worked in the Sistine Chapel, Rome, in 1481–82 with others including Botticelli, Perugino and Signorelli.

The influence of Flemish art can be seen in his realism and love of domestic detail, in such work as the *Last Supper*, Ognissanti, Florence (1480), and his two major fresco cycles in the Sassetti Chapel, Santa Trinita (completed 1485), and the Tornabuoni Chapel, Santa Maria Novella (completed 1490). His brilliant fresco technique attracted much attention. Michelangelo had his first training in the Ghirlandaio workshop.

BENOZZO GOZZOLI, *c*.1421–1497. Florentine school. He began as a goldsmith's apprentice, moving on to work with Ghiberti on the Baptistry doors at Florence, and then to be Fra Angelico's assistant at Rome and Orvieto. His fresco of the *Procession of the Magi*, which runs continuously around the walls of the chapel of the Medici Palace, shows at its best his refined but lively interest in story-telling and descriptions of contemporary life.

FRANCESCO GRANACCI, 1469/70–1543. Florentine school. Like Michelangelo he began training in Ghirlandaio's workshop, where he later became an assistant. Engaged by Michelangelo to work on the Sistine ceiling, but was dismissed with others employed in the same capacity within a month of the start of work. Although later influenced by Fra Bartolommeo, Granacci always remained a quattrocento artist in spirit.

LEONARDO DA VINCI, 1452–1519. Florentine school. The oldest of the High Renaissance artists, his art is more closely linked with the traditions of the quattrocento than that of either Michelangelo or Raphael. Trained in Verrocchio's studio, where he distinguished himself early, he worked on a number of important commissions in Florence before moving to Milan, where he is first recorded in 1483. He remained there until 1499, when the Sforza dynasty fell to the French, returning to Florence in 1500. Again in Milan in 1506, he entered the employ of François I of France in the following year. He moved to France in 1517, living under royal protection at Cloux, near Amboise, where he died in 1519.

FILIPPINO LIPPI, 1457/8–1504. Florentine artist, son of Fra Filippo Lippi. After his father's death, while still only a boy, he moved from Spoleto to Florence, where in 1472 he was working in Botticelli's studio. He completed the fresco cycle in the Brancacci chapel, and executed frescoes in the Strozzi Chapel, Santa Maria Novella. His mature style is characterised by a nervous, fluttering line and by his regular reference to antique remains, in which he developed a passionate interest during an extended visit to Rome (1488–1493).

FRA FILIPPO LIPPI, *c*.1406–1469. Florentine school. An orphan who was placed in the convent of Santa Maria del Carmine as a child, he took orders there in 1421. He was probably the only direct pupil of Masaccio, and later developed an interest in Flemish painting. Both these influences can be seen in his *Tarquinia Madonna* (1437). He experimented with the new type of unified-space altarpiece creating a fully described interior setting in his *Barbadori Altarpiece* (1438), and gradually developed away from Masacciesque concern with solidity and volume, adopting greater interest in rendering movement and in story-telling, seen in his fresco cycle at Prato, begun in 1452.

ANDREA MANTEGNA, *c*.1431–1506. Born near Vicenza and first recorded in Padua in 1441. The apprentice and 'adopted son' of archaeologist/painter Francesco Squarcione. As early as 1448 he was selected to work with others on the fresco decoration of the Ovetari chapel in the church of the Eremitani, Padua. His work there, completed in 1456, established his reputation. In 1459 invited by Ludovico Gonzaga to work as court painter at Mantua, where he produced the major works of his mature career, including the nine-canvas *Triumph of Caesar*, in which his antiquarian expertise is giving full rein.

BARTOLOMMEO MONTAGNA, *c*.1450–1523. Vicentine painter. Recorded in Venice in 1469, presumably in an apprenticeship, although this is not specified. Named as a painter in Vicenza in 1474. His work shows the influence of Giovanni Bellini, the Vivarini and Antonello da Messina.

NANNI DI BANCO, *c*.1384–1421. Florentine sculptor. A transitional figure in the development of Italian Renaissance sculpture. His work combines the decorative and expressive elements of late Gothic art, seen, for example, in his *Assumption of the Virgin*, Porta della Mandorla, Florence Cathedral, and an interest in the use of classical models, seen in works such as the *Quattro Santi Coronati*, Or San Michele, Florence.

PIETRO PERUGINO, *c*.1445/50–1523. Born in Umbria, nothing is known of his early years, although Vasari says that he was a pupil of Piero della Francesca. This would have been in the late 1460s. He moved to Florence, where he was probably taken into Verrocchio's workshop. Worked in the Sistine Chapel in the early 1480s, with Botticelli, Ghirlandaio and others. From *c*.1500–1504 the young Raphael was a pupil in his studio.

BERNARDINO PINTURICCHIO, *c*.1454–1513. Perugian by birth, he worked with Perugino on panel paintings and on frescoes (Sistine Chapel decoration, 1481–1482). His principal works are the fresco cycles in the Borgia apartments in the Vatican (1492–*c*.1495), and the Piccolomini Library at Siena Cathedral (1503–08), where his lively narrative describes the life of Pope Pius II.

ANTONIO PISANELLO, *c*.1395–1455. Painter, draughtsman and medallist, almost certainly a pupil of Gentile da Fabriano, whom he succeeded both in Venice (Sala del Maggior Consiglio, 1415–1422) and in Rome (San Giovanni in Laterano, 1431–1432). His elegant figures, detailed nature studies, and striking portrait medals won him great popularity, particularly in court circles, and he was employed at various times by the aristocratic rulers of Milan, Naples, Rimini, Mantua and Ferrara.

ANTONIO POLLAIUOLO, *c*.1432–1498. Florentine painter, sculptor, engraver and goldsmith. With his brother, Piero, he ran one of the most representative workshops of Florence in the second half of the fifteenth century. His strong interest in the interpretation of the nude figure in violent action is well demonstrated in his vigorous depictions of the *Labours of Hercules* in painting (Uffizi, Florence), drawing (39 in this catalogue) and sculpture (Bargello, Florence), and in his renowned engraving of the *Battle of the Ten Nude Men* (51a).

JACOPO DELLA QUERCIA, 1374/5–1438. Sienese sculptor who may have had some knowledge of Northern sculpture, particularly that of Claus Sluter. He was also interested in using classical motifs at an early date, decorating the Tomb of Ilaria del Carretto, San Martino, Lucca *c*.1406, with antique winged putti. His most famous work is the *Fonte Gaia*, a large public fountain for the main piazza in Siena (1409–1419). His reliefs around the portal of San Petronio, Bologna, were much admired by Michelangelo.

ERCOLE DE' ROBERTI, *c*.1448/55–1496. Ferrarese artist who became court painter to the Este family in 1479. Probably a

pupil of Francesco del Cossa, he was also influenced by Cosimo Tura's proto-mannerist distortions. His personal style seems to have been softened by a knowledge of Giovanni Bellini's work, although there is no evidence that he spent time in Venice.

LORENZO SALIMBENI, c.1374–1416/20. Worked in the Marches. His principal work is a series of frescoes in the Oratorio di San Giovanni, Urbino, which he painted in collaboration with his brother Jacopo. It shows both artists to have been influenced by the fashionable International Gothic style.

LUCA SIGNORELLI, c.1441/50–1523. Born in Cortona, Tuscany, he was, according to Vasari, a pupil of Piero della Francesca, along with Perugino. His early work also shows the influence of the Pollaiuoli in its interest in muscularity and its springy linearity. He worked in the Sistine Chapel, probably in the early 1480s with Botticelli, Perugino and others. His great masterpiece is, however, the fresco cycle in Orvieto Cathedral, for which he was commissioned in 1499, and which depicts the *End of the World*, the *Anti-Christ* and the *Last Judgment*.

PARRI SPINELLI, c.1387–1453. Son of the painter Spinello Aretino, Parri is first recorded as his father's pupil in 1407, working on decorations in the Palazzo Pubblico, Siena. However, his art is linear and elegant, and his style has more in common with the late Gothic artist Lorenzo Monaco than with the massive Giottesque forms of his father.

STEFANO DA VERONA, c.1375–1451. The principal Veronese artist of the International Gothic style. Much influenced by Gentile da Fabriano, he was probably Pisanello's first master.

GIORGIO VASARI, 1511–74. Born in Arezzo and trained as a painter and architect in Florence, his fame really depends on his writings about art, rather than on his painting. His book, *Le Vite de' Più Eccellenti Architetti, Pittori et Scultori Italiani . . . (The Lives of the Artists)* was first published in 1550 and went into a second, much enlarged edition in 1568. Its contents provide a vast amount of source material for many of the artists of the Renaissance. Although the accounts are often partial, biased in favour of Tuscan artists, and sometimes inaccurate, the *Lives* is often our only source of information about an artist, and as such is a key work for any student of Italian Renaissance art.

ANDREA DEL VERROCCHIO, c.1435–1488. Florentine painter, sculptor and goldsmith. He ran an important workshop in which Leonardo da Vinci was trained. Lorenzo di Credi, Francesco di Simone Ferrucci, and probably Perugino, were also his pupils. His craftsmanship was impeccable, his technique brilliant, and his style emphasised qualities of lightness, grace and elegance.

ALVISE VIVARINI, c.1446–1503/4. Venetian school. Son of the painter Antonio, but probably trained by his uncle Bartolommeo. The chief influences on his art were Giovanni Bellini and Antonello da Messina, from whom he learned how to control tonality.

MARCO ZOPPO, c.1433–c.1478. A Bolognese artist who probably began his training with Cosimo Tura, but moved into the studio of Squarcione and in 1455 became his 'adopted son', as Mantegna had in the previous decade. His style is less harsh and angular than either of his masters', however, which may be the result of the influence of Giovanni Bellini.

Select Bibliography

1. *Bibliography of abbreviated references*

(a) **Sources**

ALBERTI/GRAYSON Leon Battista Alberti, *On Painting and On Sculpture*, trans. and ed. C. Grayson, London 1972.

CENNINI/THOMPSON Cennino Cennini, *The Craftsman's Handbook: 'Il Libro dell' Arte'*, trans. D.V. Thompson Jr., New Haven 1933 and New York 1954.

LEONARDO/MCMAHON Leonardo da Vinci, *Treatise on Painting*, trans. and annotated by A.P. McMahon, 2 vols., Princeton 1956.

VASARI/HINDS G. Vasari, *Lives of the Painters, Sculptors and Architects*, trans. A.B. Hinds, 4 vols., London 1927 and 1963 (Dent 'Everyman' edition).

(b) **Museum catalogues**

ANDREWS K. Andrews, *National Gallery of Scotland. Catalogue of Italian Drawings*, 2 vols., Cambridge 1968.

BYAM SHAW J. Byam Shaw, *Drawings by Old Masters at Christ Church, Oxford*, 2 vols., Oxford 1976.

PARKER K.T. Parker, *Catalogue of the Collection of Drawings in the Ashmolean Museum II: Italian Schools*, 2 vols., Oxford 1972.

POPHAM AND POUNCEY A.E. Popham and Philip Pouncey, *Italian Drawings in the Department of Prints and Drawings in the British Museum: the Fourteenth and Fifteenth Centuries*, 2 vols., London 1950.

POPHAM AND WILDE A.E. Popham and Johannes Wilde, *The Italian Drawings of the XV and XVI Centuries in the Collection of His Majesty the King at Windsor Castle*, London 1949.

P. WARD-JACKSON, *Victoria and Albert Museum Catalogues. Italian Drawings I: 14th–16th centuries*, London 1979.

(c) **Exhibition catalogues**

CHATSWORTH EXHIBITION I *Old Master Drawings from Chatsworth*, London, Royal Academy of Arts, 1969.

CHATSWORTH EXHIBITION II *Old Master Drawings from Chatsworth*, London, Victoria and Albert Museum, 1973.

PARKER AND BYAM SHAW K.T. Parker and J. Byam Shaw, *Drawings by Old Masters*, London, Royal Academy of Arts, 1953.

POPHAM *Italian Drawings Exhibited at the Royal Academy, Burlington House, London, 1930*, ed. A.E. Popham, London 1931.

(d) **Other Works**

BERENSON B. Berenson, *The Drawings of the Florentine Painters*, 3 vols., Chicago 1938.

DEGENHART AND SCHMITT B. Degenhart and A. Schmitt, *Corpus der Italienischen Zeichnungen, 1300–1450, I: Süd- und Mittelitalien*, 4 vols., Berlin 1968.

FISCHEL O. Fischel, *Die Zeichnungen der Umbrer*, Berlin 1917.

LAUTS J. Lauts, *Carpaccio: Paintings and Drawings*, London 1962.

MURARO M. Muraro, *I Disegni di Vittore Carpaccio*, Florence 1977.

RAGGHIANTI AND DALLI REGOLI C.L. Ragghianti and G. Dalli Regoli, *Firenze, 1470–1480: Disegni dal Modello*, Pisa 1975.

SCHARF A. Scharf, *Filippino Lippi*, Vienna 1935.

TIETZES Hans Tietze and E. Tietze-Conrat, *The Drawings of the Venetian Painters in the 15th and 16th Centuries*, New York 1944.

2. *Other general works not cited in the text*

F. AMES-LEWIS *Drawing in Early Renaissance Italy*, New Haven and London 1981.

M. EVANS *Medieval Drawings*, London 1969.

P. GOLDMAN *Looking at Drawings: A Guide to Technical Terms*, London 1979.

L. GRASSI *Il Disegno Italiano dal Trecento al Seicento*, Rome 1956.

L. GRASSI *Storia del Disegno: Svolgimento del Pensiero Critico e un Catalogo*, Rome 1957.

J. MEDER AND W. AMES *The Mastery of Drawing*, 2 vols., New York 1978.

P. RAWSON *Drawing*, London 1969.

C. DE TOLNAY *History and Technique of Old Master Drawings*, New York 1943.

J. WATROUS *The Craft of Old-Master Drawings*, Madison, Wisconsin, 1957.

3. *Specialised works cited in the catalogue*

ANTONELLO DA MESSINA: Exhibition Catalogue, Messina 1981–82.

L. ARMSTRONG *The Paintings and Drawings of Marco Zoppo*, New York 1976.

B. BERENSON 'Les Dessins de Signorelli', *Gazette des Beaux-Arts* 6°, VII, 1932, pp.173–210.

T. BORENIUS *The Painters of Vicenza*, London 1909.

S. BOTTARI *Antonello da Messina*, Milan 1953.

K. CHRISTIANSEN *Gentile da Fabriano*, London 1982.

L. COLLOBI RAGGHIANTI *Il Libro de' Disegni del Vasari*, 2 vols., Florence 1974.

G. DALLI REGOLI *Lorenzo di Credi*, Pisa 1966.

G. DAVIES *Domenico Ghirlandaio*, London 1908.

B. DEGENHART AND A. SCHMITT 'Gentile da Fabriano und die Anfänge der Antikerstudiums', *Münchner Jahrbuch für Bildenden Kunst* XI, 1960, 59–151.

H. EDE *Florentine Drawings of the Quattrocento*, London 1926.

L.D. ETTLINGER *Antonio and Piero Pollaiuolo*, Oxford 1978.

M. EVANS 'A Signorelli Drawing for Liverpool', *Burlington Magazine* CXXIII, 1981, p.440.

G. FIOCCO 'I disegni di Antonello', *Arte Veneta* V, 1951, pp.49-54.

G. FIOCCO 'Disegni di Stefano da Verona', *Proporzioni* III, 1950, pp.56-64.

M. FOSSI TODOROW *I disegni dei Maestri: l'Italia dalle Origini a Pisanello*, Milan 1970.

M. FOSSI TODOROW *I Designi del Pisanello e della sua Cerchia*, Florence 1966.

L. FUSCO 'The Use of Sculptural Models by Painters in fifteenth-century Italy', *Art Bulletin* LXIV, 1982, pp.175-94.

H. VON DER GABELENTZ *Fra Bartolommeo und die Florentiner Renaissance*, 2 vols., Leipzig 1922.

G. GRONAU 'Uber das sogenannte Skizzenbuch des Verrocchio', *Jahrbuch der Königlich Preussischen Kunstsammlungen* XVII, 1896, pp.65-72.

D. VON HADELN *Venezianische Zeichnungen des Quattrocento*, Berlin 1925.

A.C. HANSON *Jacopo della Quercia's Fonte Gaia*, Oxford 1965.

A.M. HIND *Early Italian Engraving*, 5 vols., London 1938-48.

M. KEMP *Leonardo da Vinci. The Marvellous Works of Nature and Man*, London 1981.

R. KRAUTHEIMER 'A Drawing for the Fonte Gaia in Siena', *Metropolitan Museum Bulletin* X, 1952, pp.265-74.

P. KRISTELLER *Andrea Mantegna*, London 1901.

O. KURZ 'Giorgio Vasari's "Libro de' Disegni"', *Old Master Drawings* XII, 1937-38, pp.1-15.

J. LAUTS *Domenico Ghirlandaio*, Vienna 1943.

A. PADOA RIZZO *Benozzo Gozzoli Pittore Fiorentino*, Florence 1972.

K.T. PARKER *Disegni Veneti di Oxford*, Venice 1958.

K.T. PARKER *North Italian Drawings of the Quattrocento*, London 1927.

G. PASSAVANT *Verrocchio*, London 1969.

A.E. POPHAM *The Drawings of Leonardo da Vinci*, London 1946.

A.E. POPHAM 'The Drawings at the Burlington Fine Arts Club', *Burlington Magazine* LXX, 1937, p.81.

ANNE POPHAM *The Bloxam Collection of Drawings, Rugby School*, typescript, n.d.

P. POUNCEY 'Two Simonesque Drawings', *Burlington Magazine* LXXXVIII, 1946, 168-72.

L. PUPPI *Bartolommeo Montagna*, Venice 1962.

E. RUHMER *Marco Zoppo*, Vicenza 1966.

R.W. SCHELLER *A Survey of Medieval Model Books*, Haarlem 1963.

A. VAN SCHENDEL *Le Dessin en Lombardie jusqu'à la Fin du XVe Siècle*, Brussels 1938.

SPLENDOURS OF THE GONZAGA: Exhibition Catalogue London, 1981.

J. STEER *Alvise Vivarini: His Art and Influence*, Cambridge 1982.

J. WRIGHT 'Antonello da Messina – the Origins of his Style and Technique', *Art History* 3, 1980, pp.41-60.

Set in 11 on 13pt Monotype Dante
and printed on Westerham Museum Wove
and Cream Art papers by
Westerham Press Limited,
London Road, Westerham, Kent